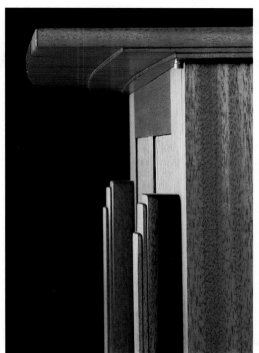

Furniture
Studio
One

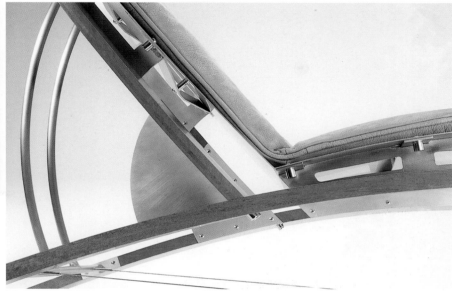

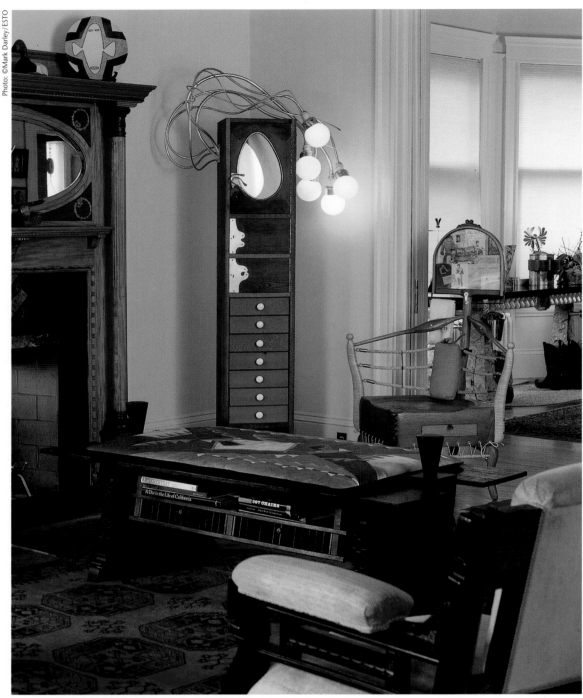

The home of Garry and Sylvia Bennett: studio furniture in a Victorian setting.

PREVIOUS AND FACING PAGE, FROM THE JURIED FURNITURE GALLERY:
Chaise #2 '97 by Richard Prisco; Savannah, GA
Mahogany, aluminum, stainless steel, leather (Photos: Paul Nurnberg)
Audio Box by Ross S. Peterson; Hanover, MN
Lacewood, mahogany, cocobolo (Photos: Ross S. Peterson)

Furniture Studio

The Heart of the Functional Arts

EDITED BY JOHN KELSEY AND RICK MASTELLI

THE FURNITURE SOCIETY

Free Union, Virginia ■ *1999*

The Furniture Society is a non-profit organization whose mission is to advance the art of furniture making by inspiring creativity, promoting excellence, and fostering understanding of this art and its place in society.

For information about permission to reproduce selections from this book, write to The Furniture Society, PO Box 18, Free Union, Virginia 22940.

Developed by Cambium Press
Produced by Image & Word / Print & Video
Editors: John Kelsey and Rick Mastelli
Design and layout: Deborah Fillion

Editorial Board of Advisors:
Edward S. Cooke, Jr., Charles F. Montgomery Professor of American Decorative Arts, Yale University
Dennis FitzGerald, Shop Manager and Adjunct Faculty, Purchase College SUNY
Amy Forsyth, Assistant Professor of Architecture, University of North Carolina at Charlotte
Brian Gladwell, Furniture designer, maker, and teacher, Regina, Saskatchewan
Loy D. Martin, Furniture designer and maker, Palo Alto, California

Printed in Hong Kong

First printing: September 1999

Library of Congress Cataloging-in-Publication Data

Furniture studio : The heart of the functional arts / edited by John Kelsey and
 Rick Mastelli.
 p. cm. — (Furniture studio ; 1)
 Includes bibliographical references and index.
 ISBN 0-9671004-0-2
 1. Furniture design — History — 20th century. 2. Chair design — History
— 20th century. 3. Furniture Society (Free Union, VA).
 I. Kelsey, John, 1946– II. Mastelli, Rick, 1949– III. Series.
 NK2395.H43 1999
 749.2'0499—dc21 99-29702

THE FURNITURE SOCIETY
PO Box 18
Free Union, VA 22940
Phone: 804/973-1488; fax: 804/973-0336
www.avenue.org/Arts/Furniture

Distributed to the trade by Cambium Press
PO Box 909
Bethel, CT 06801
Phone: 203/426-6481; fax: 203/426-0722
www.cambiumbooks.com

Preface

I remember the earliest conversation about this book with John Kelsey on the last evening of The Furniture Society's 1997 conference at Purchase College, New York. The conference had been an exciting success, attracting a diverse group of furniture enthusiasts to talk about more than the technical concerns of making or marketing studio furniture. Attentive in many ways to the meaning behind what furniture makers do and to what those who appreciate furniture appreciate about it, it was an inspiring event, especially provocative for John and me. We had worked together on *Fine Woodworking* as that magazine became a reference for the revolution that woodworking underwent in the late 1970s and early 1980s. We'd both gone on to other publishing challenges and had not talked together about the furniture community for some time. Yet the idea that percolated to the top of the heady atmosphere of the Furniture Society conference — the idea that became this book — was not new. Rather, it was one whose time had finally come.

Like The Furniture Society itself, *Furniture Studio* brings together the constituents of a community who have barely recognized themselves as such and have not had much opportunity to talk with or hear from one another. Despite the proliferation of woodworking and other craft publications over the last couple of decades, the studio furniture field has not had the forum it deserves for expressing and analyzing itself.

John had tried before to create a publication that would go beyond *Fine Woodworking's* technical mandate, one that would provide a forum for the cultural, philosophical, and historical issues that constitute the meaning of furniture for those who make it as well as those who use it. Predicated on serving portions of a number of niche markets, such a publication was judged to be neither simple nor broad enough for commercial success. Indeed, neither is *Furniture Studio*. But that is just what makes it so special and so valuable, and that is also what makes it exactly the right complement for the conferences and other programs that The Furniture Society has brought forth. This book would not have been possible but for the combined interest and resources of many supporters.

Thanks to financial support from the Chipstone Foundation, the Department of American Furniture at Christie's New York, and an anonymous foundation with an interest in the field, The Furniture Society has been able to apply the seed money to launch what we hope will be the first in a series of books. Feedback from readers (we encourage you to visit The Furniture Society website) will dictate how viable that hope is. We have also to thank the authors, who contributed more than we could pay them for; the makers and photographers, whose work appears here gratis or for generously discounted compensation; and the museums, galleries, and collectors for the access they provided to furniture or images of it. Special appreciation goes to this book's Editorial Board of Advisors for their attention and insights. Everyone involved in this project has given an extra measure of support, resulting in a uniquely communal publication.

In these pages, besides hundreds of images of contemporary furniture, you will find the furniture maker, teacher, historian, dealer, collector, and user, all writing from their various perspectives on the meaning of furniture. Without diminishing the importance of its function, furniture is always more than mere function. Perhaps we overlook its rich content because furniture is in some ways meant to be taken for granted. Nevertheless, it is the focal point for and the reflection of some of our most basic meanings. If furniture is the heart of the functional arts, meaning is its lifeblood. And so it is not surprising to find it coursing through every page of this book. What is surprising (seeing all the parts finally come together) is how many different directions it takes. Personal, historical, aesthetic, social, economic, artistic, political angles are here explored in a variety of formats not typically seen between two book covers: scholarly studies, critical essays, profiles, reviews, design explorations, reflections on work accomplished. That is why we named this *Furniture Studio:* a place to explore the manifold content of studio furniture.

—*Rick Mastelli, Coeditor*

Contents

Page 32

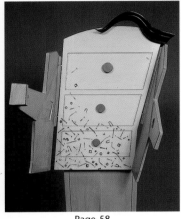

Page 58

Page 110

Page 76

Page 102

ON THE COVER, FROM THE JURIED FURNITURE GALLERY:

Arno Verhoeven, Flesherton, ON

Without Title 1997
Walnut, maple veneer, baltic birch plywood, aluminum
60"w × 20"d × 70"h

*Designed to investigate how two differing forms would work
together. Neither the cabinet on the left,
nor the plinth on the right, can stand on its own.*

Photo: Arno Verhoeven

Page 50

Page 119

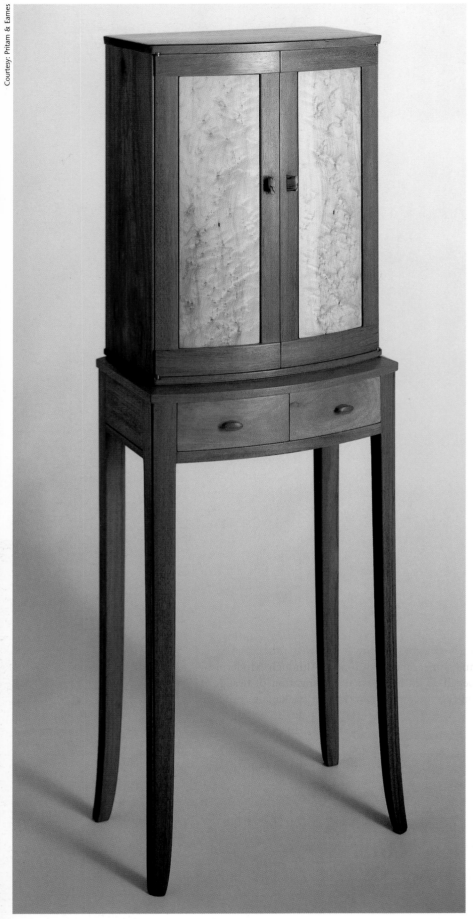

Courtesy: Pritam & Eames

James Krenov (Fort Bragg, CA), *Cabinet on Stand,* **1991, doussie, birds-eye maple.**

DEFINING THE FIELD

■

Edward S. Cooke, Jr.

■

Furniture Studio offers a rich and revealing view of an important segment of the contemporary furniture world. During the past two decades works of the sort illustrated and discussed in this volume have gained particular visibility in art and craft galleries, museum exhibitions, and popular print. The energy and conviction of its practitioners has also led to the formation of a successful international organization, The Furniture Society. This growing prominence and sense of community notwithstanding, the furniture itself raises several questions: Is this work merely a coincidental or forced assemblage of disparate individual voices? Does it coalesce into a single, coherent field? What do we call this sort of furniture?

Indeed, a wide range of work is chronicled and discussed here—from the refined joinerly furniture of James Krenov to the iconic humor of Tommy Simpson or the cross-culturally inspired work of Kristina Madsen to the textured, sculptural work of Wendell Castle. The date range of objects is also quite broad, from the 1950s to the present. There are, I believe, relationships among these works, for they are indicative products of a particular time. To see their coherence as a field, however, one must understand, and also question, past terminology and perspectives.

Furniture historians have traditionally tended to organize antique furniture according to formal stylistic categories. To their groupings of relatively high-style work they have assigned names of seminal designers or rulers or nomenclature describing aesthetic intent. Thus eighteenth-century furniture is popularly known as Chippendale or Hepplewhite, referring to the designers who codified certain styles through their publications; Louis XVI or Georgian, in honor of the magistrate who

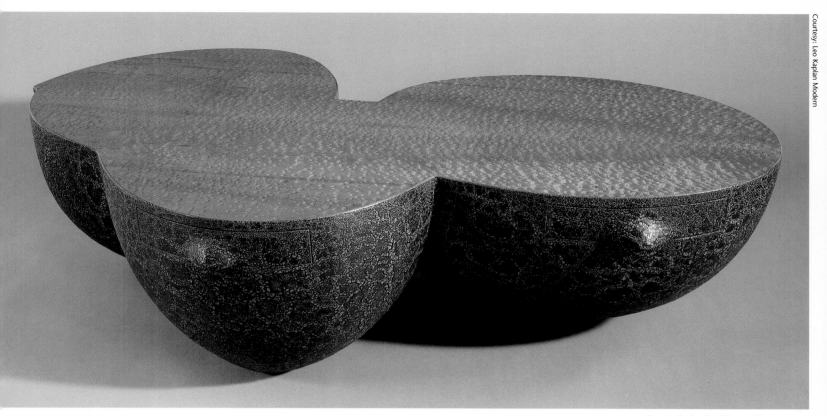

Wendell Castle (Scotsville, NY), *Three-Drawer Coffee Table,* 1997.
Below, Tommy Simpson, (Washington, CT), *Hall's Pie Safe,* 1985, spalted and figured maple, punched-tin rhymes taken from country store advertisements.

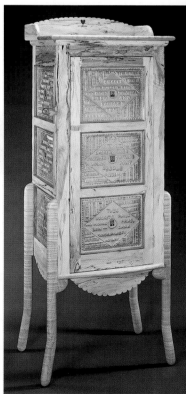

ruled during that style's popularity; or Baroque or Rococo, to signify the dominant aesthetic in the world context. As art historians such as Meyer Shapiro have argued, products of a specific time and place tend to bear the aesthetic imprint of that moment and location. Style, which may be rooted in shared outlooks of the shop masters, coherent demands of a particular client group, common printed sources, or available materials, serves as the primary means of linking objects.

With the stylistic revivals of the mid-nineteenth century and increased production due to mechanization, style became a less important barometer. Instead, taste and workmanship arose as important criteria. Following the lead of the period's writers and critics, particularly John Ruskin, English tastemakers such as Charles Locke Eastlake, and architects such as E.W. Godwin began to call for better designed furniture. Godwin developed the term Art Furniture in the late 1860s to distinguish well-designed, custom-produced work from tawdry factory work that poorly copied previous styles. In America, Art Furniture ran the stylistic gamut from the Japanese-inspired work of Herter Brothers, to the Modern Gothic of Kimbel & Cabus, to the colonial revival work of Potthast Brothers, but attention to tasteful design and quality workmanship linked the various expressions.

In the late nineteenth and early twentieth centuries Gustav Stickley, Charles Limbert, William Price, and other Arts and Crafts enthusiasts elevated the importance of craftsmanship over decoration. Good, honest structural furniture was considered to possess the greatest moral integrity that would facilitate the simple life pursued by many middle- and upper-class Americans. Furniture historians studying work from the last quarter of the nineteenth century and first two decades of the twentieth tend to categorize the work less by style and more according to the prevalent intellectual charge—the Aesthetic Movement or the Arts and Crafts Movement.

By the 1920s and 1930s, interest in abstract notions of taste and morally charged craftsmanship had waned, and a renewed interest in style and appearance developed. Although Modernism began as an intellectual investigation of design, it quickly became a new way of packaging furniture and was reduced to a style. Promoted by industrial designers, architects, and cabinetmakers, Modernism privileged new materials, industrial production, and streamlined or industrial forms. Even Post-Modernism, the subsequent response to the perceived bleakness of the modern style, has been viewed primarily as an aesthetically coherent style united by reference to historical form and detail and a fondness for color. Drawing from promotional literature of the period, furniture historians have reverted to stylistic criteria to typologize twentieth-century work.

In the post-industrial world we must grope for a specific term that is appropriate to our specific

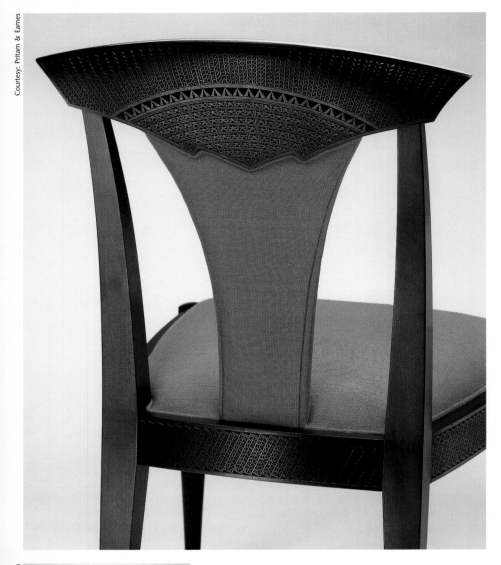

Courtesy: Pritam & Eames

ralism is striking. Critic Donald Kuspit has noted that today there are multiple uses of art and multiple styles, all with no specific hierarchy. Many furniture makers have used their independent status in the marketplace to explore a number of different directions or to distinguish themselves from others. Yet we should not take the easy path and simply refer to the contemporary furniture field featured in this publication as "pluralistic furniture." That's too vague. Other contextual terms such as Art Furniture, handcrafted furniture, and Modern and Post-Modern furniture do not work, for they have been used to describe furniture in other times.

What we need is a term unique to our own time, not one based solely on form, aesthetics, the intention of the maker, or the hype of the gallery. I favor the term "studio furniture." What really distinguishes the furniture illustrated and discussed in these pages is the background of the furniture makers; their interest in linking concept, materials, and technique; and the small shops in which they work. Studio furniture makers have not learned their skills through traditional apprenticeship systems but rather have mastered design and construction in college (either in dedicated college art programs such as California College of Arts and Crafts or Rhode Island School of Design or in college woodworking shops such as those at Dartmouth or Michigan) or are self-taught. The latter, as well as many of the academically trained, have learned through reading periodicals and books, attending workshops or short-term courses, constant experimentation, and comparing notes with other furniture makers. Unlike the wage-based, task-specialized, restrictive training typical of the furniture trade, most studio furniture makers experience a longer, self-directed, and less constrained learning period.

The term "studio" evokes this type of long-term exploratory learning, but it also suggests a high degree of visual literacy and a vigorous conceptual approach to design and construction. Many of the makers featured in this book have had some education in art or design and draw inspiration from a vast stock of images and ideas—traditional furniture or new industrial design, fine arts or popular culture, the familiarity of wood and joinery or the excitement of new materials and techniques, common notions or private dreams, etc. Constant throughout the design and fabrication process is an intellectual rigor in which a maker fully invests him- or herself to realize an idea.

"Studio" also helps locate the place in which this practice of furniture making takes place. Studio furniture makers use a variety of machinery and handtools, and often assistants or specialists; but they tend to work in smaller spaces set up to

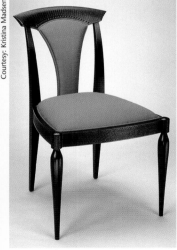

Courtesy: Kristina Madsen

Kristina Madsen (Southhampton, MA), *Dining Chair,* **1993, dyed imbuya and silk.**

National Museum of American Art, Smithsonian Institution. Gift of the James Renwick Alliance.

time and circumstance. It is difficult to describe the entire field of furniture referred to here by evoking major designers or political figures. The work of James Krenov or Sam Maloof, for instance, though widely emulated, hardly reflects enough of the field for the terms "Krenovian" or "Maloof-style" to have broad currency. Wendell Castle, though known for three or four powerfully influential styles, still might lend his name to only a portion of the story. "Bushian" or "Clintonian" is not appropriate, since there is little direct connection to the political culture. Similarly, defining the furniture illustrated in these pages in terms of aesthetic form, such as Post-Minimalist, does most of it a disservice. Other aesthetic terms, such as "California roundover" or "Northeast academic," may be appropriate for certain regional work at a particular time but do not provide a cohesive description. They merely fragment the field further.

In our time of rapid information exchange, an oversaturated market for domestic goods, and heightened interest in art and design, aesthetic plu-

maximize the effective work of the individual, and their level of production remains relatively low, occupying the middle and upper layers of the furniture market. Their spaces, approaches to work, and final products lack the scale of a manufactory. The term "studio furniture" thus highlights the independent professionalism of the furniture makers and their custom production, which is characteristic of other aspects of today's decentralized (yet networked) social and economic culture.

The marketing of studio furniture is also unique to our time. Normal retail outlets for furniture or design have little relevance to the field of studio furniture, where work is distributed through peculiarly dynamic sales networks. Works are showcased and sold through craft or art galleries or at craft or furniture shows, displayed at studio open houses where a local group of art supporters might see them, commissioned by a client, or purchased directly from the maker's shop. Some makers sell through a number of these venues simultaneously, but there is considerable variation based on region, gallery or show presence, and maker's connections. Often studio furniture tends to be concentrated in the region of its creator, but some also becomes part of an extra-local art collection, in private residences or museums. The marketing is thus distinct from the mainstream furniture trade, and closer to that of small local businesses and the fine art world. The term "studio" suggests the importance of the individual maker and his or her artistic aura in the marketplace.

Understanding the essence of today's studio furniture helps to explain why American and Canadian furniture makers are leaders in the field. In most countries the furniture field is more hierarchical, with a clear separation of design and production. Design schools, and the intellectual processes taught in them, are distinct from technical schools and apprenticeship programs, and the skills taught there. While John Makepeace and the Royal College of Art have fostered a small group of furniture makers in Great Britain, the control of professional designers and the limited power of tradespeople who learned through traditional apprenticeship contributes to the stylistic and technical coherence of each country's work. In the U.S. and Canada, the emphasis on academic training or self-education, a professional identity, and a dynamic, multi-layered market have made studio furniture making more diverse, more energetic, and more prominent.

Identifying the distinctive qualities that make up studio furniture helps to establish appropriate criteria for assessment. One must go beyond traditional formal or aesthetic analysis based upon the concept of stylistic unity and the existence of an idealized type within that style. It is also not

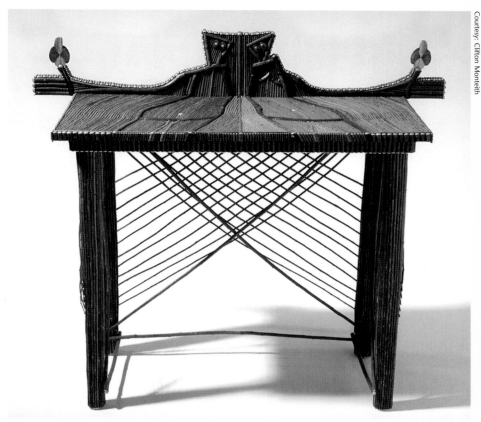

Clifton Monteith (Lake Ann, MI), *Adam and Eve Sharing an Hors d'Ouevre Preceding Their New Career in Agribusiness,* 1997, aspen, cedar, willow twig mosaic, red pine burl.

sufficient to focus only on craftsmanship or the concept behind a piece of furniture. Instead, it is important to examine all aspects of the maker's intent and performance, to truly grasp why and where an example fits within the notion of studio furniture. Critical to this endeavor is a thorough understanding of the individual furniture maker and the contemporary field.

For example, the work of Clifton Monteith makes a great deal of sense when you realize that he left his career as a graphic artist in New York and consciously sought a slower, more deliberate pace in upstate Michigan. Looking for a new livelihood, he decided to become a furniture maker, using simple stick furniture technology and local materials to cater to a local market. His willow furniture, a type that echoes the rustic furniture that soothed urban exiles a century ago in the Adirondacks, reveals both his awareness of the past traditions and his commitment to personalize it with more complex articulation and color.

The need for more in-depth and sophisticated understanding of the practice of studio furniture is only now beginning. By offering insights into the varied backgrounds and approaches of the makers, the synergy between idea and technique, and the multi-faceted meanings of the final product, the essays, articles, and images of this new publication should go a long way towards building a common history and language. ■

UNDERSTANDING FURNITURE

■

JOHN DUNNIGAN

■

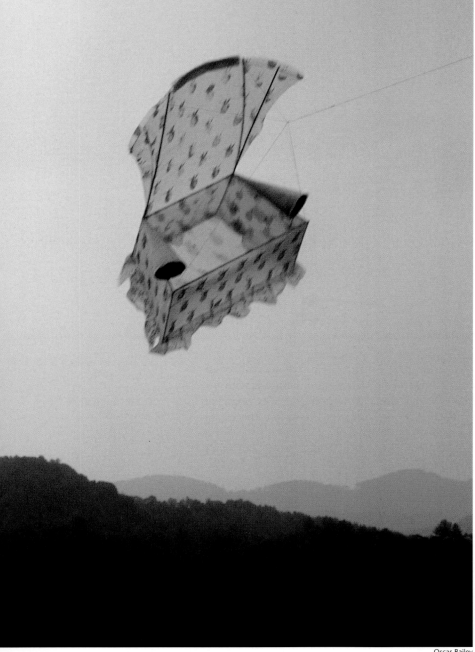

Oscar Bailey

A maker and professor of furniture design explores the relationships between culture, technology, style, and the self

Recently, someone who didn't know me asked me what I do. "I make furniture," I said. You know, it is remarkable how quickly the brain computes the subtle and complex differences between preconception and observation. The expression on his face showed immediate interest but said that he had no idea what to make of my response, though it was as plain as could be. Why? Well, that could be a long story. Anyway, maybe because the brain tends to categorize in order to comprehend, he asked, "What kind of furniture?" and I searched in vain for a short, conversational answer.

Now, it's not that I don't understand what I do, nor am I trying to inflate its importance. It's just that after twenty-five years of making furniture and thinking about it, I'm not willing to confine the definition of it to oversimplified categories of style or material. With few exceptions, they don't convey enough information to lead to an understanding of what a furniture maker does or what the furniture means. Nevertheless, I tried to answer the question by saying that I make what is sometimes called studio furniture, which was originally defined as furniture that is the result of a fundamentally artistic pursuit dependent on the convergence of art, design and craft.[1] Sometimes this kind of work is called art furniture[2] and when put in that category, my work is considered tra-

1. Edward S. Cooke, Jr., *New American Furniture* (Boston: Museum of Fine Arts, 1989), p. 10.

2. William Morris was largely responsible for reintroducing the idea of furniture as art, and by the 1860s the term seems to be common. See, for example, Charles Eastlake, *Hints on Household Taste* (1868), pp. 55, 66, 91.

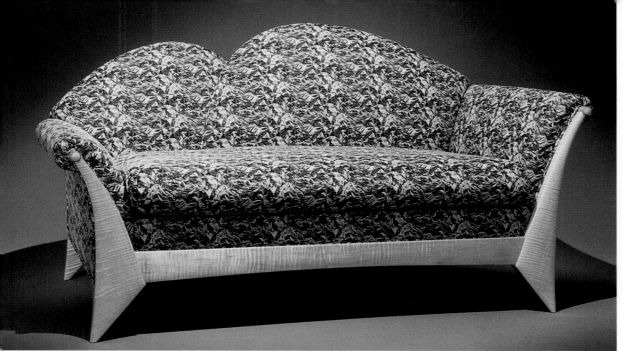

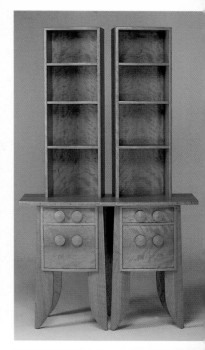

Photos: Ric Murray

ditional.[3] I was hoping that answer would be good enough when he said, "That's interesting, but what does it look like?"

Once, years ago at a party, I was having this same conversation with a small group of people. I had just read one of David Pye's books and it was on my mind, so I explained that my furniture was about the workmanship of risk as opposed to the workmanship of certainty.[4] As our conversation unfolded, I learned that one of my new acquaintances was a stock broker and another was a surgeon. We had an interesting discussion that night about relative risk, but it was clear that defining what I make in terms of risk hadn't helped.

From time to time, I've thought that "hand made" best describes my work, but this too is problematic. First, it is almost impossible to avoid implying a qualitative judgment, which would be inaccurate since there are many great machine-made things that we would not want to see made any other way. Second, although I enjoy using my hand planes, chisels, and hand saws more than any other tools and believe their use affects the nature of my work, I do use quite a few machines, too. What really is hand work anyway? Further, as if that question isn't hard enough, how do we even define the hand? Biomechanically, it is an integral part of the entire arm which itself is integrated with the neck, spinal cord, and brain.[5] If damage to the brain can cause the hand to stop functioning, should the parts of the brain that regulate hand function be considered, for our discussion, part of the hand?

The problem of trying to define the hand may be more serious, but it is as elusive as trying to define furniture. Usually I favor clarity and accuracy in language, but I've never found a defini-

tion of furniture that wasn't limited in its usefulness. In fact, when I teach classes in furniture design, I often start the first meeting by asking, "What is furniture?" In those sessions, we are sometimes able to broaden our frame of reference and break down a few narrow preconceptions, but rarely are we able to agree on a definition that is entirely satisfactory.

For example, one of the commonly used definitions of furniture is that it is a class of functional objects that carry meaning. That's actually pretty good, except it describes equally well many other things like jewelry or appliances. For instance, in most homes, the refrigerator occupies a place of extreme significance. It is the most visited and central temple of sustenance. It is functional in every sense of the word and holds not only food, but meaning as well. On the front of the cabinet, we display recent announcements, postcards from loved ones, photos, and children's artwork, not to mention magnetic poetry. In those moments of decision, big and small, we stand before it with one hand on the open door, staring into its bright interior, looking for answers. Many are the revelations associated with the indirect glow of 40 watts, and if your house is anything like mine, the price of wisdom is often measured in calories but paid in pounds. Now, if refrigerators fit the definition so well, why don't people consider them furniture? Is it because they have those lights inside? Is it because they have compressors?

"Not willing to confine the definition of it to oversimplified categories of style or material," Dunnigan's own work ranges from wing-chair kites (facing page) to cast-bronze, cast-glass tables. Sofa, 1990, curly maple and cotton, 32"h x 72"l x 36"d. Cabinet, 1997, cherry, 84"h x 48"w x 24"d. Table, 1993, cast bronze and cast glass, 16"h x 14"dia.

3. Witold Rybczynski, *Looking Around* (New York: Viking, 1992), pp. 27–33, and also "If a Chair Is a Work of Art, Can You Still Sit on It?" *The New York Times* (May 5, 1991), sect. 2, p. 1.

4. David Pye, *The Nature and Art of Workmanship* (London: Cambridge University Press, 1968; Bethel, CT: Cambium Press, 1996), pp. 20–24.

5. Frank R. Wilson, *The Hand* (New York: Pantheon Press, 1998), pp. 8–9.

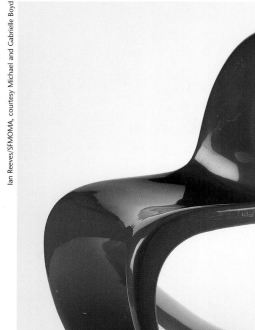

Which of these is strictly functional or purely symbolic? These few examples illustrate how "the best work...often transcends categories," blurring the modern distinctions between art, design, and craft. Clockwise from above: bench by Michael Hurwitz; chair by Verner Panton; "Dragonfly Chest" by Judy McKie; "Tube Chair" by Joe Colombo; and Lobi reclining chair (twentieth century Africa).

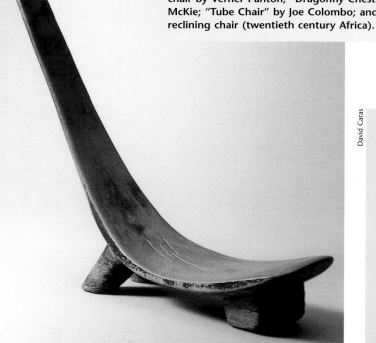

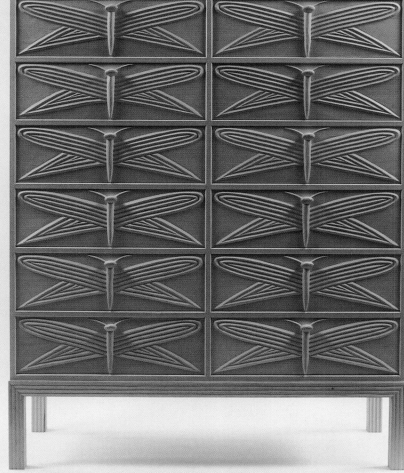

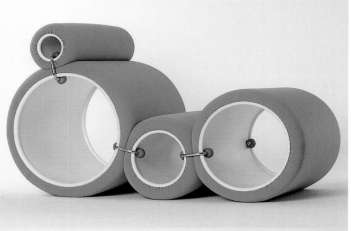

The Metropolitan Museum of Art, Purchase, Theodore R. Gamble, Jr., Gift, in honor of his mother, Mrs. Theodore Robert Gamble, 1987. Photo: Mark Darley

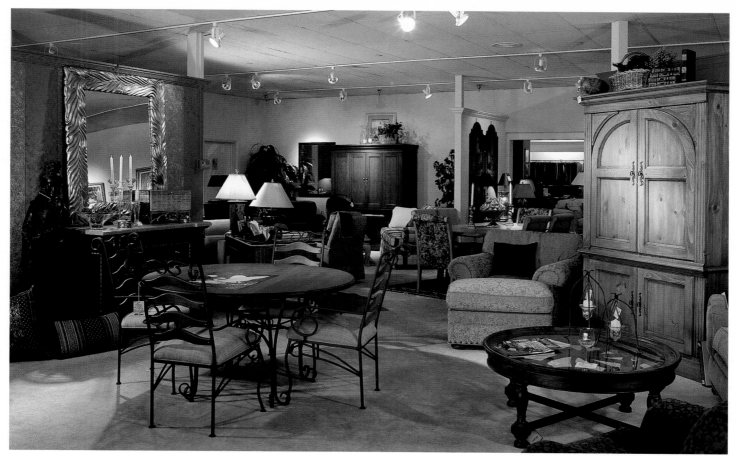

Commercial furniture showroom: "what comes to mind for most people when they think of furniture."

I write this not to make a case for refrigerators but to make a point about definitions of furniture. Perhaps the most useful way of looking at furniture right now would be to refocus out from narrow categories and to take a wide-angle view instead. For the moment, let's see how much our perspective can include, not how little. By being less concerned with what is or isn't allowed to be considered furniture, we could learn a lot from the marginal things. Likewise, by not focusing so much energy on separation of furniture into types, we might avoid some of the old traps like art versus craft or functional versus nonfunctional, and eventually new categories might make sense. Although it is sometimes helpful and necessary to focus on specific types of furniture, the best work, like the work of Judy McKie, Michael Hurwitz, Joe Colombo, or Verner Panton (facing page) often transcends categories and makes typical boundaries irrelevant.

It is unfortunate that few people ever get to see the best furniture. This is no surprise since the furniture industry in the U.S. ships about $24 billion worth of household furniture each year,[6] and they invest billions more persuading us to buy it. The most creative and original work usually exists at the fringes and will never be mainstream; moreover, there is very little room left for innovative alternatives in the general markets because they're not profitable. Given the dominance of the furniture industry and the volume of advertising,

creative alternatives are pushed out of sight, out of mind. If market ubiquity indicates preference, then the photo above shows what comes to mind for most people when they think of furniture. In this country, most people buy their furniture from giant showrooms where value is about price and terms. In most furniture advertising, the only things mentioned are the price, the delivery time, and the terms of payment: "No money down and no payments till next year! Interest Free! Get this three-piece living room set for only $795! Call today — Delivery tomorrow!"

Furniture showrooms feature a range of styles, costs, and quality all mixed together for your shopping convenience. Some of it is pretty good and some of it is terrible, but it's all mass-produced and mass-marketed, sometimes with planned obsolescence in mind, in order to encourage mass consumption. The argument for this kind of furniture is that through an economy of scale the consumer is given wider choices at lower prices than would otherwise be available, although a recent article in *The Wall Street Journal* states that this is not always the case.[7] Nevertheless, this is furniture for most people, and the rarefied world of studio furniture shouldn't forget it. Despite how artists, designers, craftsmen, and connoisseurs might feel about this kind of commercial furniture, it carries a great deal of meaning for people, and there is much to be learned from it.

6. U.S. Department of Commerce. Studio furniture sales are not included.

7. James R. Hagerty and Robert Berner, "Ever Wondered Why Furniture Shopping Can Be Such a Pain?" *The Wall Street Journal* (November 2, 1998), p. 1.

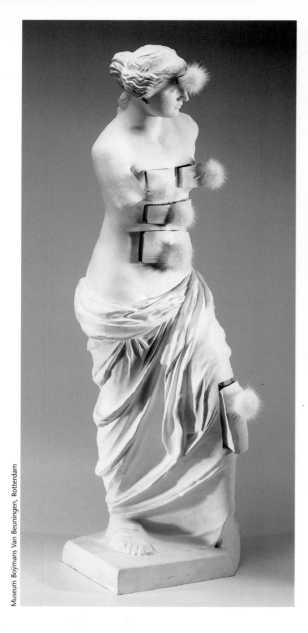

Museum Boÿmans Van Beuningen, Rotterdam

Evocative titles for provocative work: Ed Zucca's "Aliens Take Home a Souvenir" (1992), above, and Salvador Dali's "Venus with Drawers" (a 1964 copy of the 1936 original), left.

Paul Fussell in his book *Class* takes a very irreverent and provocative view of American society.[8] In his sure-to-tease-everyone style, he shows us how furniture is a sign of social status and how people say a lot about who they are by the things with which they surround themselves. This is certainly not a new idea, but Fussell reminds us in a humorous way that furniture of all kinds carries meaning across all segments of society. The Lazy-Boy recliner is as significant to one person as an antique Newport wing back chair is to another.

Professors Csikszentmihalyi and Rochberg-Halton in their book *The Meaning of Things* address the issue of how things actually get meaning. They studied over three hundred people from eighty-two families over a five-year period. Their research showed that objects reflect as well as shape personal identity and that of all things in the home that carry meaning relevant to defining the self, furniture comes first.[9] Rochberg-Halton and Csikszentmihalyi cautioned that this preference for furniture should not be interpreted as evidence for utilitarian values because only five percent of responses mentioned usefulness or practicality. The most common reasons given for why furniture was valued had to do with memories and experiences, followed by style. What determined the significance of the object often had less to do with how it looked than with what associations the owner had with it, both past and present. Of course, style is important too and it is always linked to meaning. For example, you may love the style, but it matters less what the old rocking chair looks like than that it belonged to Grandma and she rocked you to sleep in it years ago, just like you rock your children now. I do not want to suggest that meaning always trumps style, so consider that although you may not have actually had that experience, a piece of furniture that stylistically looks the part may still cause you to have those associations.

Most of the meaning eventually attached to things has little to do with the specific intent of the designer or maker. However, this does not diminish the importance of meaning that is given to things by the designer or maker, and in fact, it is the primary task of the artist to provoke the viewer or user of a thing to think or feel in a way that is beyond ordinary. Sometimes artists use evocative titles or references, as in the bench by Ed Zucca from 1992 titled "Aliens Take Home a Souvenir" or in the "Venus with Drawers" by Salvador Dali from 1936. In the best work, the overt meaning given by the artist combines with the kind of meaning that comes from use or association and has universal cultural resonance.

So, even if we can't quite define furniture in a singular or exclusive way, it does hold significant

8. Paul Fussell, *Class* (New York: Touchstone Books, 1983).

9. Mihaly Csikszentmihalyi and Eugene Rochberg-Halton, *The Meaning of Things* (London: Cambridge University Press, 1981), pp. 58–62.

meaning. If categories of type and kind are limiting when used by themselves, is there any better way of explaining what furniture makers do? I think so. Furniture can be understood as a material expression of the symbiotic relationships between technology, culture, style, and the self. This framework sets up a flexible system for seeing why things look the way they do, and it sets up a necessary context for meaning. With this, we can resist the tendency to rely on simplistic cause-and-effect relationships between things. For example, in an abstract sense, culture doesn't really create style nor does style create culture. Technology is not capable on its own of searching for style. They are interdependent realms that humans affect, as they are also affected by them. The maker may shape the object, but the object also shapes the maker. Wherever we look and whatever we look at, this framework can help us make the connections between things.

From the Paleolithic to the present, the history of humanity is framed by the phases of our relationship to technology. The development of our species is inseparable from the development of technology; this is represented in culture and style, and it is evident in furniture. A great example of this idea can be seen in the work of Charles and Ray Eames.

In 1946, the Museum of Modern Art in New York staged a one man exhibit titled "New Furniture By Charles Eames," which featured technologies and materials developed during World

War II. That show included the DCM and DCW chairs developed the previous year at the Eames studio.[10] Both chairs utilized plywood molded into compound curves, a technique developed for making lightweight airplanes and boats for the war effort that relied on improved synthetic glues and inexpensive veneer. The Eames studio perfected these techniques while working for the U.S. Army to develop and produce molded plywood leg splints for wounded soldiers. The stainless steel rod frame of the DCM chair was welded with the latest techniques used in building warships. At the beginning of the war, the engineers at Chrysler had invented this new electronic-cycle welding for the automobile industry but the government restricted its use to the war effort. Charles and Ray Eames, as designers working for the government, knew about the new type of welding early on, and as soon as the restrictions were lifted after the war, they put it to use in furniture. The chair also featured neoprene gaskets between the wood and the steel, making them an important part of the design aesthetic. Neoprene was one of the new synthetic rubbers invented when the United States and England lost access to the natural rubber plantations in the Pacific. As a successful marriage of design, technique, and materials, and with political support, this chair became a symbol of American Modernism and victorious technology.

From September 1886 until October 1887, the Boston chair maker William B. Savage ran a monthly advertisement in *The Decorator and Furnisher* offering a chair made out of recycled spin-

Eames DCM chair, 1946: "a symbol of American Modernism and victorious technology."

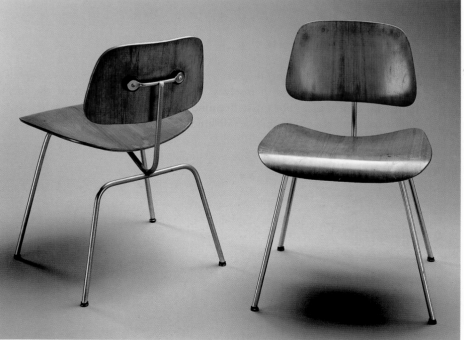

"DCM" chairs, 1946. Designed by Charles Eames (1907–1978) and Ray Eames (1912–1988); manufactured by Evans Products, Co. for Herman Miller, Inc. Wood, steel, metal, rubber. Cooper-Hewitt, National Design Museum, Smithsonian Institution/Art Resource, NY. Gift of Olive Enslie, 1990-112-1,2

10. Pat Kirkham, *Charles and Ray Eames: Designers of the 20th Century* (Cambridge: MIT Press, 1998), p. 219.

ning wheel parts as a nice gift for newlyweds. This would have made sense to the readership since by that time, the spinning wheel had become a recognized sign of old fashioned home and hearth.[11] When Henry Wadsworth Longfellow published his poem "The Courtship of Miles Standish" in 1858, he popularized the values of an earlier epoch and contributed to the revival of interest in American colonial heritage. In the poem the virtue of Priscilla Mullins is linked to her use of the spinning wheel, as is the fate of John Alden. Savage's advertisement borrowed Longfellow's lines:

> *So as she sat at her wheel one afternoon*
> * in the Autumn,*
> *Alden, who opposite sat, was watching*
> * her dexterous fingers*
> *as if the thread she were spinning*
> * were that of his life and fortune.*

Here we have a poet and a furniture maker using the same artifact as metaphor.

To grasp how the spinning wheel became such an effective popular symbol, we need to see it in the context of a new nation searching for its identity and wrestling with such forces as Manifest Destiny, the Civil War, and the Industrial Revolution. These upheavals filled the nineteenth century with stylistic revivals, and among the many factors contributing to the milieu, technology was particularly significant. The spinning of fibers like wool and flax into thread by hand had been a constant domestic activity since prehistory, and the spinning wheel had been in use since the fourteenth century in Europe. But during the nineteenth century, in just a generation or two, that all changed dramatically.[12] By the 1830s the steam or water-powered spinning jenny had shifted the production of thread from the home to the factory, making possible radical changes in the production of cloth, not to mention the social fabric of domestic relations.[13] In previous centuries, the spinning wheel had been standard household equipment, but by the 1830s it had become obsolete and was relegated to the attic or barn. As the spinning wheel lost its utilitarian function, it acquired a new symbolic function. A cultural

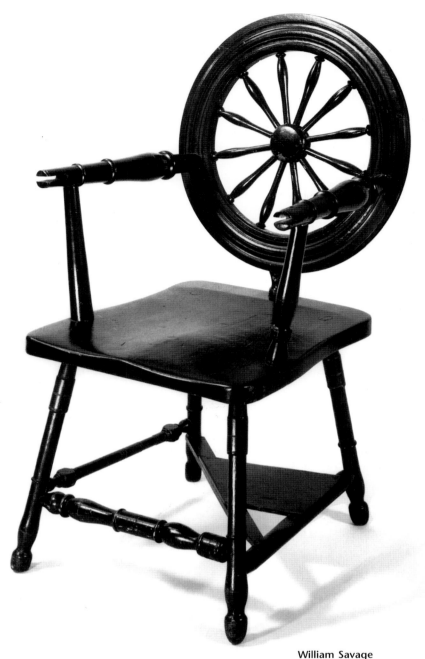

William Savage "Spinning Wheel Chair," 1886, a nineteenth century example of recycling and "a nice gift for newlyweds."

Museum of Art, Rhode Island School of Design; Gift of Elizabeth Norris Smith in memory of Natalie Larrilard Bailey Morris

identity crisis, along with new technology, had turned an everyday object into an icon.

You can learn a lot from a chair. When I first saw the spinning wheel chair at the Museum of Art at RISD, I was curious because it was so strange looking and had recycled parts, but I didn't see much beyond that. Then one day it struck me that my mother had a spinning wheel in her house which she had used as a planter since the 1950s when she decorated with new Colonial Revival furniture. As a kid, I didn't care much about that stuff, but I remembered trying not to crash into it when I ran by with my skates and hockey stick. And then after years of forgetting, I also remembered how both of my parents loved the poetry of Longfellow and could still recite passages they had learned in school. Since that day in the museum years ago, the spinning wheel chair has meant a lot to me not just because it's such

11. Christopher Monkhouse, "The Spinning Wheel as Artifact, Symbol, and Source of Design," *Victorian Furniture*, Kenneth L. Ames, editor (Philadelphia: Philadelphia Victorian Society in America, 1982), pp. 154–172.

12. Elizabeth Wayland Barber, *Women's Work: The First 20,000 Years* (New York and London: Norton, 1994), pp. 30–38.

13. The spinning jenny was actually invented in 1770 by James Hargeaves but was not in common use until later.

an interesting expression of its time but because it makes some connections in my own life.

Though furniture is an expression of its time, it would be an oversimplification to assume that any one style or kind of work could always express the historical period. Usually, there are opposing styles representing conflicting ideologies, or at least different opinions. The furniture of Michael Thonet and William Morris illustrates this dialectical relationship. In many ways their work represented irreconcilable polarities, the ultimate synthesis of which describes design reform in the 1850s and on into the early twentieth century.

In 1851 The Great Exposition of the Industry of All Nations was held at the Crystal Palace in London. This international event galvanized public sentiment on both sides of the issue of industrialization. Many people were impressed, but some were as horrified by the shoddiness of design and construction as they were by the awesome power of new technologies. Michael Thonet, a German furniture maker living in Vienna, displayed several of his bentwood pieces and won an award for "curious" designs.[14] Learning the cabinetmaking trade in the first quarter of the nineteenth century, Thonet's early work was at least partly in the Biedermeier style, which gave him expertise in working with veneered curves. It is no small coincidence that the steam-powered veneer-cutting machine, invented at about the same time, had a big impact on the way furniture was made and also on people's perception of it.

Thonet's original design experiments in the 1830s featured forms made up of laminated strips of veneer, and the furniture he showed at the Crystal Palace was still made that way. His elegant work from that period already demonstrated much of the design resolution and unique stylistic brilliance of his later steam-bent solid wood pieces, but it seems that he was not content to stop there. It is plausible that Thonet persevered in developing his system for steam-bending solid wood for reasons of production and marketability rather than for aesthetic innovation. Of course important stylistic developments accompanied the eventual shift from laminated to steam-bent solid

wood furniture, but those seem like subtle refinements compared to the fundamental radical departure of his earlier laminated pieces.

For Thonet, the problem was that furniture that relied entirely for its structural integrity on the hot hide glue available at the time could not be guaranteed against failure if shipped to a warm, moist environment. While Thonet was a gifted designer and a well trained craftsman, he was also an entrepreneur who probably hoped for unlimited distribution. He spent years trying to secure patent protection for his business and in the European political climate of the 1840s, he finally found it under the patronage of Prince Metternich of Austria.[15] In 1856 Thonet eventually built the first of several factories in a Moravian forest of copper beech. There he perfected his system for steam-bending solid wood, secured additional patents for his inventions, and began to mass-produce furniture.[16]

Thonet's chair #14 from 1859 may have been the first successfully mass-produced chair built in a factory using a system of divided labor, but without question it was the first to be successfully mass marketed. The number of parts in each chair was reduced to six so they could be shipped anywhere as a lightweight kit, ready to assemble. Chair #14 was stylistically unique and yet consistent with its Biedermeier, Empire, and Rococo ancestors. It completely altered the relationship between form and ornament, decades before Modernism took up that banner. But none of that would have mattered as much if the chair had not struck a sympathetic chord with a new and growing democratic population that had a willingness to buy furniture that was affordable, beautiful, and that fit their new status as middle-class citizens. Thonet's unprecedented system of distribution and mass marketing was as important as his extraordinary designs in changing the history of furniture. Michael Thonet's furniture was the successful manifestation of industrial capitalism, and as such its form followed its function.

If Thonet's work celebrated industrialization, the work of William Morris from the same period rejected it. When he was seventeen years old,

Thonet chair #14, "the successful manifestation of industrial capitalism."

Courtesy Golden FitzGerald; photo: Rick Mastelli with Sarah McCollum and Stephen Clerico

14. Christopher Wilk, *Thonet: 150 Years of Furniture* (New York: Barron's Press, 1980), p. 20.

15. Prince Clemens Von Metternich was Chancellor of the Austro-Hungarian Empire and Prime Minister to Emperor Franz Josef. He was as well known for his vigorous support of entrepreneurial invention as he was for his suppression of political dissent. (See any of several references listed in Columbia Encyclopedia, 5th ed., Columbia University Press, 1993, p. 1760.) His support of Thonet is interesting on several levels. In the 1840s Europe was rife with political upheaval and revolutionary fervor as the new urban industrial work force had grown large enough to organize itself against exploitation. Those in political power were nervous and Metternich actively resisted the industrialization of the urban areas like Vienna, partly to avoid the growth of a strong centralized worker movement. No doubt it was a good deal more than the access to raw materials that encouraged Thonet to build his first factory in the forests of rural Moravia.

16. John Dunnigan, "Michael Thonet," *Fine Woodworking* (Newtown, CT: Taunton Press, January 1980), pp. 38–45.

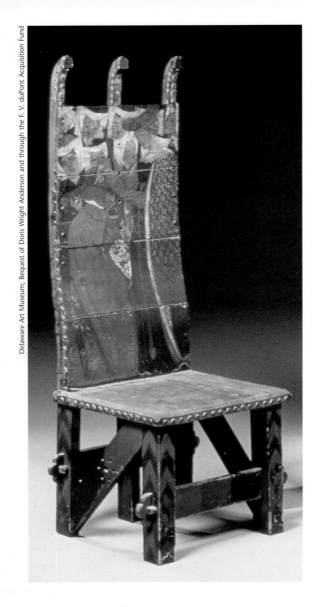

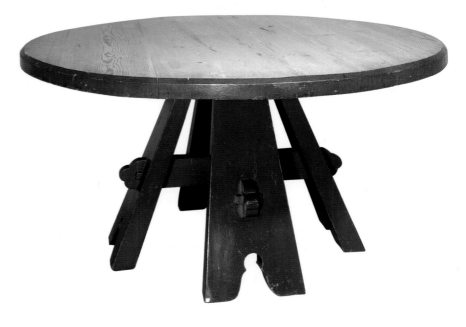

dustry. The early furniture of Morris didn't rely heavily on mechanical fasteners or glue to hold it together, and the preferred material was often domestic oak. Morris seems to have shared his view of veneer with Charles Dickens, who considered it cheap and disingenuous.[18]

Morris always campaigned for design reform, but he never separated it from political, social, economic, or artistic reform. He was not opposed to technology, but he hated the debasement of craftsmanship that accompanied industrialization. He believed that in an ideal world, everyone could spend time making things and that true Art would be the unforced natural expression of joy in labor. He was appalled by the alienation caused by the division of labor,[19] but he also disagreed with Marx's view that work was not living and that a person worked only to provide the means of living.[20] Morris believed in the necessity of labor being pleasurable as a prerequisite for a healthy civilization.[21]

Chair ("The Arming of a Knight," painted by Rosetti) and pine table, both designed by William Morris in 1856: "The heavy timbers and exposed joinery are meant to show an honesty of construction that Morris believed antithetical to the values of industry."

Morris table: Cheltenham Art Gallery & Museums, Gloucestershire, UK

Morris' family visited the Crystal Palace where Thonet's work was exhibited, but when they arrived, Morris refused to enter and waited outside in disgust. When he went to Oxford at nineteen years of age, he had already resolved to enter the priesthood and to withdraw from what he considered the shoddiness of Victorian society. Fortunately for us, he became involved with what most mothers would call the wrong crowd, and decided to devote his life to art.[17] Although Morris gained fame as a poet and as a textile designer, he became skilled in several media, including carving and painting. In 1856, when he was just twenty two, he designed some chairs and a table which are among his very first works. The chairs were painted by him and his friend Dante Gabriel Rosetti, the famous Pre-Raphaelite, with scenes from the legends of King Arthur. They are intentionally Medieval or pre-industrial in their style, provocative when the growing bourgeois world considered industrialization as synonymous with progress. The heavy timbers and exposed joinery are meant to show an honesty of construction that Morris believed antithetical to the values of in-

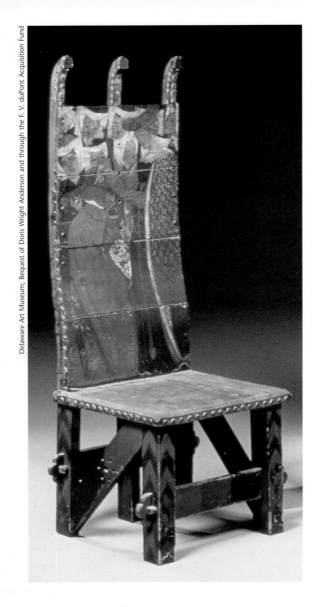

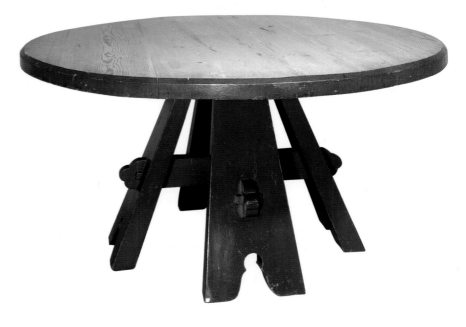

Delaware Art Museum; Bequest of Doris Wright Anderson and through the F. V. duPont Acquisition Fund

17. For more information on Morris, try one of the many books about him such as E.P. Thompson's *William Morris: From Romantic To Revolutionary* (Stanford: Stanford Press, 1955, 1976) or Fiona MacCarthy's *William Morris: A Life For Our Time* (New York: Alfred A. Knopf, 1995).

18. Dickens created the characters Mr. and Mrs. Veneering for his novel *Our Mutual Friend,* written in 1864.

19. Adam Smith, *An Inquiry into the Nature and Causes of the Wealth of Nations* (originally published in 1776), Edwin Cannan, editor (Chicago: University of Chicago Press, 1977).

20. Karl Marx, "Alienated Labor," 1844. From the "Economico-Philosophical Manuscripts of 1844." See *The Portable Karl Marx,* Eugene Kamenka, editor (New York, London: Penguin Books, 1983), pp 131–146.

21. William Morris, "Useful Work Versus Useless Toil," *Signs of Change* (1888). Reprinted in *William Morris: News from Nowhere and Other Writings,* Clive Wilmer editor (London, New York: Penguin, 1993).

It is significant that Morris' first volleys in his personal war against the age took the form of furniture because it tells us as much about the role of furniture in that culture as it does about the artist himself. The possibilities of the medium and the power of style are made evident in the complex message of Morris' work. He used furniture in the same way he used paint on canvas or words on paper, as a vehicle for social commentary. He used style to express ideas about the relationship between technology and culture. He used a way of working to elucidate connections between production and community, between art and society. He attempted to break down the artificial barriers that had been raised between art and craft since the end of the eighteenth century. In 1861 he founded Morris, Marshall, Faulkner and Company, also known as The Firm. They advertised themselves as "Fine Art Workmen in Painting, Carving, Furniture, Metalwork, Textiles, Embroidery and Stained Glass."

When Morris declared his goal of restoring the applied or decorative arts to their rightful place beside the fine arts, he was responding to several interconnected conditions. One was that in the previous hundred years, the Industrial Revolution had changed the way many things were made and therefore had changed their nature. The newly designated fine arts, such as sculpture and painting, were inevitably affected, but not in the same direct way as furniture, apparel, ceramics, etc., and this contributed to a fracturing of the arts that had not existed before. A second condition was that the increasing power of market capitalism accelerated the commoditization of objects, changing the relationship of people to these objects. Another condition was the destruction of the monarchy in the prior ages of Enlightenment and Revolution, taking with it the system of patronage that had supported the old craft guilds. Discrediting the aristocracy required discrediting those arts most closely associated with aristocratic decadence, and furniture was a primary target.

One characteristic of the old regime was conspicuous consumption, used as a way of asserting power. History shows us that patronage is based on politics as well as aesthetics, but any artist working today can tell you that.

A good example of the role furniture can play in this is the work André Charles Boulle made for Louis XIV, who ruled France from 1643 to 1715. A gifted furniture maker, Boulle's services were largely controlled by the king. He was made a member of the court and given the title of Ebeniste du Roi. The cabinet on stand at right made between 1675 and 1680, a remarkable piece of work in any context, was made to display the splendor and absolute power of the Sun King. The

Cabinet on stand (1675–1680) by André Charles Boulle with medallions after Jean Varin, "made to display the absolute power of the Sun King."
The J. Paul Getty Museum, Los Angeles

main part of the structure is made of oak, but it is veneered with exotic ebony, tortoiseshell, pewter, brass, ivory, horn, boxwood, pear, thuya, satinwood, amaranth, cedar, walnut, mahogany, etc. The drawers are made of lignum vitae, and the mounts are cast bronze gilded and painted. I'm unaware of records of hours or cost, but they must have been way over the top. Obviously, considerable value was attached to conspicuous consumption of the highest levels of skill as well as of rare materials. If just looking at Boulle's work does not persuade you of its powerful symbolic function, consider that in 1660 Louis XIV insti-

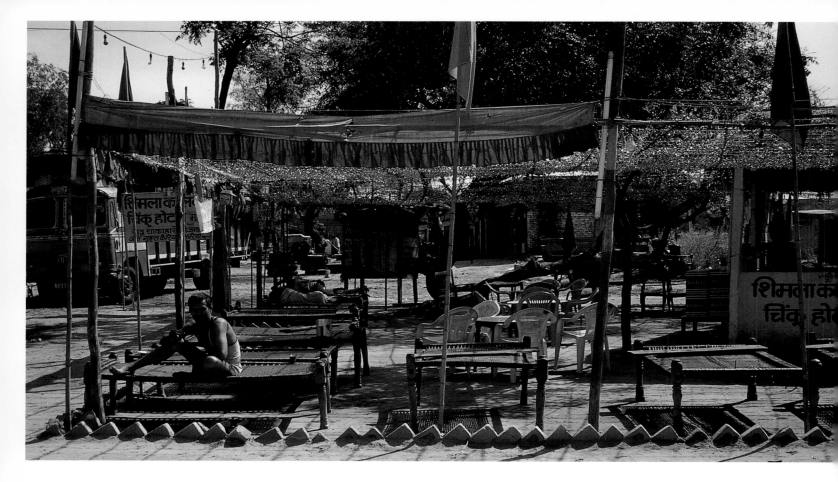

Ancient beds and plastic chairs in India: "I knew I was looking simultaneously at the oldest and the latest in furniture and, in a way, at the whole rich history of furniture."

Photos: John Dunnigan

tuted laws regulating the use of exotic and precious materials. The use of gold and silver on furniture was prohibited except for the king.[22] In this way, he could control style and harness its power to enhance his position. Almost thirty years later, in 1689, a serious fiscal crisis threatened France and the king preferred to melt down his luxurious solid silver furniture instead of selling it. Though he could have raised considerably more money for the furniture than for the raw metal, he refused to allow anyone else to own such significant personal symbols of his power. When servants and courtiers at Versailles were in the presence of certain objects belonging to the king, they bowed before them whether the king was present or not. These objects stood in for the king and were treated with the same respect. The more luxurious and elaborate were the king's things, the more they reinforced his absolute authority.[23]

When this way of life was finally discredited, so were the symbols of it. If aristocratic or royal patronage helped make the eighteenth century the Golden Age of furniture making, it also helped create the inevitable backlash against the highest levels of craftsmanship. Opposition to craftsmanship for its own sake became the thin end of the wedge driven between art and craft.

These examples show that whether furniture is excessively elaborate like Boulle's or plain and common like Thonet's, it is layered with meaning. Often, we don't know the intent of the maker,

but even if the designer or maker is not particularly interested in the conceptual content of the work, the furniture cannot escape having meaning as a cultural symbol. Sometimes the meaning is easily recognizable and sometimes it is not so obvious, but it is always there.

I was in India a couple of years ago and came across hundreds of rope and strap beds at truck stops. They're sporadically used by travelers stopping for food and some sleep who, by the way, couldn't see what I was so excited about. What amazed me was that these beds are almost identical to beds found in Egyptian tombs from the Old Kingdom, which was five thousand years ago. I have always admired ancient Egyptian furniture because it is such strong proof of the sophistication of furniture so long ago. On the basis of aesthetics, execution, and content, the furniture from the New Kingdom tomb of Tutankhamun[24] appears more sophisticated to me than some of the furniture being made today. It is also impressive how the makers were able to fashion it with cop-

22. Leora Auslander, *Taste and Power* (Los Angeles, London: University of California Press, 1996), p. 47.

23. *Ibid.*, pp. 35–36.

24. The tomb of Tutankhamun dates from about 1350 B.C.E. and was discovered by Howard Carter in 1921. See any of the good material on the subject, including *Treasures of Tutankhamun* (New York: Metropolitan Museum of Art, 1976).

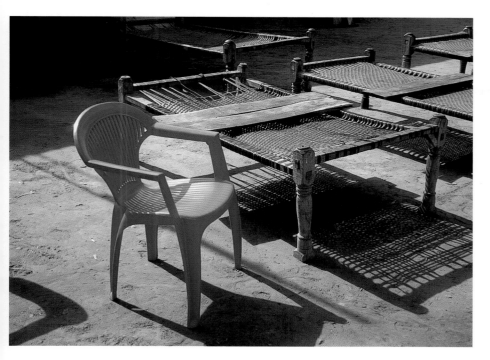

I visited several village workshops of local artisans, and I couldn't help wondering if their traditions would survive the siege of the new. Their way of working is threatened by the global domination of Western popular culture, which has a tendency to homogenize or even erase history. Western popular culture, as an aspect of political economy, is predominantly anti-diversity, anti-craft, anti-art, and anti-intellectual, except when these things are temporarily marketable. Its primary function is to promote mass consumption in the name of freedom.

How does anyone, particularly an artist, define himself or herself when the international hegemony of capitalism promotes identities of the self based increasingly on consumption, not production? In a capitalist culture objects are rated as successes or as failures based on their performance as commodities, so some of the most creative work is often not sufficiently recognized. Those who believe that aesthetics, ideas, and skills should be valued for their own sake are sometimes disconcerted by the message of the market.

The heart of the creative process may be mysteriously intuitive, but no art form is completely autonomous. In one way or another, each is an expression of the interdependent relationships among culture, technology, style, and the self. As a final example of this, consider the Electronic Revolution that is currently overwhelming us. To say that this explosion of technology has had remarkable positive effects is an understatement if ever there was one. Nevertheless, it could be argued that electronic technology has contributed to the further separation of thinking from the making of physical things. This is a significant problem, which has manifested itself both in the collective consciousness and in the things that are produced today.

When I started making furniture, I did it as an alternative lifestyle. A lot has changed over the years, but in my opinion thoughtful making has become even more counter-cultural as our society moves further from it. Making, itself, promotes diversity, individuality, thought, and skill, as well as community. While we don't necessarily need more objects, we just might benefit from more making. I'm not suggesting that we could build Utopia by everyone making furniture, but we should never forget that humans have the ability to make things, from pies to pianos, and to think about the making of those things, which contributes to the development of personal and cultural identities. We need some new models for considering these kinds of issues, and that will begin to happen when we find meaningful ways to reconnect making with thinking. Understanding furniture can help with that. ∎

per saws and bronze chisels. Since India, I've been really curious how something rare and ancient got to be so common in another country five thousand years later. But that's another story.

Anyway, next I found some truck stops that also had those plastic injection-molded chairs you can buy here at the supermarket for $3.99. I knew I was looking simultaneously at the oldest and the latest in furniture and, in a way, at the whole rich history of furniture. Though the chairs and beds appeared to represent the antithesis of one another, nobody seemed to think twice about putting them together. The technique of injection molding may not be the very newest thing in furniture, but what about this business of buying furniture at the supermarket with bar codes prominently displayed? I bought a couple of the chairs to see what could be learned from them. They're actually very interesting and I'm quite sure that I'll never remove the adhesive strip with the bar code across the front because it's one of the really interesting things about them.

I don't actually know what the people I met in India thought of their plastic chairs or their wood and strap beds because I don't speak the language. But to some extent, the objects spoke for them. While the ubiquitous beds were made by local craftsmen with hand tools the way they've been made for thousands of years, the chairs were made by machines and are globally mass-marketed. That may seem strange, but I could only guess that both types of furniture were attractive, inexpensive, and durable for that setting. For me, seeing these pieces thrown together was a symbol of India itself, whose diverse culture is a collision of ancient and modern.

> ∎
> **While we don't necessarily need more objects, we just might benefit from more making.**
> ∎

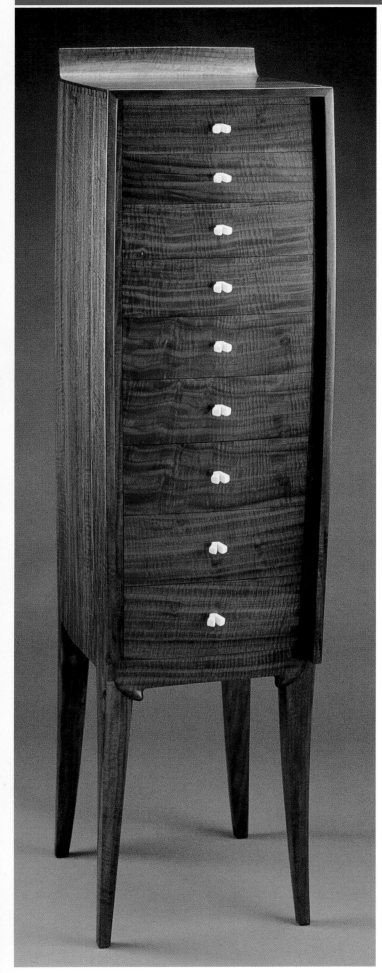

GALLERY OF STUDIO FURNITURE

■

Juried work from members of
The Furniture Society

■

What is studio furniture? The pictures on these pages show recent work by members of The Furniture Society, solicited for this book and selected from hundreds of slide entries by the *Furniture Studio* Editorial Board. Is this work different from traditional furniture? How is it different from manufactured products sold by regular furniture stores?

Style. Unlike earlier furniture movements, you will not find stylistic consistency in today's studio furniture. Although you will see trends, no clear stylistic direction has emerged, nor is likely to do so. Instead, many different styles coexist side by side.

Function. Functional service differentiates studio furniture from sculpture. However, the function of a piece often is extremely particular, tailored to the exact idea of the maker, or to the peculiar needs of the person who commissioned it.

Materials. While beautiful woodworking predominates, today's studio furniture is by no means always made of wood. You will find metal, glass, plastic, leather, fabric, even ceramics, concrete, and found objects, as studio makers are quick to experiment with new materials, in search of new forms.

Manufacture. Studio furniture is made by one person or by a small group of artisans working together. It is not the product of factory-based production runs. The making is under complete control: materials can be selected with care, tooling (including handwork) can be adapted to the design, and details need not be compromised by limitations of mass production.

Idea. Like other art forms, studio furniture embodies an idea. The designer/maker has a message to communicate and has chosen to express it through furniture. Some messages are graphic and clear. Some are complex narratives. Some are simple assertions about function or materials. And some ideas are subtle, emerging only through use and interaction. ■

Jere Osgood, Wilton, NH

Semainiere et Deux 1998
Santa Clara walnut, faux ivory knobs, 15.5"w × 18"d × 60"h

Within rather narrow confines I was trying to give the piece a delicacy of form with shaping that would elicit a sensual feeling (or response). The sides are formed using compound stave lamination. The drawer fronts, also laminated, curve gently in two planes. Photo: Dean Powell

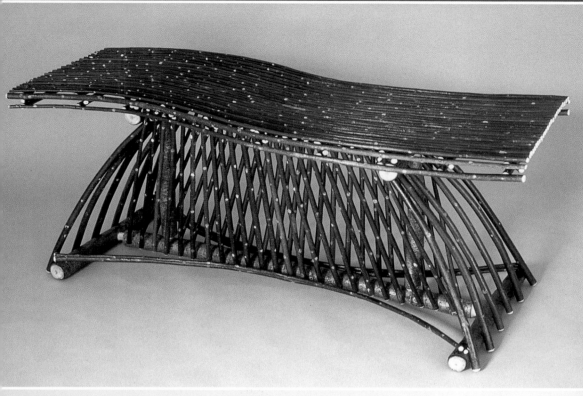

Kimberly Sotelo
Madison, WI

Wavy Top Table 1998
Willow and aspen
48"w × 15"d × 22"h

In this piece my idea was to create a contemporary design and to truly transform the material. The top is a willow grid, level enough to set a footed goblet on.

Peter Pierobon
Berkeley, CA

Rhythm Rhyme 1997
Ebonized poplar
66"w × 60"d × 24"h

A large coffee table incorporating shorthand glyphs as structural elements.

Photo: Tom Brummett

Peter Harrison, Cragsmoor, NY

Ode to M 1997
Maple, white lacquer
14"w × 14"d × 57"h

This piece came to life after I saw the Mackintosh show at the Metropolitan Museum of Art. I loved how he emphasized the importance of line with a pure white finish.

Photo: Bob Barrett

Kerin Lifland
Los Angeles, CA

Dining Table 1997
Madrone burl and padauk
60"dia. (78" extended) × 30"h

My ambition was to reduce this frankly traditional dining table to as simple but detailed a sculptural statement as I could. The gestural curves of the leg structure are emphasized by the bent lamination construction together with the striped figure of the grain. The burlwood top, with a honeycomb core (to minimize the weight of the extension leaf), is laid up in a subtle gem-cut pattern. Equalizer glide hardware is mounted to the underside of the extension rails.

Photo: Douglas Hill

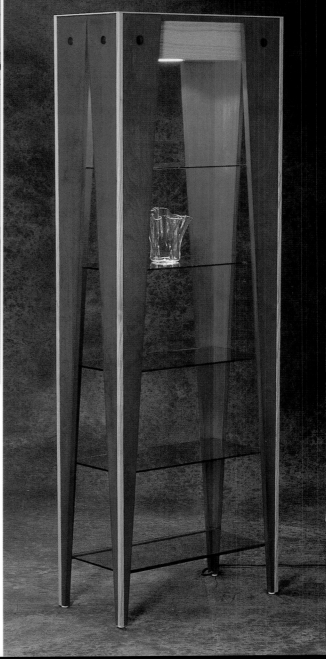

John M. Henderson, III
Garland, TX

Pretty Legs & All™ Narrow Etagère in production since 1994

Aniline dyed birch and natural ash with glass shelves and accent light
24"w × 12"d × 72"h

This design, the premier piece in an extensive collection utilizing a common leg design, shows off the elegant and playful lines derived from left-over, cut-off pieces of another project. Through the fine accent lines of contrasting colors and the use of brilliant transparent dyes, a simple design takes on a lively though refined character.

Photo: Robert Smith

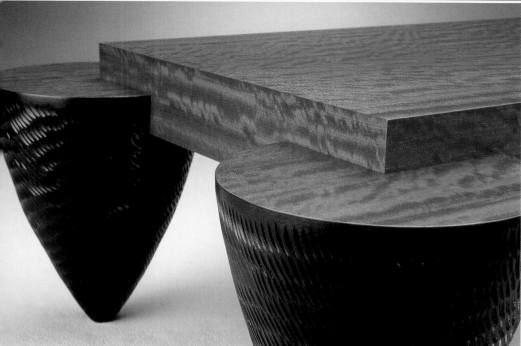

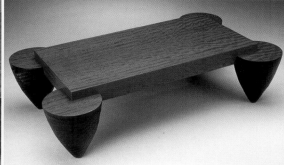

Richard Judd, Paoli, WI

Coffee Table 1997
Mottled makore, mahogany, MDF
50"w × 30"d × 16"h

*The rectangular top is a veneered torsion box.
The legs are stack-laminated mahogany, carved
and varnished black, and veneered on top.
They provide a bumper for the table's sharp
corners, to make it more friendly.*
Photo: Bill Lemke

Tom Eckert, Tempe, AZ

Three Boscs with Cloth 1998
Bolivian rosewood, linden wood, lacquer
20"w × 6"d × 13"h

Carved and painted.
Photo: Dan Vermillion

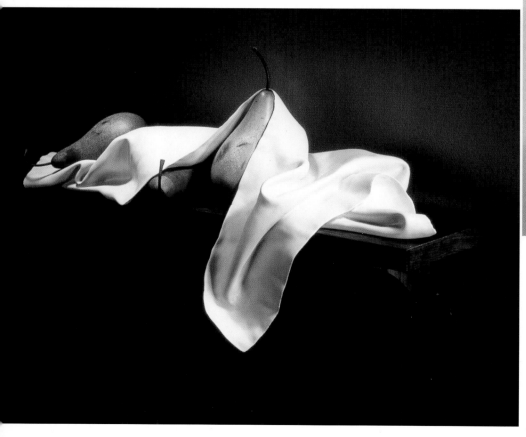

Susan Flores, Plainfield, MA

Muffler Table 1997/production

Steel (lacquered and waxed), glass
16"w × 16"d × 22"h

*The cylinder drawer in this table is made
from a truck muffler pipe—thus the name;
the legs are angle iron. I like the idea of
manipulating classic industrial material into
elegant designs. The drawer, which does not
conceal but reveals the possessor's life, is a
theme of mine.*
Photo: M. Gottlieb

Brad Smith, Worcester, PA

Pitchfork Bench in production since 1992
Cherry, ash, steel, 60"w × 21"d × 32"h

This is an adaptive use concept: off-the-shelf parts used in an entirely different way than intended. Pitchforks make ideal bench and chair backs.

Photo: Bruce Blank

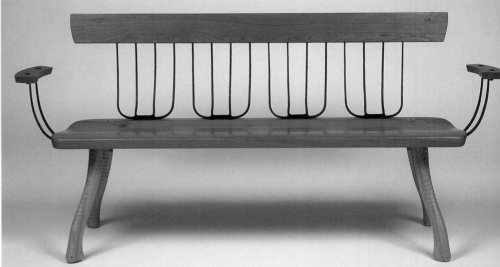

Jeffrey Greene Design Studio, Doylestown, PA

Windsail Bench 1998
Ash, 86"w × 36"d × 88"h

This piece is designed to fit a specific curved wall under (at the side of) a staircase. Spindles are green bent and hand planed.

Photo: Jeffrey Greene

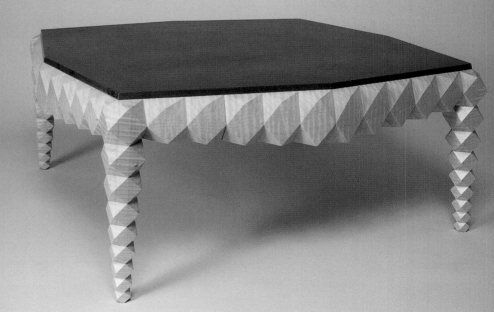

R. Thomas Tedrowe, Jr.
Chicago, IL

Freeark Coffee Table 1998
Curly maple, Corian
36"w × 36"d × 16"h

This table is based on a module (cuboctahedron) stacked, tapered, and scaled, repeated.

Photo: Garry Henderson

Michael Cullen
Petaluma, CA

The Little Prince 1998
Carved and painted wood, basswood interior, pearwood base, stained glass
11.5"w × 10.5"d × 40"h

This shrine was inspired by "The Little Prince." The central door (door within a door) houses a passage from the book (inscribed on rice paper). The purpose of this piece is to house an object that is close to the heart.

Photo: John McDonald

Robert Griffith, Hallstead, PA

Tripod Table 02 1997
Forged copper, optional glass top (not shown)
16"w × 16"d × 23"h

*A series of tables illustrating the maker's
involvement with vessels—now adapted to
tables. A glass top makes the table more
functional. These tables premiered as part of
a touring exhibition that opened in Glasgow,
Scotland, Oct. 1997.*

Photo: Lisa Hinkle

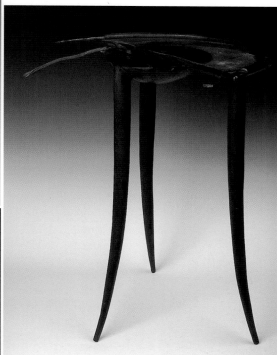

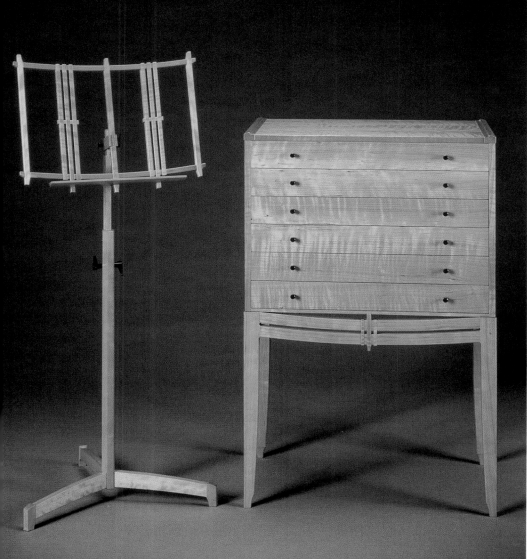

Ross Day, Seattle, WA

Musician's Suite 1997
Figured cherry, East Indian rosewood,
bronze, maple
Cabinet: 26"w × 17"d × 40"h
Music stand: 20"w × 10"d × 40–60"h

*An ensemble whose materials, lines, and
design elements play off each other to
"make music," with the goal of being
aesthetically beautiful and ultimately
functional. It was like building a very large
jewelry box. Each cabinet drawer holds two
banks of sheet music and has a removable
divider if a larger drawer space is needed.
The top of the case is designed to hold a
removed drawer securely.*

Photo: Mike Seidl

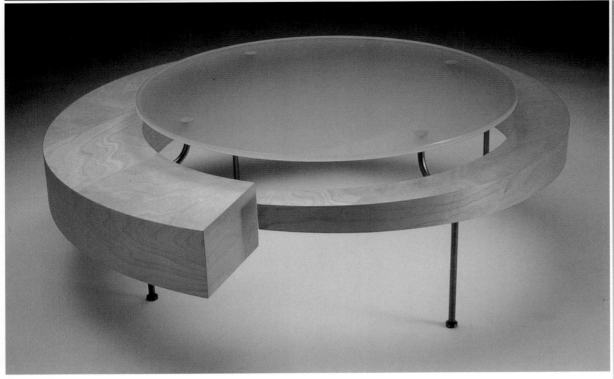

John Fanfara, Toronto, ON

Orbit Table edition of 12, begun 1996
Birch, glass (sandblasted), steel
43.5"w × 14"h

*Torsion box construction to create
gradually increasing volume and mass.*

Photo: Peter Hogan

Donald Fortescue, Oakland, CA

Quill 1998
Jarrah, stainless steel, 12"dia × 72"h

*Quill's staves are held in tension by stainless steel cables
running between the stainless steel hubs. The form of
the shade, which allows light to pass through but
obscures the bulb, is determined by the flex of the staves
under tension. The solid base is turned to conform.*

Photo: Kallan Nishimoto

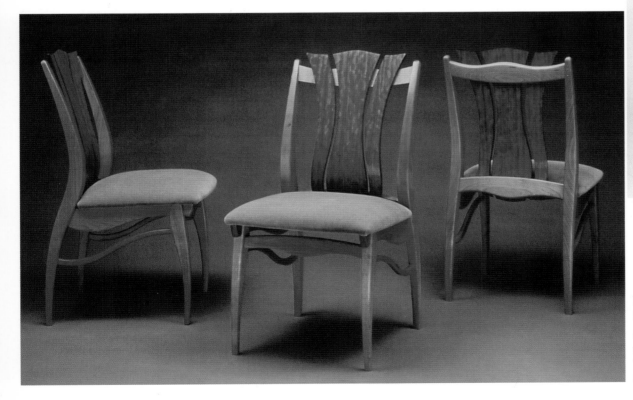

Blaise Gaston
Earlysville, VA

Chairs 1997
Cherry
18"w × 18"d × 30"h

Photo: Philip Beaurline

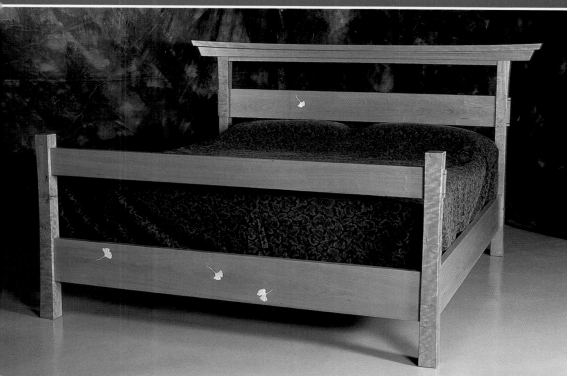

Brian M. Condran
Martinez, CA

Torii Bed 1998
American cherry, Alaskan yellow cedar
93"w (headboard) × 93"d × 58"h

*Designed for a client after their visit to
Japan where they were inspired by the
torii, or gate, that leads to shrines and
temples.*

Photo: Kathleen Bellesiles

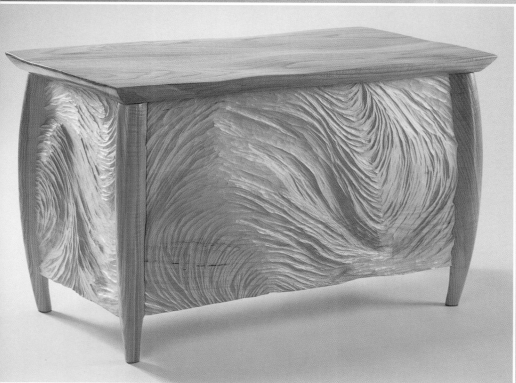

J.M. Syron and Bonnie Bishoff
Gloucester, MA

Ilseboro Series Small Chest 1997
Basswood, ash (hand carved)
36"w × 20"d × 22"h

*This series derives its forms and surfaces from
the fluid motion of water over land forms.*

Photo: Joseph Chielli

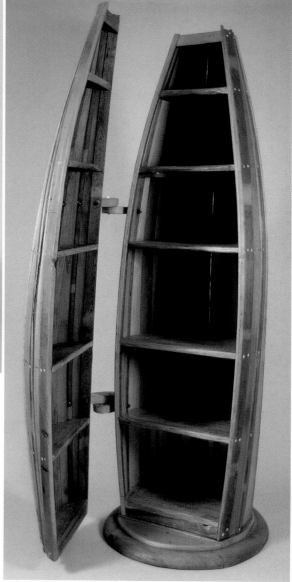

Stephen Whittlesey
West Barnstable, MA

Keeper 1997
Salvaged wood
32"w × 32"d × 92"h

*This piece was inspired by
old barrels and canoes.*

Photo: Stephen Whittlesey

Gallery continues on p. 50

CALIFORNIA DREAMING

■

GLENN ADAMSON

■

The second generation of studio furniture makers in Northern California bring commercial and artistic sophistication to a movement that began as a pastoral retreat

Why do people become furniture makers? At a time when working with one's hands is undervalued, why devote a lifetime to craftsmanship? Most furniture makers of the past forty years have persisted only by defying the realities of a permanently small market. Yet today, they are more numerous than ever before. What prompted the rise of this subculture, and why has it persisted, even prospered?

To answer these questions, one has to look into the underlying causes of the boom in furniture making that occurred in America during the 1960s and 1970s. Until that time, only a handful of pioneers, such as Wharton Esherick, Sam Maloof, George Nakashima, and Walker Weed, pursued careers as studio furniture makers. But by the late 1960s, a larger "second-generation" of furniture makers began to work in small, self-owned shops.[1] In so doing, they paved the way for today's craftspeople. In order to understand this period of transition, and the motives that lay behind it, this study focuses on one area in which it was particularly dramatic, Northern California.

I was first drawn to the history of this region's furniture while organizing a panel on this subject for The Furniture Society's 1998 conference, held in San Francisco.[2] As I explored the complex fabric of the area's furniture scene, I found that it offered an unparalleled demonstration of craft's importance as a tool of social change. It was particularly interesting that second-generation makers in the Bay Area mostly operated outside institutions that promoted woodworking. They lived away from cities, worked in small one- or two-person shops, and sold their wares through local, informal venues. In contrast to the nationally oriented Modernism of the 1950s, the style and outlook of the new group was local, perhaps even parochial. Customers were often friends or relations. The furniture was meant to inhabit the rustic, hand-built houses that dotted the Bay Area landscape.

The motivations of this new crop of Californian makers had something to do with making beautiful objects but a great deal more to do with a politicized lifestyle. Indeed, one can say that their stance was explicitly anti-institutional: theirs was a revolution in the pastoral mode. They sought to hold a distance between themselves and centers of power, a distance that permitted them freedom and autonomy. This idea had its roots in the pastoral ideal of the commune, a key component in the vibrant counter-culture centered on San Francisco in the late 1960s. Much of the region's furniture emerged directly from this counter-culture, in an unprecedented integration of personal politics and craft practices.

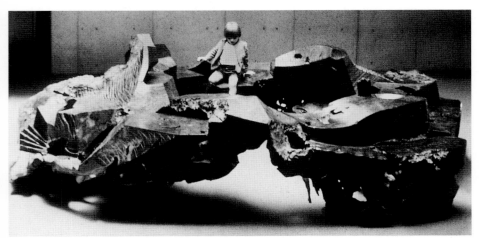

J.B. Blunk chain-saws monolithic furniture/sculpture from huge chunks of wood. "The Planet," redwood, 13' diameter, 1969.

1. This generational construct was introduced in Edward S. Cooke, Jr., *New American Furniture: The Second Generation of Studio Furniture-makers* (Boston: Museum of Fine Arts, 1989).

2. I am indebted to the Furniture Society for the opportunity to moderate the panel, speakers for which included Don Braden, J.B. Blunk, Art Carpenter, Marcia Chamberlain, and Michael Jean Cooper. Additional unreferenced material in this article is drawn from interviews conducted in June and September of 1998 with the panel speakers and with James Bacigalupi, John Bauer, Garry Knox Bennett, Sylvia Bennett, Skip Benson, Jeffrey Dale, Robert Erickson, Al Garvey, Kathleen Hanna, Dale Holub, John Kapel, Miles Karpilow, John Kassay, David Marks, Grif Okie, Bruce Mitchell, Norman Peterson, Sas Quinn, Merryll and Ed Saylan, Ed Stiles, and Dorothy Weiss. My thanks go to all of these people for their generosity.

The First Generation

The pastoral ethos that would become widespread among the second generation of Bay Area furniture makers was anticipated by three early ("first generation") craftsmen, all of whom still live and work in the area: J.B. Blunk in Inverness, John Kapel in Woodside, and Art Carpenter in Bolinas. Though Carpenter is better known than Blunk or Kapel, all three were equally ahead of their time. Each began working in wood in the 1950s, and each has persisted in his career to the present day. All three continue to work in rural, isolated settings. They prefer an independent working environment over stable economic ties, a choice that later makers would admire and emulate.

J.B. Blunk is particularly determined in his self-sufficiency. For forty-five years, he has literally lived off the land in the middle of a state-owned forest. Originally from Kansas, Blunk moved to California in the late 1940s and studied ceramics with Laura Andreson at UCLA. Following service in the Korean War, Blunk lived in Japan, where he apprenticed to two well known potters and befriended the sculptor Isamu Noguchi. In 1954 he returned to California to work in clay full time but soon took a job as a house carpenter and through it saw the possibilities of working in wood. Untrained in joinery, he carved furniture from huge chunks of redwood and cypress with a chainsaw and gouges. Despite the roughness of this technique, Blunk soon became adept at bravura texturing and free-form composition. He applied the principles of Japanese design he had learned as a potter, creating asymmetrical furniture with rough, densely worked surfaces. Formally, Blunk's work resembled contemporary stack-laminated furniture by Jack Hopkins, of San Diego, and Wendell Castle, of Rochester, NY. But his Japanese sense of form was unique, as was his use of chainsaw to shape and texture whole tree trunks and root sections.[3]

In contrast to Blunk's monolithic work, the furniture of John Kapel is erudite and joinerly. He spent his formative years at the design program at Cranbrook Academy in Michigan, and then in George Nelson's offices for Herman Miller in New York City. Yet, like Blunk, he rejected a steady job and chose an isolated, rural life, preferring the precarious economics of small shop production to the commitments of a steady job. Kapel slipped out of the craft mainstream following his move to California in 1955, but unlike Blunk, he maintained strong contacts with the design community. He thought of his hand skills as a kind of design research, and in this respect he was an archetypal "designer-craftsman" of the 1950s. As Kapel says today, "Doing drawings was nothing. You really had to work it out." Well-acquainted with the gently curving Scandinavian style that was then in vogue, he produced armchairs reminiscent of those by the Danish designer Hans Wegner, and made cabinets with layered, biomorphic decorative panels. Glenn of California, a Los Angeles manufacturing firm, produced his chair designs for many years, as did the Japanese firm Kosuga. Despite his success, however, Kapel retained a distance from industry and remained somewhat secluded.

Arthur Espenet Carpenter also moved to California in order to pursue woodworking, in 1948. Inspired by the work of James Prestini, he started by turning bowls and plates in teak, and gradually moved on to furniture. Like Blunk, he designed and built his own house and shop in a wooded setting north of the city. And like Kapel, Scandinavian design was an important early influence. But, unlike his two contemporaries, Carpenter was committed to the idea of training younger makers. As a result, his influence on the local furniture scene was tremendous. The first of his apprentices was John Barrow, whom Carpenter hired as a shop partner in 1964. Barrow was a skilled furniture maker and house builder with a shop in the bohemian Potrero Hill area of San Francisco. Barrow's shop partner, Miles Karpilow, had studied with the painter Elmer Bischoff at the Institute of the Fine Arts, and Karpilow and Barrow worked together for some time, producing Scandinavian influenced furniture. For both of them, Carpenter was inspirational: he represented the

Erudite and joinerly furniture by John Kapel: walnut cabinet, 1968.

Scandinavian-inspired "Osborne chair," by John Barrow and Miles Karpilow, walnut and leather, 1961.

3. For more on the work and career of J.B. Blunk, see my article "California Spirit: Recovering the Furniture of J.B. Blunk," *Woodwork* (October 1999).

ideal of the liberated craftsman. As his influence grew, an increasing number of young makers apprenticed with him, and Carpenter's shop became the spiritual and social center of a counter-cultural craft movement.[4]

A Quiet Revolution in Learning

The catalyst for this new movement was the Baulines Craftsman's Guild, which emerged directly from the counter-culture that had the region in its grip—a combination of Beat art and poetry, New Left protest politics, and drop-out communalism.[5] Furniture maker Tom D'Onofrio, the founder of the Guild, was immersed in this counter-culture from his first days in California. While watching a Berkeley campus SDS (Students for a Democratic Society) rally from a distance, D'Onofrio was caught in a melee between students and police and clubbed on the head. The experience led him to join the protest movement against the Vietnam War. He organized a nonviolent demonstration group called Ministers for Peace, but he eventually became disenchanted with the student organizations, abandoned direct political engagement, and began to focus on individual lifestyle as a form of activism.

D'Onofrio's insight was that a politicized lifestyle could be built around craft activity. Originally from upstate New York, D'Onofrio had always been intrigued by woodworking: he had grown up building cabins in the woods with older relatives and friends. Through Sara Bass, who taught carving at San Francisco State University, he met Art Carpenter in 1969. Carpenter took him on as an apprentice, after John Barrow left. Carpenter wasted no time in introducing D'Onofrio to the workmanship of risk, making him responsible on his first day for finishing a desk for the Oakland Museum. D'Onofrio recalls Carpenter telling him, "There's nothing you can do to that piece that I can't fix."

In late 1970, D'Onofrio left to open his own shop, but the experience of working with Car-

Tom D'Onofrio

penter had transformed his ideas about political action. He burned every book and paper collected during his academic ministerial career, and instead wrote a thesis entitled "Craftsmanship and the Quest for Self-Discovery," an extended consideration of improving society through creative artisanry. The centerpiece of the essay is the individual artisan, a figure modeled on Carpenter himself. D'Onofrio wrote that "the artisan is his own authority and he moves out from that center," and thereby could escape the constraints of society.[6] This ideal of self-sufficiency and spiritual completion was romantic, but it was also a potent model for change—as D'Onofrio put it, "a quiet revolution in learning."[7]

D'Onofrio put his ideas into action by organizing a guild that would operate through the traditional structure of apprenticeship. He persuaded Carpenter to come on board as a master furniture maker, then in April of 1972 gathered local craftspeople from the Bolinas area together at the home of bronze sculptor Lewis Seiler. Though the leaders of the group were woodworkers, the new Guild was remarkably wide-ranging and inclusive. It embraced practitioners of any craft, including house carpentry, fiber work, pottery, glass, bronze sculpture, enameling, print-making, and even film-making and photography. D'Onofrio's idea was that bringing these varied makers together would promote the free flow of ideas and provide training for beginners in a "school without walls." More fundamentally, the organization became the structure for a social network. Apprenticeship in the Guild was more than a way to acquire skills. It was also a means of entry to a tightly knit group of like-minded craftspeople.

The Guild expanded rapidly, limited not by numbers of interested students but by the availability of qualified masters. Several of the young furniture apprentices came from the woodworking department at San Francisco State University. This program was directed by John Kassay, who approached woodworking as a technology to be mastered, stressing historical precedents such as Shaker and Windsor furniture. His program was not meant to train studio craftspeople, but industrial arts teachers. Despite his conservative approach, however, Kassay was forward-thinking enough to invite Art Carpenter to teach a series of workshops to a group that included students James Bacigalupi, Dale Holub, and Don Braden, as well as Vietnam veterans Bruce McQuilken and Grif Okie, and graphic artist Michael Bock. As he had for Barrow and Karpilow in the 1960s, Carpenter opened a window into another way of life for these young makers. He imparted not only a set of basic technical skills, but also an ideal to be emulated.

4. The best general account of Art Carpenter's career is Rick Mastelli, "Art Carpenter: The Independent Spirit of the Baulines Craft Guild," *Fine Woodworking* #37 (Nov/Dec 1982), pp. 62–68.

5. The alternate spelling of "Baulines," rather than the town name of Bolinas, was chosen to highlight the fact that not all of the members lived there. The Guild's spelling was the original name of the town. The Guild has since been named the California Contemporary Craft Association. For a history of the artistic side of the Bay Area counter-culture, see Rebecca Solnit, *Secret Exhibition: Six Artists of the Cold War Era* (San Francisco: City Lights Books, 1990).

6. Tom D'Onofrio, "Craftsmanship and the Quest for Self-Discovery" (unpublished manuscript, 1976), p. 15.

7. Tom D'Onofrio, "A Craft Guild for Bolinas Craftsmen, A Proposal" (unpublished manuscript, 1972), p. 3.

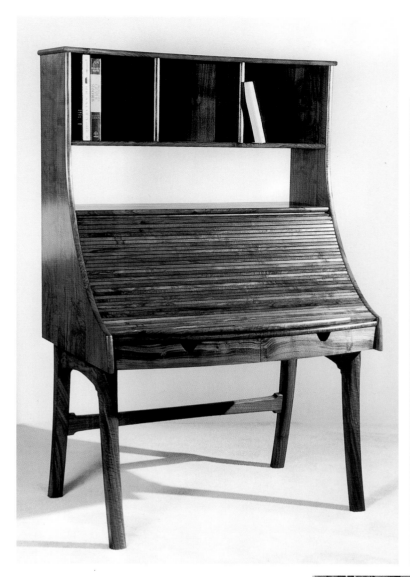

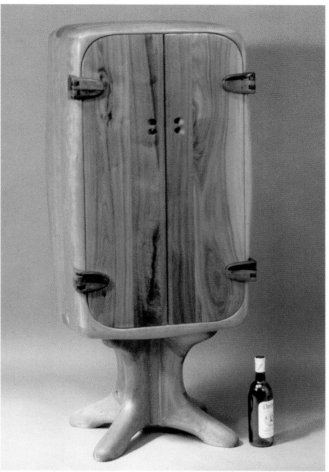

Northern California furniture of the early 1970s often featured softly rounded edges, which could be quickly shaped with an electric router. Left, walnut desk by Dale Holub, ca. 1972; below, cherry and walnut liquor cabinet by Don Braden, 1974; bottom, walnut and cherry desk and chair by Michael Bock, 1974.

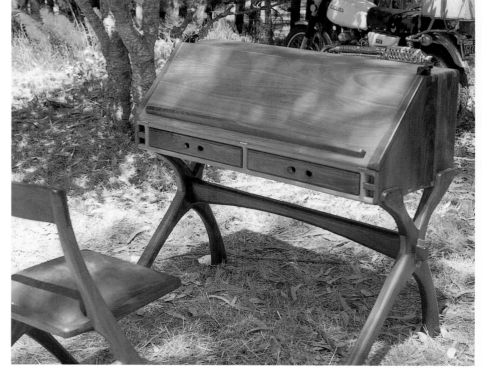

Carpenter was also brutally honest, making it clear that the life of a woodworker was not a financially profitable one. Bacigalupi remembers his realistic advice: "Kid, if you want to spend $50,000 on equipment and twenty years on this, I'll tell you any secret I know." Soon, Braden, Holub, and Bacigalupi dropped out of the university program in order to apprentice in Carpenter's shop through the Guild. Along with McQuilken, Okie, and Bock, they absorbed and developed his formal vocabulary. Their furniture was fashioned from solid hardwoods, and exhibited a flowing organicism derived from Carpenter's Scandinavian-influenced designs. These makers had received only initial training from Carpenter, who had always been relatively uninterested in advanced technique, so they devised technical shortcuts appropriate to their limited experience. The furniture's uniformly curved edges were fashioned quickly with a 3/8-inch router bit, inspiring the

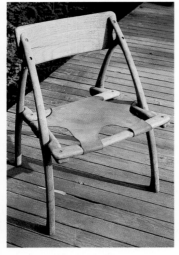

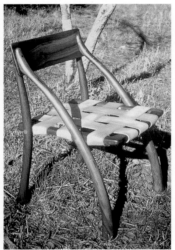

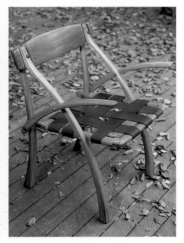

Though exemplary of the roundover style, Art Carpenter's furniture continues to evolve. "Wishbone" chair (top), 1960, pecan, rawhide. "Wishbone" chair (center), 1968, walnut, leather. "Wishbone" armchair (bottom), 1988, walnut, leather. "Wishbone" desk and chair (right), 1984, walnut, leather.

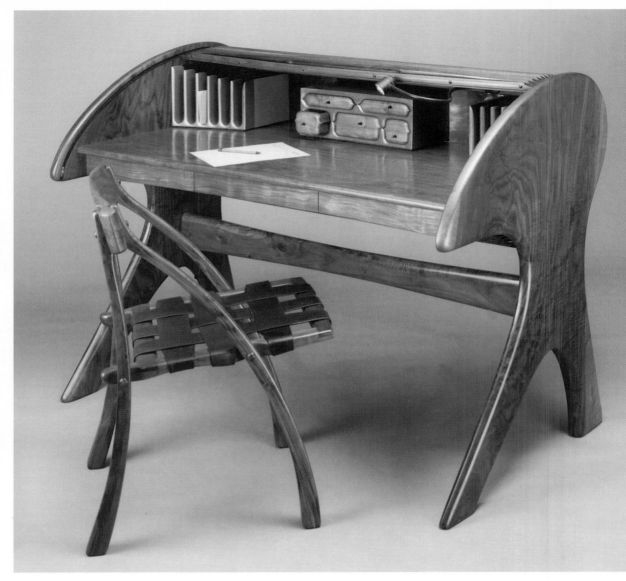

name of the style: California Roundover.[8] But the early Guild furniture should not be discounted because it was technically naive. The rounded edges may have been expedient, but they also intimately connected the user to the wood. This was not an extension of an earlier "truth to materials" aesthetic, but rather an attempt to make the furniture as immediate for its user as it had been for its maker.

Art Carpenter himself moved toward such principles in developing his classic design, the "Wishbone" chair. A comparison of versions of the chair from 1960, 1968, and 1988 shows an increasing tendency towards appealing, sensual forms, providing insight into the central formal characteristics of the Roundover style. The 1960 original is ingenious in conception, but stiff in ex-

ecution. The seat frame and back rest flatten the design, while the legs are arcs with a consistently narrow dimension. Eight years later, Carpenter had reoriented the design towards smooth, linear flow. The front legs are no longer parabolic curves, but swelling s-shaped members that join with the back rest in a pleasingly gentle triangle. The curves of the back legs are reversed, so they echo the more dominant shape of the front of the chair. Since the late 1960s, Carpenter has continued to refine these soft transitions and rounded handholds. By the 1980s, the Wishbone had become a sophisticated array of interlocking curves. The tops of all four legs are let into a fully shaped back rest, and rounded pins draw attention to the organic fit of the joint. The seat has rounded corners, inviting the sitter to move his or her legs freely across the front.

Not all of the Guild's furniture was close to Carpenter's in style. Several makers were interested instead in using wood as a graphic medium, an approach inspired by folk sculpture. John Bauer was the chief exponent of this more pictorial style. He

8. For a Guild member who later developed more sophisticated router technology, see Jeff Dale's "Shaping with a Router," *Fine Woodworking* #93 (Mar/Apr 1992), pp. 44–48.

developed an idiosyncratic vocabulary that shared the cartoonish qualities of contemporary fantasy furniture by such innovators as Tommy Simpson. Guild founder D'Onofrio also was a figural carver. Though he produced little furniture during his tenure as president, in 1976 he finished an elaborate table in the shape of a dragon for Grace Slick and Paul Kantner of the Jefferson Airplane. The pictorialist component of the Guild also included David Foss, who made leather-upholstered chairs and other boldly-shaped furniture, and Al Garvey, a graphic designer and founding member of the Guild. In the early 1970s Garvey became an architectural woodworker, making Japanese baths and hot tubs out of wine casks, and executing house details for a web of local friends and neighbors.[9] He also taught print making and furniture making to Guild apprentices. He saw his activities not as commercial, but as contributions to a local communal lifestyle: "I never made a business out of anything I've done, [but] we got along in great

style on almost nothing... We were all just a bunch of anarchists, but we were all willing to break our necks to help each other. A lot of people helped me, and I helped a lot of people. That was the idea of the Guild."

Garvey also contributed posters to the group for their informal sales events. In 1973 and 1974, three-day roadside shows were set up at Carpenter's house and shop in Bolinas. Despite what D'Onofrio calls their "down-home simplicity," the sales attracted a surprising number of customers— 7500 at the first event—and the attention of the local and national press.[10] The sales were full-scale counter-culture events complete with music and in one case a huge macramé playpen by weaver Alexandra Jacopetti. The Guild's other main sales organ was Dovetail Gallery in San Francisco, which opened in 1972. Its owner was Grif Okie, a Yale graduate who was dissatisfied with the quality of life he had found as a white-collar worker on the East Coast. Okie moved to the Bay

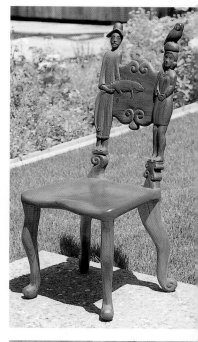

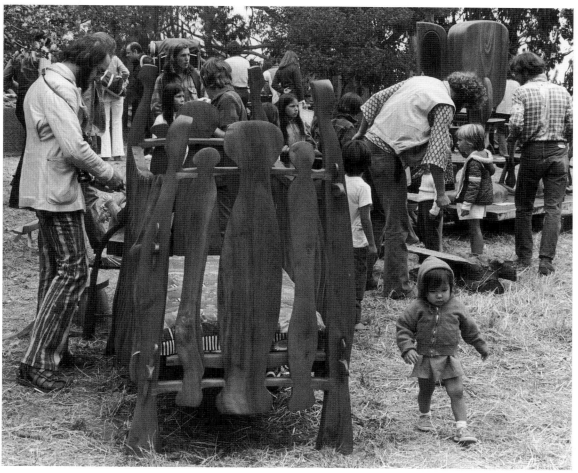

Some early California makers developed a graphic vocabulary of forms. Above, crib by David Foss, walnut, 1973, shown at an outdoor sale organized by the Baulines Guild. Right, chairs by John Bauer, early 1970s.

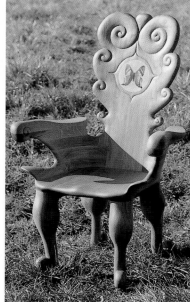

9. See Garvey's door for the Saxe home on p. 76.

10. See "Return of the Guild," *Newsweek* (August 20, 1973), p. 46; and Janet Peacock, "Craftsmen Worthy of the Name," *California Living* (February 24, 1974). Peacock's article is the most substantial published account of the Guild.

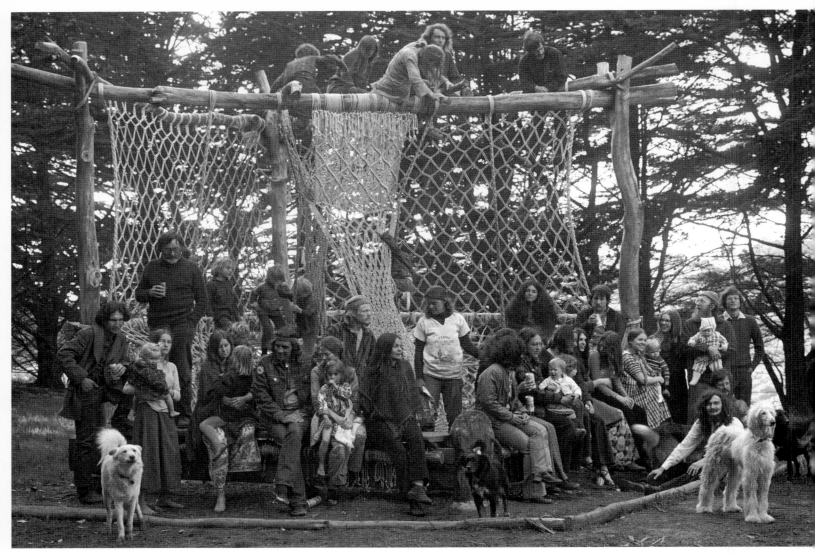

Baulines Guild sale with macramé playpen by Alexandra Jacopetti.

Area in 1966 and was eventually introduced to the Baulines Guild by Dean Santner, whose boxes and cutting boards he had seen at sidewalk sales on Telegraph Avenue in Berkeley. In addition to furniture by Santner, Carpenter, Karpilow, Garvey, and Holub, the shop sold tie-dyed fabrics, turned lamps, jewelry, and like merchandise. In the years to follow, Okie himself sold work through Dovetail and became one of the central furniture makers in the Guild.

Outside the Guild

Though the Guild dominated the Bay Area craft scene in the early 1970s, there were some makers who avoided membership. Some, like Blunk and Kapel, were established but isolated; others, like Karpilow, found the apprenticeship system unappealing. One important Bay Area furniture maker who remained totally separate from the Guild was Ed Stiles. Like Carpenter, Stiles had attended Dartmouth, where he had been inspired by New Hampshire craftsman Walker Weed to make furniture. After graduating, Stiles found himself "uniquely unsuited for the world of business," so he traveled around the country looking for other

furniture makers. He landed in California in 1962, where he worked at nights in Carpenter's shop. In 1965, he set up a shop in Mill Valley in the house of architect Roger Somers, operating under the slogan "Nicer than average things for nicer than average people."

Somers turned out to be a connection to the rural subculture then on the upswing, a group that included poet Gary Snyder and Zen spiritualist Alan Watts. Though distinct from the more overtly political circles of the Baulines Guild, the Mill Valley group were also devoted to pastoral ideals of rural detachment. Stiles absorbed these values, and inculcated them into his apprentice, Robert Erickson, who moved to the Bay Area from Nebraska in 1969. Erickson had come to find Art Carpenter; but at the time Carpenter could not take him in his shop and sent him on to work with Stiles.

Stiles' big break came when he did some house carpentry for Graham Nash (of the musical group Crosby, Stills and Nash) in San Francisco. He befriended Nash and worked on a series of commissions for him, including a basement recording studio and a case for a Wurlitzer piano. Unfortunately, this custom work wasn't very profitable,

and when the electronic technology he dressed up became obsolete, Stiles' wooden cases usually were scrapped. In the early 1970s, feeling financial pressure, Stiles turned to the more lucrative business of house contracting. Erickson continued to make furniture under his influence, however, and today is among the more prominent furniture makers of Northern California.[11]

The Guild Recedes

Stiles' frustrations foreshadowed those of other Bay Area makers. As they tried to build credible careers, their utopian project went through growing pains. The year 1976, in particular, was difficult for the Baulines Guild. For the first time, their annual sale was held outside of northwest Marin County, and the move turned out to be a disaster. Without its local network, the Guild was unable to raise much excitement. The same year, D'Onofrio resigned as leader of the organization so he could spend more time on his own work. Although these internal difficulties sapped the Guild's momentum, in the long run they were less important than the larger developments in the woodworking landscape. Art Carpenter's shop was no longer the sole source of training for an emerging woodworker. The California College of Arts and Crafts (CCAC) began a more robust wood program under Rochester Institute of Technology graduate Skip Benson. In 1976 Benson took over the shop, which had largely been devoted to vocational and architectural work; in 1977 he inaugurated a new major in woodworking. By 1983, when Gail Fredell was hired to run the program, CCAC had a dozen students in wood. This development was part of a national trend to establish academic furniture design programs emphasizing technical skills.

Simultaneously, the Swedish-trained cabinetmaker James Krenov started a new woodworking program at the College of the Redwoods near Mendocino, north of the Bay Area. Krenov is known to most furniture makers as the author of an inspirational series of books published in the late 1970s.[12] Krenov's writings espoused some ideas about woodworking that also were at the heart of the Baulines group. He extolled, for instance, the intimacy between maker and work, and he valued the independent lifestyle of the craftsman. Yet, with his emphasis on finely tuned handmade tools, and his rhapsodic reverence for the figure and texture of wood, Krenov's perfectionism was leagues apart from the Guild's scrappy self-taught spirit. Though he shared the Guild's taste for sensitive edges, on the whole his furniture was exacting rather than organic. Krenov raised the bar in terms of technique and brought a rigor to the region's furniture making,

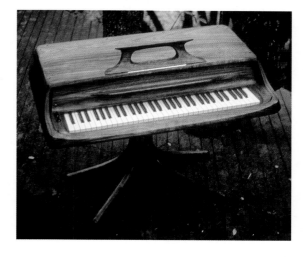

Custom cabinetry seems ideally suited to electronic instruments, but it rarely survives rapid cycles of obsolescence. Wurlitzer piano case by Ed Stiles, walnut, 1970.

but he also offered a new outlook that had little to do with that counter-culture.

The emergence of new sales and exhibition venues was also important in the changing complexion of the Northern California furniture scene. In San Francisco, Signature Gallery was founded in 1976, and in 1982 Norman Petersen & Associates opened. Petersen, himself a woodworker, was particularly attuned to the changing economic climate of the early 1980s, and saw his showroom as a way of promoting local furniture makers as professional designers. Thanks to the proliferation of Krenov's students and followers, Mendocino had two new venues — Gallery Fair, which has evolved into the high-style William Zimmer Gallery, and Clyde Jones' Highlight Gallery. Institutions such as the Oakland Museum also contributed to the professionalization of local crafts.

Most importantly, the last of Eudorah Moore's California Design exhibitions was held in Pasadena in 1976. Staged twelve times following its inception in 1952, the California Design shows celebrated the expanding state economy and focused on the products of Southern California. But over time Moore came to espouse more liberal cultural values. To accompany the last exhibition, she produced a volume entitled *Craftsman Lifestyle: The Gentle Revolution*.[13] Region by region, the book details the personal lives and living conditions of Californian craftspeople working in all media. It is a loving paean to the pastoral retreat of craftspeople into the countryside; and it is perhaps the most evocative and lasting document of the

11. See pp. 64–66.

12. *A Cabinetmaker's Notebook* (New York: Van Nostrand Reinhold, 1975); *The Fine Art of Cabinetmaking* (New York: Van Nostrand Reinhold, 1977); *The Impractical Cabinetmaker* (New York: Van Nostrand Reinhold, 1979); *James Krenov Worker in Wood* (New York: Van Nostrand Reinhold, 1981).

13. Olivia H. Emery, *Craftsman Lifestyle: The Gentle Revolution* (Pasadena: California Design Publications, 1976).

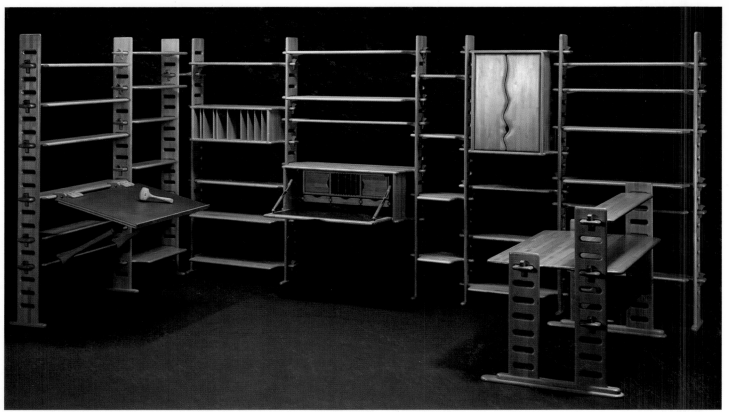

Dean Santner's, "Ossa" cabinet system, 1978, attempted to marry the idealism of the early Baulines Guild with economic realities.

counter-cultural furniture makers of the time. But by 1976, the phenomenon Moore described was already in decline. Though the original Guild members continued to work in small shops, others moved into new territory while struggling to retain the principles that had motivated their older friends and teachers.

Technical, Commercial, and Artistic Advances

Dean Santner was typical in this regard. After opening a workshop in Berkeley in 1969, he made laminated furniture in the style of Wendell Castle, whose work he had seen in Rochester. But he was dissatisfied with making knockoffs, so he created a line of boxes and small objects that he sold at craft fairs. This work led him to join the Guild in 1973. In the mid-1970s, Santner reinvented himself and developed a modular cabinet system. Entitled "Ossa" ("Bones"), the product line was a stylistic combination of Roundover edges and the bandsawn-box technique of Art Carpenter with the more marketable concepts of modular parts and ergonomics: "a combination of craft, small batch production, and engineering." Today Santner, who says, "You bet I'm still a hippie in

a lot of ways," designs furniture especially for handicapped people.[14]

Other Northern Californians shared Santner's dilemma: though their beliefs were counter-cultural, they found the Guild's insularity to be limiting, its antipathy to the commercial sphere suffocating. Many of the older craftsmen turned to custom interior woodwork to escape the "hand-to-mouth existence" (as Dale Holub calls it) of studio furniture making. As new makers turned to studio furniture, they faced not only this financial challenge, but also increasing competition for shares of the small market. Younger craftspeople were forced to sell their work actively, establishing commercial ties that earlier makers had largely avoided. In this respect they were diametrically opposed to the early, anti-establishment Guild members. Nevertheless, the ideals that lay behind their decision to make furniture were similar. As a result, their techniques tended toward the expressive, the elaborate, and often the experimental. Most of all, they continued to hold on to a counter-cultural value system.

Garry Knox Bennett exemplifies this wave of more commercially sophisticated furniture makers. He was steeped in left-wing hedonism as early as the mid-1960s, when he manufactured electro-plated peace signs and roach clips. When he turned to making clocks and then furniture, it was with a stylish irreverence. Like the early Guild members, his furniture was technically simple: where Roundover furniture came off the router, Bennett favored the bandsaw. His compositions featured

14. For more on Santner's experimentation with modular office furniture, see Dean Santner, "Keeping Quality in Production Runs," *Fine Woodworking* #24 (Sept/Oct 1980), pp. 80–83; Tom Toldrian, "From Alligators to Ergonomics: A Creative Woodworker," *Woodwork* (Summer 1990), pp. 39–46: David Meiland, "Dean Santner: Navigator Desk Systems," *Woodwork* (October 1997), pp. 60–65.

flat, unshaped slabs with strong graphic profiles. Unconcerned with the touchability of wood that earlier Guild members had prized, Bennett later led the field in his experimental use of paints, metals, and plastics. His work's commercial success has, perhaps, obscured his origins and his real motivations for becoming a furniture maker. Like Art Carpenter, he first saw furniture as a means, not an end—a way of living apart from the expectations and constraints of straight society, even in the context of suburban Oakland.

Bennett's strategic combination of humor, technical proficiency, and social rebellion was not unique among furniture makers in the area. Michael Cooper and Robert Strini, for example, had similar backgrounds and also sought to include subcultural imagery in their work. Both had studied at San Jose State College in the 1960s and shared a studio together for several years. Together, Cooper and Strini developed a style that featured elaborate bent laminations and "hot rod" imagery. Cooper's influences also included kinetic sculpture, which he had seen while studying art at Berkeley in the late 1960s, and a visceral antipathy to handguns, growing from his youth behind the counter of the family store.

Cooper's 1975 "Captain's Chair" was his first mature statement in furniture. Despite its accomplished workmanship, there is a hostility to this chair, which perches precariously on a tilted platform. Not only does it roll away if you try to sit on it, but it is outfitted with an array of threatening, unidentifiable apparatus. Cooper's bent-wood techniques lend the piece a fragility at odds with its mechanistic imagery; the tension is unsettling. Taken as a whole, the piece is as much sculpture

as furniture, an anti-chair. Its radicality transcends form; it both satisfies our expectations of a piece of furniture and frustrates those expectations, not only by flaunting iconographic propriety but also by retreating. Cooper taught his approach to furniture in a pair of important workshops in 1977 in Southern California (at the University of California at Northridge and at San Diego State University). There he was a crucial influence for younger makers, notably Martha Rising. Like Ben-

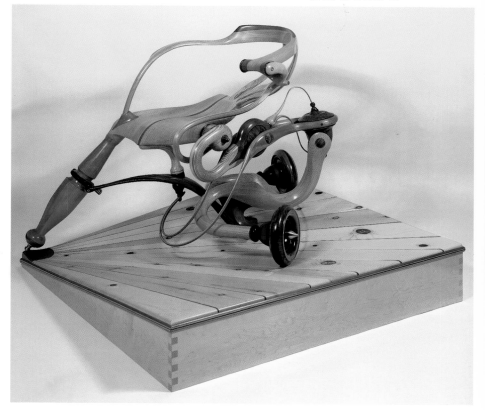

"Captain's Chair" by Michael Cooper, 1975, is as much sculpture as furniture, a direction soon followed by other young makers; laminated hardwoods, 48"l × 48"w × 29"h.

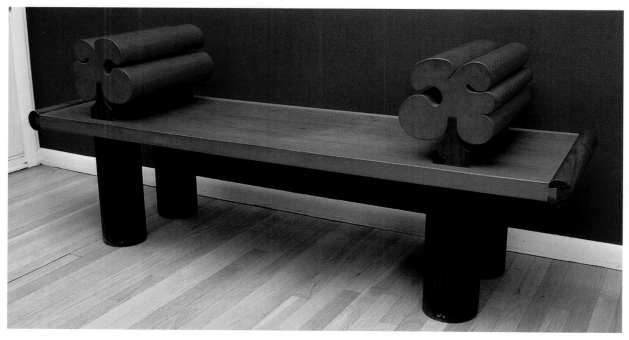

Stylish irreverence characterizes the distinctive furniture of Garry Knox Bennett. "Bench," 1981, mahogany and redwood, 70"l × 20"d × 29"h.

A Long Way Coming

What a difference a few decades make! As a new furniture maker in the mid 1970s, I remember being part of the Baulines Craftsman's Guild exhibit at the Marin County Fair in San Rafael, California. Although the main art and crafts exhibits (even dolls made from pine cones) were being showcased in the beautiful, curvilinear Exhibit Hall designed by none other than Frank Lloyd Wright, we were relegated to the dirt area that surrounds the buildings.

We were a multifarious group of mostly young and long-haired types, trying to earn a livelihood by building furniture, weaving rugs, or throwing pots, and were part of the recently formed Baulines Guild. There were tie-dyed banners, breast-feeding mothers, and quite an eye-opening scene for a rather traditional easterner like myself. One of our senior members—and local heroes—Art Carpenter was showing a roll-top desk in the tented booth. I will always remember the guy who put his cup of beer on the tambours and then pulled the desk closed, spilling beer all over the desk, just as a dust-devil swirled through the space.

Within a few years our group was not only invited into the Exhibit Hall, we were given VIP status—even headlined at some of the later fairs. Members of the Guild went on to teach crafts for the University of California at Berkeley Extension Program—before being displaced by the rising tide of computer science.

Anyway, to contrast those early days, I must recount my experience at the Wood Arts Collectors Forum held in the Renaissance Parc Hotel in downtown San Francisco, September 1998. As I stood on a step-ladder hanging lights for our same organization, now notably renamed the California Contemporary Crafts Association, I lamented to Bob Erickson that we would need some extension cords. A man, decked out in a tuxedo and ruffled shirt, overheard our problem, and pulled out a cell phone. We had three extension cords delivered by the hotel electrician in ten minutes!

We have come a long way into the real world. There are still many challenges for all of us craftsmen and women on an individual creative and marketing level. But as a group we have been accepted as a serious and enduring segment of the community. — *Grif Okie*

extensive lineage. From the back-to-the-land woodworkers of the 1950s through the Beat and Funk movements of the 1960s to the Baulines Guild in the 1970s, San Francisco had nurtured the pastoral ideal of the detached, critical artisan. When Garry Bennett drove a nail into the front of a carefully made padauk cabinet in 1979, he not only began a new chapter in American furniture, he also put the exclamation point on a long story of idealistic defiance.[15]

The Beat Goes On

Of course, a skeptic might well ask: what *were* the real accomplishments of these makers? What has been their lasting contribution to the crafts scene, or to politics? Aren't they simply dated, quixotic remnants of an era gone by? I would say no. First of all, while the Baulines Guild was a unique phenomenon, it was by no means the only intersection of crafts and social upheaval in the late 1960s. In Los Angeles, Vermont, Boston, Philadelphia, the Pacific Northwest, and upstate New York, to name a few centers, the counter-cultural attitude was no less important. In fact, I hope this case study will inspire a more culturally aware rethinking of furniture made in these and other regions, one that will emphasize the politics of lifestyle.

Second, the account presented here suggests that the important thing about the Guild was its impact on the lives of individuals, not any transformation of the overall political climate. As Dale Holub puts it, "I wasn't trying to change the world... [but] I wanted my own freedom." Craft criticism should take this model of change into account. For example, Garry Bennett may be a design genius, and he may be a master of technique, but he also is a willful provocateur. His urban-guerrilla Captain Craft persona is every bit as important as the flamboyant style of his work.

This suggests we should be asking social and political questions about the state of affairs in furniture right now. Too often, the crafts are analyzed as merely a stylistic engine, a churning wheel of formal innovation, or they are seen as the poor cousin of some formalist strand in sculpture. But they stand for something larger than that. To me, the attraction of the crafts is that they are embedded in the social fabric. Seen in that light, the Baulines Guild is more than a quirky piece of craft history. Its fundamental motivations continue to propel the contemporary craft movement, indeed to justify its very existence. ■

nett, Cooper was able to remain connected to the wider craft world without losing his critical edge.

In the early 1980s, Bennett and Cooper translated the independent spirit of the Bay Area craft scene to a wider audience. Their tough-minded indifference to demands for technically polished, stylistically conservative furniture had a lasting impact on the furniture field. But it must be remembered that these were inherited attitudes with an

15. Bennett's "Nail Cabinet" was featured on the back cover of *Fine Woodworking* #24 (Sept/Oct 1980). Both Dean Santner and Don Braden assisted Bennett in building this cabinet, Santner executing the box joints and Braden the dovetails. For the impact of the piece on the field, see the irate letters of response in *Fine Woodworking* #25 (Nov/Dec 1980), and Michael Stone, "Garry Knox Bennett," *American Craft* (Oct/Nov 1984), pp. 24–26.

MEMOIR

■

ARTHUR ESPENET CARPENTER

■

*An opinionated woodie tells how he fled
New York for San Francisco in search of
honest materials and the rewards of touch —
the sense closest to the heart*

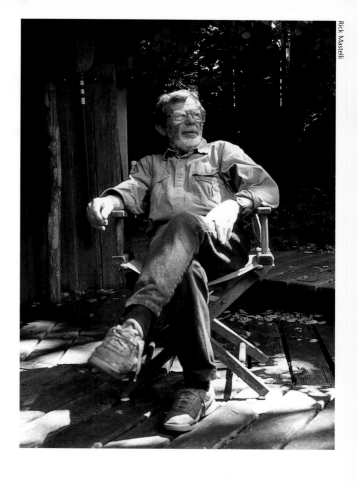

Neither in environment nor in heredity can I find the exact instrument that fashioned me, the anonymous roller that passed upon my life a certain intricate watermark whose unique design becomes visible when the lamp of art is made to shine through life's foolscap.

■

Vladimir Nabokov

There were several early signs of my future as an artisan, all legitimately unremarked at the time. The most tenuous was genetic, which might be teased out of an ancestry partially Huguenot, a people who were allegedly recognized for their craftsmanship. Huguenot is the origin of the family name 'Espenet' (my middle name and a grandmother's maiden name) which, when I opened shop, I chose as a trade name. My last name suggested a profession for which I had even less qualification than the one I was attempting. At least "Espenet" was neutral.

I can't wring much of a crafty predisposition out of the other New England antecedents who, in general, were a self-congratulatory group, engendering little but Pilgrim austerity and pride in being Presbyterian—and perhaps a knack for independence. The Pilgrims and the Huguenots seem to have passed on a gene for contrariness; one escaped from France and the other from England because of their insistence on being politically incorrect, religion being much the politics of the time.

There were indications of a character bent more obvious and direct but still unrecognized, for they consisted of what it was assumed most boys did—at least middle-class American boys—building, making things. Beginning with the still fondly remembered feel and smell and whiteness and lightness of Tinker Toys, I segued over the years into model ships, airplanes, trains, houses, stage

sets, and even, a bit anticipatorily, a tiny lathe at a time when I hardly knew what a lathe did. I look back with remembered sensual pleasure at my first job (other than mowing lawns)—assembling and nailing sweet-smelling precut pine slats into vegetable boxes for my farmer grandfather. (I sublimate the tedium and also the frustration at nails hammered askew.)

At the age of twelve I made a table which I recognize now, in memory, as 1920s De Stijl (painted the obligatory 1920s silver and black), which I probably copied from a magazine. I continue to plagiarize from the de Stijl artist Piet Mondrian. In the seventh grade I "took shop" and hated it, probably because it was tightly structured and the project ideas weren't mine. I never "took shop" again. In high school I occasionally dabbled with constructions, but girls and books took precedence, and in college—an all-male college— books took over.

I majored in economics at the behest of my CPA father, who was paying for my education, and since I seemed to have no alternative talent, I went along with some distaste and did poorly. Fortunately, I saved face in the arts and sciences— the more tangible and, therefore, to me and my right-brain tilt, the more credible disciplines. I particularly enjoyed the courses in the visual arts, where I was introduced to my enthusiasm: the projected slides of bridges (particularly the clean lines

A college enthusiasm for Robert Maillart's prestressed concrete bridges, the hiatus of World War II (which opened the way to an unmarked path), and an encounter with James Prestini's "mouthwatering" wooden bowls (above right) led Carpenter to consider, "it just might be within my capacity to make handsome objects."

The artisan as a young sailor, New Guinea, World War II.

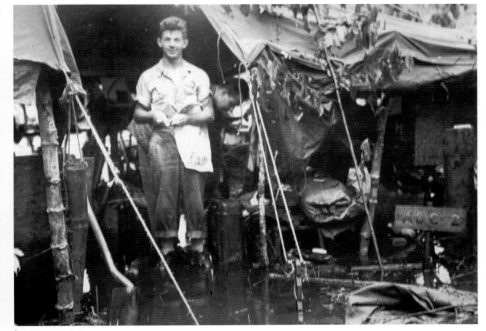

of Robert Maillart's prestressed concrete bridges), buildings, paintings, sculpture. These were a revelation to me, opening a new and exciting world. I was young and impressionable enough to absorb and burn many of the slide scenes into memory.

I joined the Navy in my graduation year (1942), since World War II intruded at this fortuitous time, fortuitous for me because I was relieved not only of the necessity to take final exams but also of the need to find a job, a search I was not looking forward to. I received my draft notice and immediately checked in with the Navy. Death was too sure in the Air Force and mud was inevitable in the Army so I chose what I considered a reasonable option—clean sheets. This interruption in the pursuit of the white collar had considerable to do with my eventual occupation, for it weakened the path of that quest by allowing me to be open to bluer collars. And of course it was a time when I did some growing up—at government expense.

After this hiatus in my as yet unknown career path, I found myself in New York City taking night classes at Columbia and working at a wholesale Asian art establishment—a job suggested by my father for, again, neither of us had a better idea of what to do with me. These occupations, however, were no hindrance to steeping myself in the lore of the Museum of Modern Art.

In the late 1940s and early 1950s Edgar Kaufman curated an annual exhibit at MoMA called "Good Design," which focused on the recognition of beauty in utility. College had touched on that idea, but now I saw the idea brought down in scale from bridges and buildings to the daily artifacts of life. Hallicrafter radios, Olivetti typewriters, Eames and Bertoia chairs, and James Prestini's exquisite shapes in the form of wooden bowls—these were all framed and pedestaled with the same deference that is accorded to Art. (Marcel Duchamp declares that such display *is* what makes it Art.) So it dawned on me that in there somewhere might be my niche. It just might be within my capacity to make handsome objects rather than merely deal parasitically in handsome objects made by others centuries ago.

It was a gradual acknowledgement of a direction that had a little to do with inheritance, more to do with inclination, considerable to do with education—philosophically and visually—and was topped off with four years of WWII detachment, which allowed an indulgence in the fantasy of pursuing the unmarked path.

It didn't take much introspection for me to pack up and head for San Francisco—my idyllic city. It was where I had spent several deliciously remembered months of shore leave. Nothing like making a beginning in the most welcoming place possible.

Mission Street

On arrival in San Francisco in 1948 I found the cheapest space available: a two-story condemned Victorian derelict on Mission Street, one of the

older and sunnier districts of the city, for $20 a month, and bought a lathe—not a whole one, just the headstock and motor. I also signed up for the GI Bill, which gave veterans $100 per month for twelve months to jump-start an occupation. One could live on $100 per month then, though admittedly, not high.

It was a crash course in learning a skill of which I had absolutely no knowledge. I picked wood as a medium not only because of the mouth-watering pieces by Prestini that I had seen at MoMA but also because it appeared to be a medium that required more modest skills and less esoterica than working with metals or clays and therefore something that I could plunge into without prior training. I had the sublime confidence of one who has never been told what is not done nor even what is not possible with the material. And so with the wrong tools (scrapers) and the right attitude I began learning some of what is possible on the lathe. Fortunately it turned out that a lathe is an excellent tool with which to begin the knowledge of wood and its mysteries. It was something that James Prestini understood years before in his role as wood technologist at the Chicago Institute of Technology.

A clean shape and sturdy delicacy without being fragile were my aims—I wanted the silhouettes to be handsome, the feel to be strong and tough, and the heft to be light. And they had to be useful, for utility was of prime concern from the beginning, and from the beginning I was after a sensual message—if contained in a useful object, the message couldn't be overlooked. This was sculpture to be lived in, on, and with and, above all, handled, for it is through handling that the object is fully known. The early incarnation of this quest was the evolving of bowl-shaped turnings that hovered around one quarter inch thick from rim to bottom. Thinner was too fragile; thicker was too clunky. And so began production.

Hardwood lumberyards were at hand in San Francisco and so were cabinetmakers and turners. These latter were all older men who, because of age, had missed serving in WWII and therefore were still working in their established shops, and they were free with their advice and help. Perhaps they were generous because they thought they saw in me a regeneration of the trade in which they had spent a lifetime, and I seemed to be the rare one who was interested. One of the turners (Walrath was the only name I knew him by) had turned ship spars on his 50-foot lathe when hand-turned ship spars were in demand. He introduced me to gouges and skews, tools that I never really did master. It was to be the better part of a year before I became aware of the most notable turner in the Bay Area, Bob Stocksdale,

and his work, even though he lived just across the Bay.

Even with the input I was given, much was trial and error. But with considerable practice I became fairly proficient and soon was selling all that I and eventually an employee or two could make through Bay Area stores and, within a year or so, through wholesale marts in Los Angeles and Chicago. New York MoMA's Edgar Kaufmann saw the work in Chicago, and for several years I was included in the same MoMA "Good Design" show that prompted me to make wood bowls in the first place.

At this stage I considered myself to be a manufacturer of utensils. And I still do, for that matter, taking the phrase literally—hand maker of useful objects. It was only later that the appellation "craftsman" was tagged on. But that is by others, for I still aspire to the skill and patience that it denotes. I make what James Krenov refers to as "engineer art." That is, I use machines whenever they can do the work as well or better than I can do it by hand. I even devised a Rube Goldberg system to remove the interior of large bowls in one piece so that the wood would not be wasted. Crafty perhaps, but not craft.

The romance of woods from everywhere was seductive, so I ordered woods I had never heard

Carpenter's Mission Street bowls eventually were included in the MoMA "Good Design" shows that originally had inspired them.

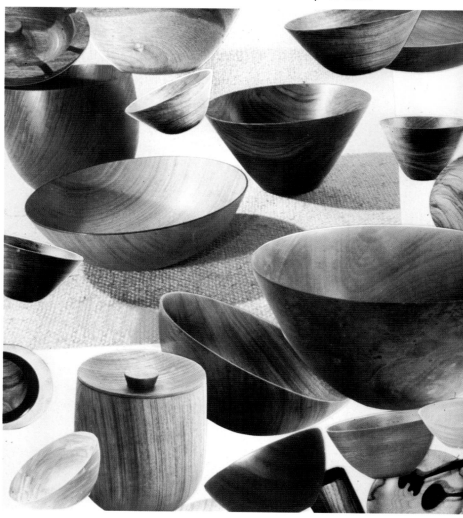

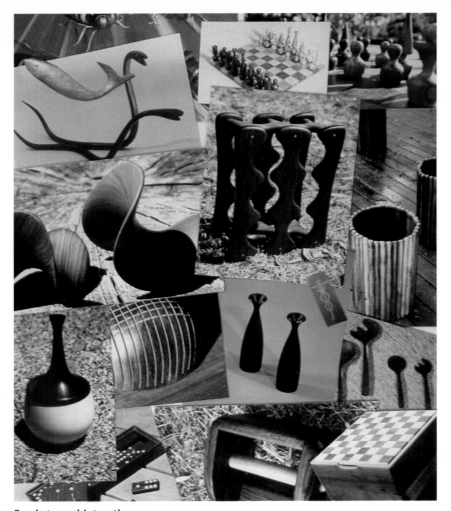

Bowls turned into other treen and treen into furniture, as Carpenter expanded his skills, machinery, and business: "I was not making Art for the wealthy; I was making artifacts for the middle class."

If you don't work your ass off, you'll never make it.

■

James Prestini

of from importers in New York. The planks and logs would land in a perfumed pile on a San Francisco dock after coming through the Panama Canal. Romance heaped on romance! I of course bought every variety possible. The availability of particular woods in particular sizes has changed over the years, for then 20-inch-wide planks of Costa Rican prima vera, Honduras mahogany, Cuban mahogany, Mexican genisaro, and even 16-inch-wide planks of Brazilian rosewood were common. I experimented with logs of Gabon and Macassar ebony, snakewood, grenadillo, satinwood, and even sticks of sandalwood. It finally came down to teak as my favorite wood for turning, for the same reason California walnut is my preferred material now—availability in large sizes and quantities, beauty, workability, and stability. Teak had a special romance, for I bought it through Davis Hardwoods just down the street from the Ghirardelli chocolate factory. My specially ordered teak came in large handsome, hefty, gray-green blocks with 'Product of Thailand' stenciled on them, and they were imbued with the aroma of elephants, tropical soil, copper sunsets and, of course, chocolate.

The turning years lasted for about a decade. Gradually I added stools and chairs, all with turned parts, and eventually treen other than

bowls. ("Treen" is a handy old English word meaning small things made from trees.) Treen included salt and pepper shakers, gavels, chess and domino sets, wine racks—in other words, anything that I could think of that could be made of wood—small practicalities. On another scale we made onions that sit today on top of a Russian orthodox church in San Francisco.

Slowly I was acquiring machines and learning to use them in order to expand my capabilities beyond the circumscribed product of the lathe. Or what I thought was circumscribed, for I had no conception of the beautiful turnings that David Ellsworth and his peers would invent a decade or two later.

My furniture designs were particularly influenced by the clean, no-nonsense, unadorned directness of purpose and unabashed nakedness of material exemplified in chairs by Charles and Ray Eames, Harry Bertoia, and Hans Wegner. This was also the free-form era, when all products had elements of peanut or boomerang shapes, which may have derived from the 1950s popularity of Alexander Calder with a bit of Isamu Noguchi thrown in. I made them all, from aluminum-edged cabinets to pipe-legged boomerang tables. It took the decade of the 1950s to evolve my own way of doing things, which is still open to experiment.

My basic purposes, accounting to a certain extent for style, were to keep prices within reason and the quality as high as I could, with that limitation. I was not making Art for the wealthy; I was making artifacts for the middle class. I still tend in that direction, although occasionally I am open to seduction. It seems to me easier to make an $8,000 chair than to accept the challenge to make a handsome and comfortable $800 chair. I have to leave it to machines to make the $80 chair.

The immediate post-war years saw the recognition of what was then called "honesty in the use of materials." Materials, it was realized, had a legitimacy of their own. They did not have to be hidden. Radios dropped their wooden or fake wooden facades, as did station wagons and Pullman cars. Silverware became steelware, even though the prior name endures, and Eero Saarinen made plastic acceptable and beautiful. Architects allowed the imprint of the wood forms on concrete, and structure was uncloaked.

The same was true of things made of wood. Heavy varnishes and glassy lacquers succumbed to finishes that proclaimed wood. The handsomely designed Danish imports of the time helped to confirm the woodsy trend. This era has lasted for three decades and is now, in the Post-Modern era, reverting back to facades and cloakings. Veneers, paints, and lacquer or plastic shine are returning in sometimes new and exciting forms. The crafts-

manship is frequently remarkable. More often than not, however, these changes are in the service of Art rather than utility and meld into an amalgam which I call Artiture. This amalgam begs to be called a crafty Art — an artifact that derives its value from being decorative or ornamental, rather than deriving its value and its beauty from purposeful structure.

California Roundover

The Japanese make a small carving about two inches around to tie on one end of a cord which holds at the other end a small snuff or pill box. This is so that the cord will not escape from the waist sash over which it is looped. The carving is called a *netsuke*. All proper netsukes, even though they may depict anything from a mushroom to a mouse, are rounded, with no corners nor protrusions to catch on clothing. This exquisite little piece of functional craft is an exemplar of the reason for softened and rounded edges — another instance of form following utility.

In the early 1980s John Kelsey (at that time editor of *Fine Woodworking* magazine) made a reference in a lecture at the University of California to the "California Roundover Style." He accused me of being a prime practitioner of the art. I say accused because the lilting word "California" is always pejorative when spoken through the envy of anyone unfortunate enough to live east of the Rockies. And "accused" because the word "roundover" indicates a veering away from the classic detailing of hard-edged furniture and is

therefore "not done." I will have to admit that it is a detailing that can be used to cover sloppy work, for it is easier to see errors of joinery when sharp edges are juxtaposed rather than when rounded edges are used. It is also true that the two prime practitioners of this style in the 1960s were Californians, Sam Maloof and myself. We seemed to be doing it independent of each other. I do not remember consciously picking it up from him and I am sure he did not pick it up from me, for he was rounding edges while I was still caught up with Bertoia's wires and Eames' plywoods and the hard edges of both. Actually, Greene and Greene (California architects in the earlier years of this century) were early perpetrators of this aberrance and were perhaps the impetus for both of us to experiment with round edges.

My use of the rounded edge begins with the commission for making the furniture for the Mill Valley Library in 1965. It had been my observation that well used old furniture and particularly old institutional furniture was thoroughly bruised on all corners and well on the way to being rounded — its own angle of eventual repose. If the pieces are veneered, the damage is even more evident and most ugly, for the films begin to peel at the edges. In the interest of longevity (both the library's and mine, for I did not wish to wear myself down with repairs) I gave all the edges their inevitable eventual angle of repose ($3/8$- or $1/2$-inch radius). To date, the ploy has worked and the library, if I do say so myself, is still handsome and well functioning with only two repairs — at least repairs that I was informed of — in thirty-plus

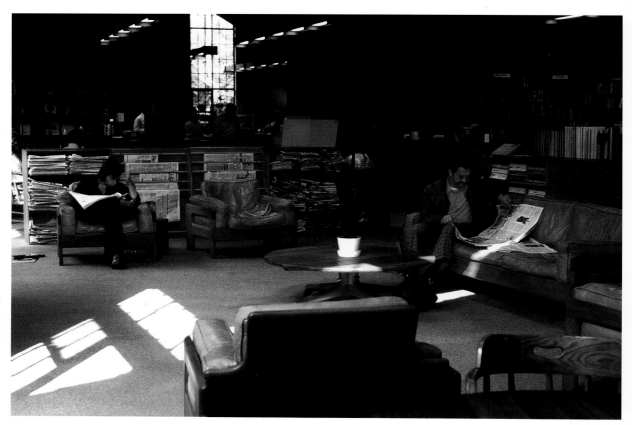

...and I conceived free angles and free forms, making the edges of my tables flow so that they would be attractive to feel or caress.

■

Wharton Esherick

Japanese netsuke of ivory.

Carpenter's 1965 furnishings for the Mill Valley Library are "still handsome and well functioning."

years. It exemplifies my goals of design for utility, and is visually and tactilely calm and pleasing. It is neither numbly heavy nor floatingly light, and is sturdily built for a long public life.

The library was my first public commission and my largest, and it remains one of my most favored and savored. It has accomplished well its purpose and my intent. I received the commission through the approval of the library board, the head librarian, and Don Emmons of Wurster, Bernardi and Emmons, the architects of the library. My initial models, which had curves in what I thought were the appropriate places, went the rounds and were returned with all the curves straightened. This was a modest blow to my ego but certainly simplified fabrication. I have spent much of the last few years making new pieces for an extension to this library. Concomitant with making the new pieces was the request to refinish the old, which we did by sending the table tops through a wide-belt drum sander, after chipping thirty years of gum off the undersides.

The curves of Carpenter's initial model for the Mill Valley Library, above, were straightened in the finished carrels, below.

It is true that the indulgence of rounding over the edges to excess, particularly on the face of a cabinet, can make the piece look heavy. In general, creasing or a shadow line or a crisp edge will help to lighten and elevate a piece, whereas soft and rounded edges are more earthbound. My preference at the moment for utilitarian pieces is a combination of curve and crease, something that I call "pillowing," which allows a softness on the faces and a crisp shadow line at the edges of these faces. Pillowing is the combination of a gently accelerating curve ending in a sharp crease.

Though initially "hogged out" (i.e., the bulk of the material is removed by machine), the final touches are done by hand plane, which gives a vibrato to the edge that machines can't impart. It's here that the feel of the silky cuts of a sharp hand plane are most appreciated. Planing is work—many times to the point of sweat—but it has its reward. To watch a surface gradually come up to a revelation of its natural beauty is a great pleasure and helps to reinforce the sometimes forgotten knowledge that the process can be, for the maker, of as great a value as the product.

Touch

Anaxagoras thought that man was the most intelligent of creatures because he had hands, and Aristotle suggested that he had hands because he was the most intelligent of creatures, and Kant wrapped it up by saying that man can be seen as a rational animal as proved by the shape and organization of his hand, his fingers, and the tips of his fingers. And, to bring it up to date, Frank R. Wilson in his book *The Hand* says that, like musicians, surgeons, and jugglers, all crafters turn hands into "the essential physical instrument for the realization of their ideas or for the communication of closely held feelings."

There seems little point in making anything by hand today the purpose of which is to be simply useful and/or fashionable, for a machine can make it faster, cheaper, slicker, and with no mistakes and in multitudes. And with CNC (computerization) you don't even have to think about it. That is, of course, if utility and fashion are your only considerations. But an object of utility can be satisfying in more profound and fundamental senses than can be instilled by machine. The method of making inevitably imbues itself into the object made, and that makes all the difference in its appreciation over and above its physical purpose.

Touch is, of all the senses, the sense most "in touch" with the heart—with feelings. A pat on the back or a kick in the shins are bold for instances. The phrase "I am touched," the words "feelings," "tact," "hard," "soft," "smooth," "rough" all tie finger tips to emotions. Touch is the premier

power in craft. In craft touch and sight are bound—as bound as a Hindu symbol for healing—the eye in the palm of the hand. Sight divorced from touch I leave to Art, for touch is incidental to Art and is even discouraged by the exhibitors, purveyors, and owners of Art. Among object makers the crafter is by definition the one concerned with touch, for it is the crafter who makes by hand—by feel. I think that one can be assured that it is purely serendipitous that a cool can of beer feels good to the touch. Both Industry and Art leave touch to the crafts.

With hands, the crafted object is formed and, through hands, craft is communicated, because a handmade object is made for tactile as well as visual and functional consideration; it is the feel of a piece that communicates its sensual value. I have frequently noticed hands caressing the edge of a table almost unconsciously; hands are drawn to furniture that is visually seductive to touching. (This ensures that I smoothly finish the reachable undersides of things.) A craft-made object carries the vibrato of the spirit with which it was made, including the affection in the making.

One of my favorite examples of this is a much and lovingly repaired Polynesian wooden bowl that has been on display for years in a San Francisco museum. By the careful patchings and sewings that have been lavished on it, one can see that it has had meaning beyond its simple utility. This is true for all thoughtfully made craft. It is meaning that no machine-made utility can aspire to. This homely truth is revealed in the dishes we wash every day—those made feelingly by ceramicists versus those made slickly by machine. Homely tasks are made pleasurable when the homely objects have meaning. There is furniture that invites touch and there is furniture that repels touch. It's the difference between an alive thing and a dead thing.

The disinterest of Art in any part of the body below the head was confirmed for me recently by an exhibit in San Francisco's new Museum of Modern Art of a small selection of chairs, which again made evident the fact that Art is not in the least concerned with touch even when the object is of a form determined by the shape of the human body—the touch of the body from foot to head. These were the usual beautiful-to-look-at creations (I'm not saying that these things can't be handsome) that exhibited great interest in new material and interesting technique but an unconcern for warmth and feel. This was visual Art furniture; it showed objects designed for the eye, for the machine, and for the museum. The visual arts that museums profess are just that. They don't pretend to include any of the other senses and in this case even including objects theoretically made

to service the human frame. The role of crafters is to keep the sense of touch alive in a culture that sees the function of touch only in relation to a keyboard or, perhaps, the feel of the paper that serves to reference actual objects—a culture already drowned in virtual reality.

Heft is another aspect of touch that is an appreciable part of the enjoyment of an object. In this, too, there is a visual component and it is sometimes wrapped in surprise when lifting a piece that looks heavily substantial to find that it is unexpectedly light. This is most pronounced in hollow turnings that give the appearance of weightiness but are light as an eggshell. The firm lightness that is possible with chairs and music stands contrasts with the rooted heaviness of many a dining table or chest. These are all aspects of the intermingling of sight and touch.

My continuing need to conform to the mid-twentieth-century edict "don't hide the material" is to keep wood surfaces as much like wood as possible. I would not apply coating on many a wood object if it would be serviceable without it, but finger marks, stains, and moisture absorption prevent such fundamentalism. (It is feasible to have no finish if the surfaces are frequently bleached and/or abraded to keep them presentable—if you have the crew to do it.) My solution has been soft finishes—basically linseed and turpentine and/or heavily cut varnish—that preserve the look and feel of wood.

The dictum "don't hide the material" was impressed on me in a much less subtle form when, on a cold Alaska morning, I hesitantly prepared to set my butt down in the privy and found to my delight that it was not icy cold but quite warm. Appropriate use for appropriate material; plastic foam has its uses no matter how picturesque and satiny a wood seat might have been.

■ ■ ■

It's the physical and mental ways we spend our days that ultimately matter—only secondarily the product of those days. There are those who do, onanistically, revere and collect their own stuff, but most of us hope that our work will be purchased so that we are enabled to repeat the pattern of designing and making. We only hope that we have been led to a living pattern that we wish to repeat. Inevitably a good segment of our ego rides on the product as it travels abroad for, in a way, via the product, we are asking approval for the way we are spending our lives; but, inevitably, it is the product that is noted by others, not the process. This accounts for the culture's reverence for the things made rather than for the occupation of maker. Which is, of course, just as well, for it helps to keep any latent hubris in check. ■

Modern culture continues to emphasize vision at the expense of touch—because our social ways make so little allowance for people's need to touch.

■

Kenneth Baker

The history of work and of the people who did it exists hardly at all. When found, it is in scraps and pieces, trivia inadvertently dropped in corners and accidentally carried along in the heroic march of time.

■

Reg Theriault, *How to Tell When You're Tired*

FURNITURE GALLERY

More great studio furniture from The Furniture Society's 1999 juried competition

Bob and Jeanne Hyypio
Lower Lake, CA

Bell Tansu 1997
Alaskan cedar, 36"w × 26"d × 48"h

This is our answer to the problem of the huge tv in the small space; the step up reduces the overall scale of the tv box. The grid that is often in our work is drawn from the castle gates in Japan.

Photo: Petra Hyypio

Timothy Coleman, Greenfield, MA

Carved Cabinet 1997
Maple, bubinga, 27"w × 19"d × 63"h

This is the first in my recent explorations of carved and stamped patterns. The pattern came first. It had somewhat of an Asian feel to it, and this guided the form of the cabinet.

Photo: Will Elwell

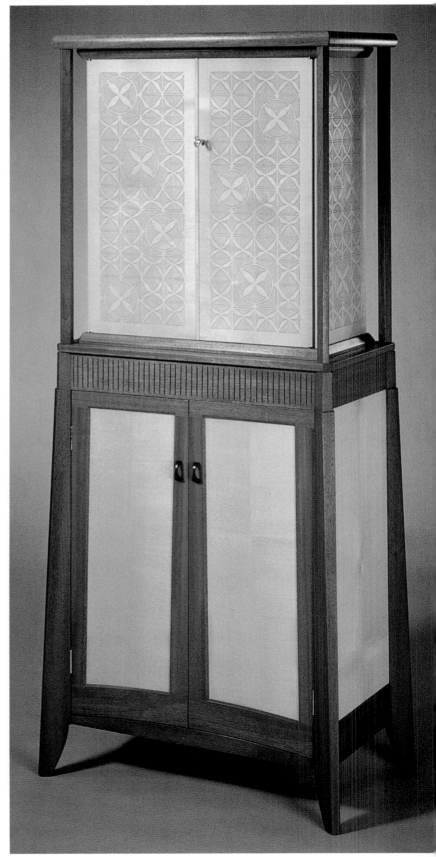

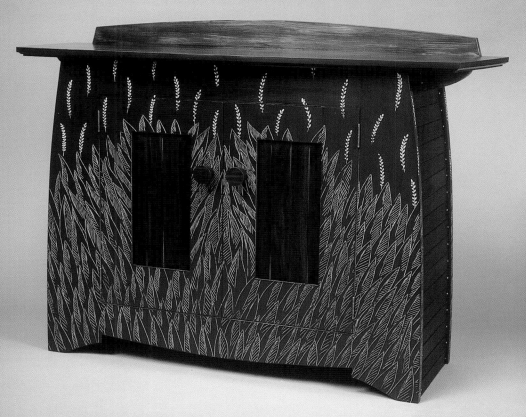

Jenna Goldberg
Asheville, NC

Moments of Clarity 1998
Carved maple with Brazilian rosewood slats
56"w × 19"d × 40"h

*Sideboard/buffet. Freehand intaglio carving
on painted maple.*

Photo: Tim Barnwell

Stewart Wurtz, Seattle, WA

Luna Chair 1997–98 (production)
Cherry, 21"w × 20"d × 34.5"h

*In designing the Luna Chair I reflected on what was the "essence"
of a form. I wanted to create a chair that was pleasing both
visually and ergonomically, yet not a nightmare to produce. I'm
still assessing my success!*

Photo: Terry Reed

Gary S. Magakis, Philadelphia, PA

Floor Lamp N 1998 (edition of 50)
Steel, bronze, copper, 22"w × 8"d × 67"h

*The lamps I make I consider sculpture that
utilize light as one of its elements. I also
believe the light switches should be part of
the design. I mix metals, patina, and texture.*

Photo: Jerome Lukowicz

Rich Tannen, Honeoye Falls, NY

Bench 1997
Ash (veneer and solid, dyed, and bleached), 72"w × 18"d × 16"h

This commissioned piece was an opportunity to apply some of my aesthetic interests and direction to the museum setting. From a practical point of view, the piece had to be sturdy enough to hold up to ongoing public use. I also wanted to take advantage of this setting to create a truly three-dimensional piece, one that could occupy the middle of a gallery and be sat upon to view the surrounding art work in any direction. As well, the piece changes and evolves as the viewer moves around it.

Photo: Geoff Tesch

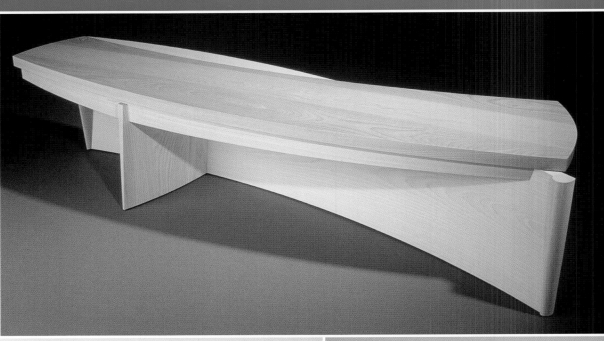

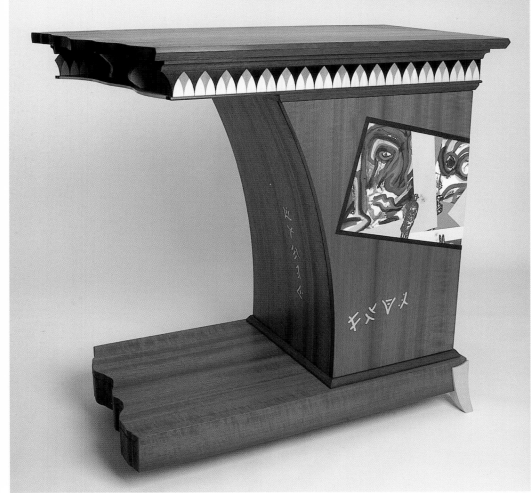

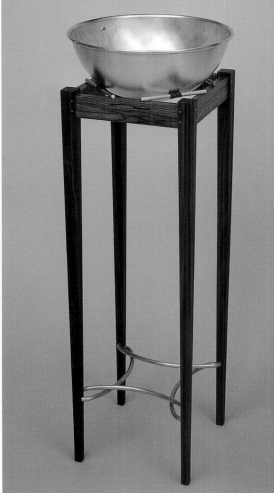

Douglas A. Haslam, Calgary, AB

Sophia's Bachanal 1997
Purpleheart, various veneers, poster
39"w × 18"d × 39"h

This cabinet was commissioned by an artist to mark his having been chosen to design a wine label and poster for a local firm.

Photo: Chris Thomas

Jane Swanson, Media, PA

Cocobolo with Copper 1997
Cocobolo, copper, brass, leather
12"w × 12"d × 34"h

The combination of materials and the suspension of the bowl by "sticks" wrapped in leather give this piece a primitive feel and a sense of ceremonial role.

Photo: Lance Patterson

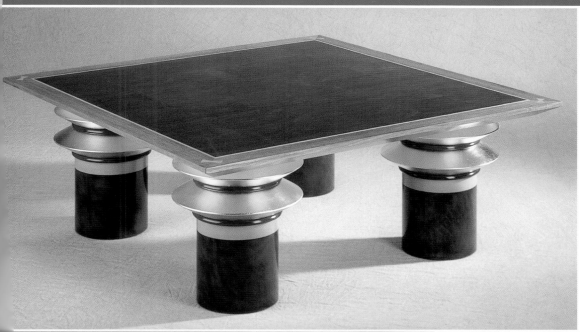

Garry K. Bennett, Oakland, CA

Square Coffee Table with Gold Leaf
1999
Mixed woods, walnut inlay, gold leaf, PVC
47"w × 47"d × 18"h
Photo: Lee Fatheree

Claire Fruitman, Newton, MA

Key Table 1998
Mahogany, metallic powder, lacquer
27"w × 9"d × 29"h

This key table came out of a friend's superstition that it is bad luck to lay one's keys on a dining room table. So, we decided on a table specifically for keys. It also ends up being a wonderful place to empty one's pockets at the end of the day.

Photo: Lance Patterson

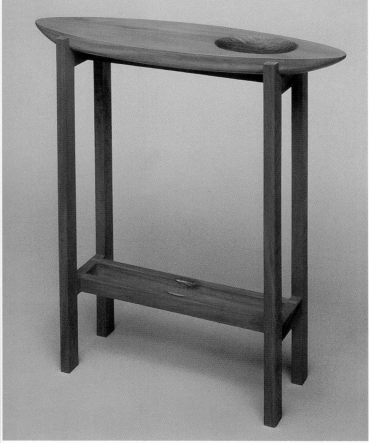

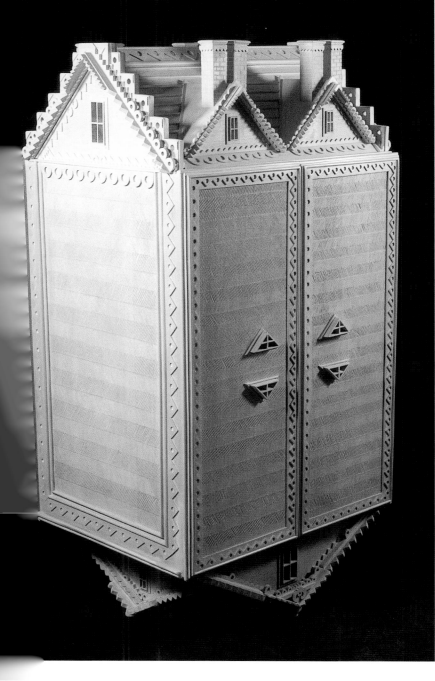

John McNaughton
Evansville, IN

A Cabinet to Flip Over 1998
Hard maple with white oil stain
26"w × 18"d × 54"h

This cabinet has no specific top or bottom. If you get bored with one house design, turn the cabinet over and get a new design.

Photo: John McNaughton

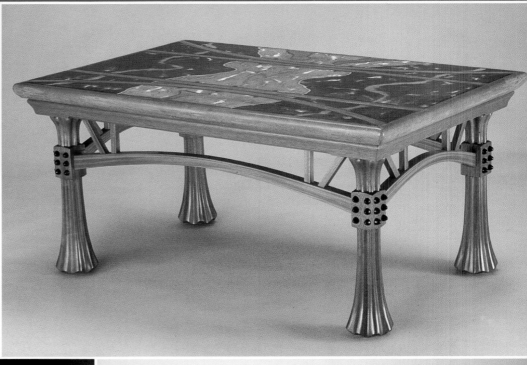

Craig Nutt
Kingston Springs, TN

Bridge Table 1997
Mahogany, wenge, polychrome concrete
37"w × 24"d × 18"h

*The top is cast concrete —
color is mixed into the concrete.*

Photo: John Lucas

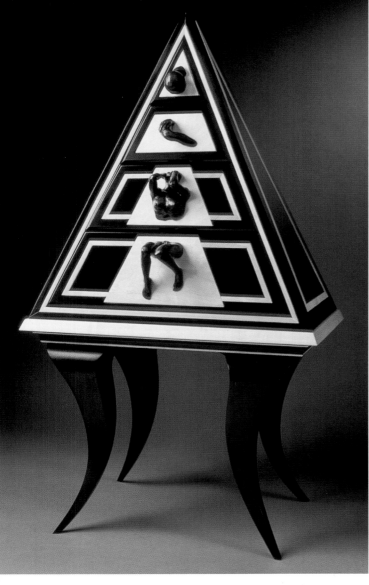

Priscilla Cypiot, Oakland, CA

Production Side Tables
1998
Maple, ziricote, trupan, lacquer
23"w × 23"d × 24"h

*In designing this table I wanted
to get away from a traditional
boxy shape, but I also wanted it
to be a production piece and to
ship flat. This table breaks down
without any tools into three
pieces. The legs fit together with
a deep lap joint, and the top
twists into its locked position.*

Photo: Lee Fatheree

Kevin Irvin, Phoenix, AZ

Petite Anniversary Cabinet
1997
Ebonized and natural maple,
bronze, 17"w × 11"d × 32"h

*A tabletop cabinet (a smaller
version of a larger freestanding
cabinet). It contains four drawers
with bronze partial figures as
drawer pulls.*

Photo: William McKellar

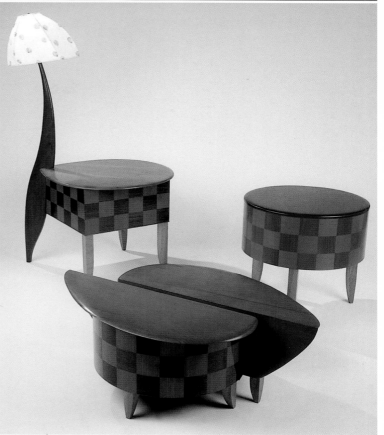

Jack Larimore, Philadelphia, PA

Chapeaux Tables 1998 (limited production)
Mixed hardwoods and veneers
Various sizes around 24"dia

Inspired by the delightful dialog between a hat and its box.

Photo: T. Brummett

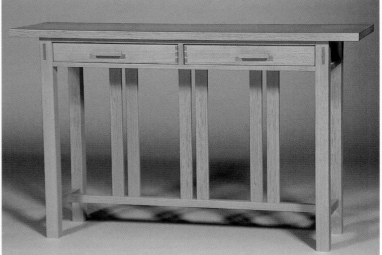

Frank Klausz, Pluckemin, NJ

Corner Cabinet 1997
Mahogany, poplar, crotch mahogany, satinwood, holly, ebony
38"w × 18"d × 86"h

*I designed this corner cabinet to match my Hepplewhite furniture in
the dining room. I framed the gothic arches by replacing the glass
surrounding them with crotch satinwood.*

Photo: Bill Prouty

Alan Powell, Philadelphia, PA

Side Table 1997
Quartered douglas fir, 48"w × 14"d × 34"h

*The warm color of quartered douglas fir drove the design of this table
with matching mirror (not shown). There is a play of symmetry and
asymmetry around the drawer area with through dovetails and mortises.*

Photo: Alan Powell

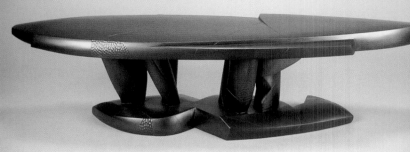

Joël Urruty, Philadelphia, PA

Freestyle 1998
Wood, paint, graphite
72"w × 14"d × 16"h

A massive bench with freedom of form. It was designed as I went along and left black so the viewer can focus on the form.

Photo: Tim Barnwell

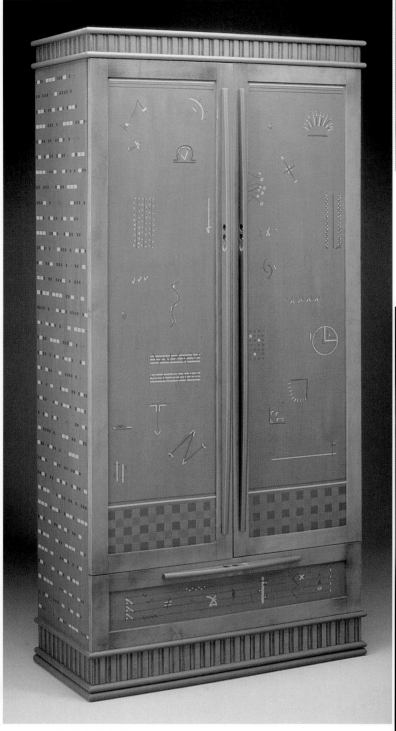

Mark Del Guidice
Norwood, MA

Garden Cupboard 1997
Maple, maple plywood, waxed oil paint
34"w × 17"d × 76"h

Both sides have Morse code translations of sentences about the love of gardening (mine). The front is painted in hieroglyphics depicting elements and aspects of gardening.

Photo: Dean Powell

John Eric Byers, Portland, OR

Siamese Dresser 1997
Milk paint, mahogany, 48"w × 21"d × 74"h

Traditional joinery, french dovetail drawer construction. Each hand-carved square is individually painted with five layers of paint — a minimum of 150 hours in the painting alone.

Photo: Phil Harris

Colin Reid, Berkeley, CA

Jewelry Cabinet 1998
Pearwood with ebony
20"w × 11"d × 54"h

Ten drawers in top cabinet, three below. Top lifts open to another compartment. Side panels swing open for hanging necklaces. Several hidden compartments included. I used only one wood to let the form of the piece have priority, afraid that contrasting woods would confuse the design, becoming too busy. I use surface texture to add a subtle contrast, adding more depth to the work as the viewer gets closer. The texture on the side panels is hand-cut, gunstock checkering.
Photo: Lee Fatheree

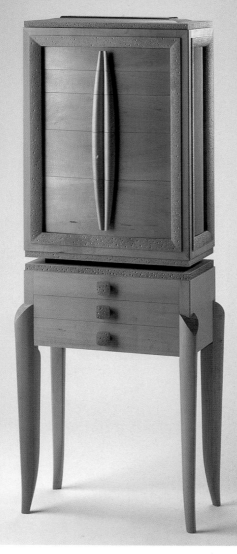

Tina Chinn, Oakland, CA

Cast About 1998
Mahogany, cast and patterned glass, 48"w × 14"d × 18"h

The cast feet on this piece are some of the products of an incredibly inspiring class at Pilchuck. The thrill and challenges of pouring hot glass are quite unlike the usual woodworking experience. It was great to combine the two. Photo: Koichi Hayashi

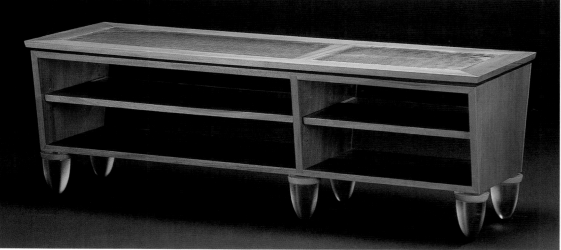

Brent Skidmore; Charlotte, NC

Twin Head Chest 1998
Poplar, bass, acrylic, mirror, maple
31"w × 15"d × 78"h

This five-drawer chest with mirror is the last of six with similar dimensions. African tools and dress served as inspiration.
Photo: David Ramsey

Gallery continues on p. 94

FROM A DISTANCE

■

ROGER HOLMES

■

A former furniture maker surveys what's happened while he's been away, and wonders whether he can afford to rejoin the game

You've heard the tale before: Professional man just shy of fifty gets a hankering to be a woodworker. He pores over tool catalogs, doodles designs for sideboards, and daydreams about living the uncomplicated life of the craftsman. Some friends diagnose mid-life crisis. Others, who have known him longer, suspect an outbreak of repressed idealism, the redemptive urges of a lapsed counter-culturalist. His wife, a practical soul, thinks of the mortgage and the three soon-to-be college-age children and simply pronounces the venture risky.

And what's worse, he's gone through all this once before. He should know better.

Thirty years ago I dropped out of college, set up a shop in an old grocery store and became a furniture maker. Or so I thought. A few months of wrestling with recalcitrant tools and puzzling joinery brought the extent of my woodworking ignorance into sharp focus. So I packed up and went to England seeking the secrets of old world craftsmanship. Fifteen months in Alan Peters' Devonshire workshops gave me a solid technical grounding and introduced me to the rewards, frustrations, and uncertainties of the life of the designer craftsman.

For the next seven years I built furniture in England and the U.S., sometimes in my own shops, sometimes in those of others. By the early 1980s I was ready for a change. I still enjoyed working wood, but I was tired of ending each day with a nose full of sawdust and each week with a wallet full of, well, more sawdust.

So I went to work as an editor, and for almost twenty years I've earned my living making magazines and books. It has been stimulating, often demanding work. It has been reasonably "fulfilling." And it has provided a comfortable living.

Why, I ask myself now, become a bench jockey again? Why subject my fifty-year-old body to work that often taxed me when I was twenty-five? Why start a new career when I was just beginning to think I'd figured out the current one? Why inflict on my family an income that barely supported me when I was footloose and childless? I feel like one of those middle-aged men who abandons his wife and family to run off with a woman half his age.

Seeking answers to these and other pertinent questions, I revisited some of the sources that inspired my youthful enthusiasm, and I've paged

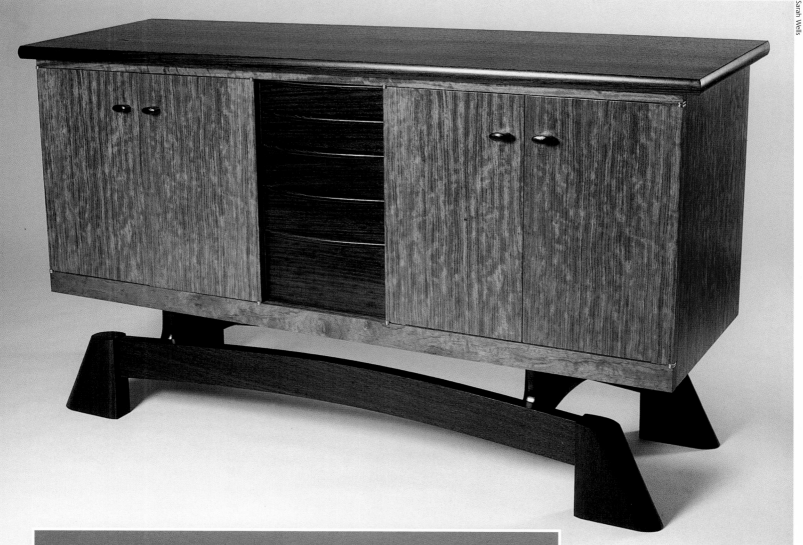

Technical proficiency and an eclectic range of stylistic references characterize today's studio furniture. "My first reaction to current work," says the author, "is how good much of it is." Facing page: Andy Buck's (Portland, OR) Post-Modernist "Blossfeldt Chairs" were inspired by the photographer Karl Blossfeldt; "Wave Buffet" by Robert Diemert (Dundas, ON) strikes a Neo-Classical look. Above, Michael Puryear's (New York, NY) buffet presents itself on more modern lines. And left, Timothy Coleman's (Greenfield, MA) desk and chair, with it's elegant and subtle curves, blends traditional features in a contemporary vein.

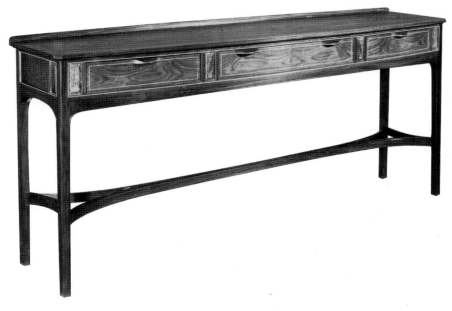

through current magazines and books to see what woodworkers have been up to in my absence. I have found reassurance and invigoration, and I have been reacquainted as well with old uncertainties.

Studio Furniture's Arts and Crafts Roots

My first reaction to current work is how good much of it is. Impeccable workmanship and self-assured designing are evident across a remarkable range of styles. The faded publications of the late 1960s and early 1970s reveal only a handful of established furniture makers who exhibited a similar maturity. Walker Weed, Tage Frid, Robert Whitly, Sam Maloof, Bill Keyser, Jere Osgood, Art Carpenter, Wendell Castle, all combined technical proficiency and sound design, though the work taken as a whole was stylistically much more circumscribed.

In contrast, work of the younger generation of makers starting out in those heady days was all over the place. Page after page of photos record ongoing struggles with material, technique, and form. Few pieces exhibit balance between all these elements. Some feature several good design ideas that don't quite hang together. Others are more coherent designs, but are let down by insufficient technical skills. Two problematic preoccupations stand out. First is an overriding concern with technique. Again and again, pieces are little more than technical exercises. Second is a striving for "originality" with results that range, with too few exceptions, from the merely embarrassing to the truly hideous.

The fascination with technique isn't surprising. Most woodworkers take great pleasure in making things and the mastery of difficult skills is the source of considerable pride. In this, we continue more than 100 years of Arts and Crafts tradition. Like many of us, the Arts and Crafts pioneers of the nineteenth century were middle-class folk whose embrace of craft work was far more than a career choice. My Arts and Crafts heroes, Ernest Gimson and the brothers Sydney and Ernest Barnsley, were promising young architects when, in the 1880s, they fell under the spell of John Ruskin and William Morris. The young devotees' initial furniture designs were, like their architecture, produced by trained craftsmen. But designing alone didn't satisfy them, and they abandoned London and the drawing office for rustic workshops in the remote Cotswold Hills. There they combined the designing and the making of objects, making whole once again a process believed by Ruskin to have been fragmented by the Industrial Revolution with, as both Morris and Ruskin preached, dire consequences for individuals and society alike.

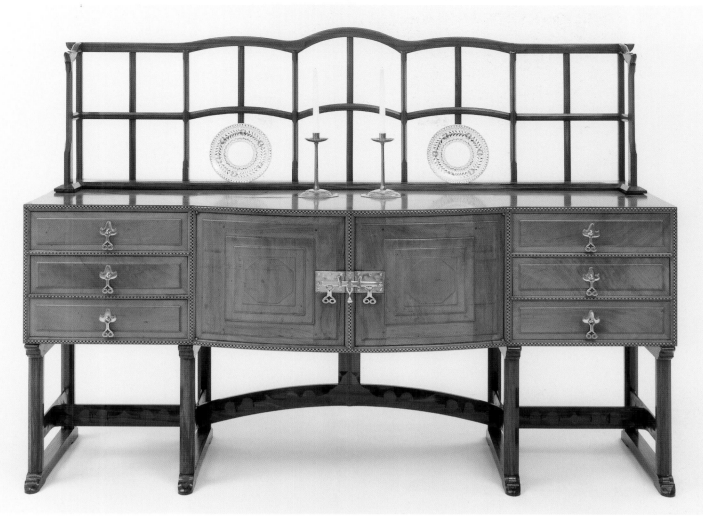

I discovered the English Arts and Crafts Movement early on in my career, while poking through some dusty periodicals in the library of the local university. At the time I was as attracted by the movement's social underpinnings as to the furniture its woodworkers produced. Most of all, I was attracted to the traditional joinery these pieces so proudly displayed. Surrounded throughout my life with mass-produced furnishings and the *Popular Mechanics* constructions of my father and his friends, I was thrilled to see evidence of "real" craftsmanship—dovetails, through-wedged mortise-and-tenons. While my appreciation of the designs was inchoate—I knew I liked the stuff, but didn't really know why—my fascination with the joinery and technical prowess it evidenced was tangible. I knew I wanted to be a craftsman.

I don't think my story is unusual among contemporary woodworkers. Whether directly inspired by the Arts and Crafts Movement or not, making what we design is central to the attraction. And, like Gimson and the Barnsleys, most of us who started in the late 1960s and early 1970s were self-taught craftsmen. Opportunities for formal training were rare then, and even craft programs like those at RIT (the School for American Craftsmen) and Rhode Island School of Design offered nothing like the depth or breadth of a traditional European apprenticeship. Looking back at the early Gimson-Barnsley pieces I am struck by how obviously their lack of technical skills limited their initial designs. These early projects seem formulated to provide a chance for practice or experimentation with this or that technical challenge.

An Armchair Study

Today the challenge to make things well is evidenced in page after page of beautifully constructed work in contemporary publications. In the best, the maker's technical prowess is under the control of the designer's vision. Confident of their skills, these folks have made technique the servant of design, while the breadth and depth of their technical skills has clearly expanded their design vocabulary. The capability to produce furniture of considerable complexity and sophistication is shared by a large number of makers. For them, technique is no longer a barrier, but a gateway.

So, what is all this formidable technique being expended upon? Compared with thirty years ago, contemporary furniture design is remarkably wide ranging. Gone, for instance, are the inhibitions or

These four sideboards illustrate a steady evolution from sturdy simplicity to refined elegance in the work of Arts and Crafts pioneers Ernest Gimson, Sydney Barnsley, and Barnsley's son, Edward, whose careers span more than a century of furniture making. Each of these men had to balance changes in their clients' circumstances and tastes with their own commitment to Arts and Crafts ideals and the pressures of running a viable business. Facing page, from top to bottom, the work dates from 1902, 1924, and the 1960s. The sideboard above was made in 1915.

Sideboard with plate stand designed by Ernest Gimson (1864–1919), made by Ernest Smith and Percy Burchett, 1915 (walnut). Cheltenham Art Gallery & Museums, Gloucestershire, UK/Bridgeman Art Library, London/New York.

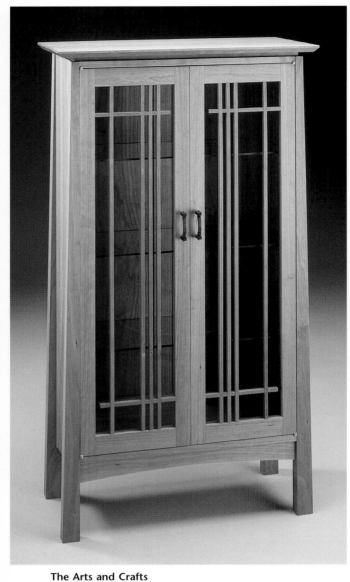

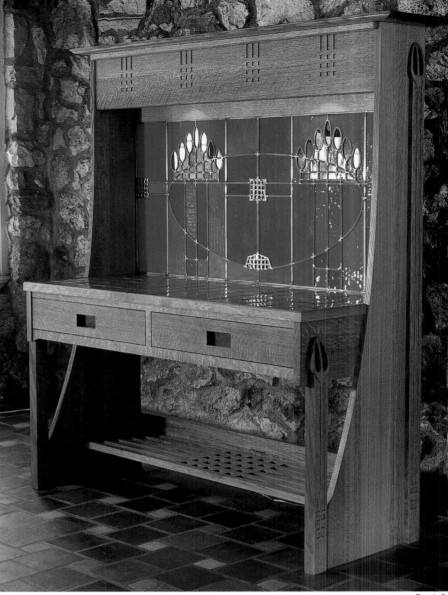

Dennis Grie

The Arts and Crafts tradition is richly reinterpreted in contemporary studio furniture. John Reed Fox (Acton, MA) often incorporates an oriental flavor in his work, as in "Jasmine Cabinet," of cherry and East India rosewood, above. At right, "Argyll Server," oak with leaded art-glass and Chinese Blue Fulper tiles, demonstrates the fidelity to the idiom that Kevin Rodel and Susan Mack (Pownal, ME) observe in their line of new Arts and Crafts designs.

strictures about working in existing styles that seeped into the craft world from the Modern Movement. The premium on originality, inherent in a design ethos that distrusts or rejects the past, has been devalued or perhaps recast in broader terms. Today thousands of years of design history across the spectrum of the world's cultures is embraced, from ancient Egypt to Art Deco Paris; from the courts of Ming emperors to the huts of Fiji Islanders. There is superb work that is indistinguishable from its models. There are more freely interpreted pieces "in the style of." There are pastiches, where the world's stylistic store has been mined, smelted, and recast in new, hybrid forms. There are pieces that invoke the spirit, rather than the tangible form of this or that model. And there are still, of course, "original" pieces, both whimsical and serious, that have less to do with precedent than with a personal vision or a personal response to material or circumstance.

Thirty years ago I wouldn't have approved of

such eclecticism, but today I find much to appreciate and enjoy in a stylish smorgasbord that ranges from Lance Patterson's 18th and 19th century reproductions to Judy McKie's animalian furnishings, from Frank Pollaro's Ruhlmann redux to Daniel Mack's twig seating. In part this is due to the mellowing and broadening effects of time's passage — thirty years have taught me how hard it is to do anything well, let alone to do something extremely well. I am also less inclined to judge work by the immutable yardsticks ("truth to materials" "form follows function") of my youth. Now it seems much more rewarding to try to judge work on its own terms. If form isn't following function in this or that piece, better to ask what it is following and how successfully it does so, than to dismiss it out of hand.

That doesn't mean old favorites don't hold their own. I still find the furniture of Gimson and the Barnsleys (including Sydney's son, Edward) as compelling as when I first happened upon it.

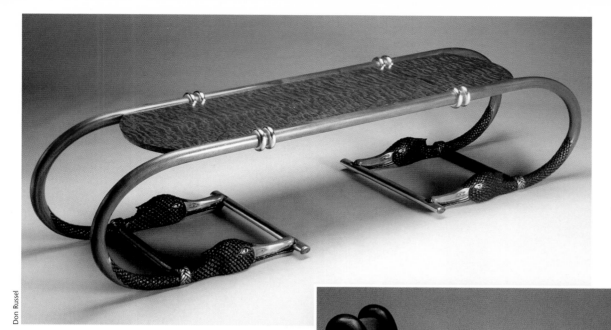

Don Russel

Taking inspiration in imaginative directions: Coffee table, left, by David Marks (Santa Rosa, CA), with carving by Gwen Rosewater, is inspired by Egyptian art. The design for "Ripple" bench, below, by Kim Kelzer (Freeland, WA), began with the choice of fabric.

The attraction of the designs is clearer to me now. It is, as William Morris had counseled furniture should be,

> ...solid and well made in workmanship, and in design have nothing about it that is not easily defensible, no monstrosities or extravagances, not even of beauty, lest we weary of it...well made and well proportioned but simple to the last degree.

Not surprisingly, contemporary work that exhibits these qualities most attracts me. And, again, there is much more of it about than there was thirty years ago. Technically accomplished and stylistically varied, these pieces are, for the most part, functional. They're not showpieces, and they don't demand attention in a room. They are refreshingly free of what furniture critic Glenn Gordon has called the "desperate novelty that marks so much of modern craft."

As for simplicity, few people today would describe Morris's own designs as simple. What he had in mind, I believe, is a simplicity defined by contrast with what he called "state furniture," the extraordinary furniture trophies produced for kings and nobility and, by the mid-nineteenth century, for newly minted barons of industry. In the best contemporary work, what I would call simple pieces exhibit a whole range of subtle touches of form, proportion, and detail, even decorative ones. Simple need be neither bland nor Puritanical. While these pieces don't scream for attention, they do attract it, and it is these subtleties that reward closer inspection once a viewer's eye or curiosity has been aroused.

While Morris's vision of good design wears well today despite the obvious differences in taste between his time and ours, it is clear

K. Kelzer

to all that the world of craft-based socialism he envisioned (and some of us may have imagined in the giddier moments of the 1960s) has not come to pass. Craft workers, particularly furniture makers, exist at the margins of our society, not at its center. The reason is simple. The things we choose to make and the way we choose to make them are time consuming and, if we want to earn even a modest living, expensive. Often very expensive. Craft work is not an option for the ordinary furnishing needs of most people.

"Lateen" chair, of sapele pomele by Janice Smith (Philadelphia, PA), confirms her commitment to furniture design as a combination of sculptural and functional concerns.

Ruben P. Wade

"Ming" armchair, above, by Robert Spangler (Seattle, WA) represents a zesty rendition of an ancient design. "Imelda's Bench #3," below, is Ross S. Peterson's (Hanover, MN) answer to the perennial need for a seat in an entryway to help remove footwear. The piece extols the natural character of the materials and techniques that went into it: white oak left unfinished from the plane.

Ross S. Peterson

This is not news to anyone who has tried to earn a living as a craftsman in the last 100 years. Gimson and the Barnsleys quickly abandoned early attempts to make furniture for the common man. Even working for well-heeled clients, they had to subsidize their workshops with private incomes. Sydney Barnsley's son, Edward, whose shop produced superb furniture for over sixty years, had financial worries for at least forty of those years. I certainly couldn't support myself, let alone a family, on what I earned as a woodworker in the 1970s. And few furniture makers I knew of in England or the U.S. were doing much more than getting by financially.

But seeing all this good work in my tour through recent publications has me wondering if there is a bit more room at the margins than there was. The general prosperity of the past twenty years has certainly provided a large segment of the upper middle class with wads of disposable income. I expect the constantly improving quality and increasing breadth of the work itself has helped to expand the market for it. And the commission process undoubtedly has a lot to do with this. Addressing people's particular needs is the one area where craft furniture makers have an advantage in the marketplace. And judging by makers' comments in the books and magazines, working with clients is a source of satisfaction as well as income.

Reality Check

Having examined past and present in publications and memories, it seemed prudent to see what a couple of live craftsmen had to say about my contemplated career shift. Hank Gilpin and Robert Erickson both started woodworking about the time I did, but they stuck with it. Both are fine designer/craftsmen and hard workers who have managed for many years to support themselves and their families as full-time woodworkers.

Gilpin and two or three employees in his Lincoln, Rhode Island, shop produce about 50 pieces a year, and 30 of these are new ideas in response to client needs. The trick, Gilpin says, is to serve a range of clients from middle class to ultra rich. He didn't have much sympathy for my grousing about how expensive it was to do good work. "We've lost the ability or interest in being creative within a budget," he said. Citing the Shakers among others, he pointed to a long tradition in the U.S. of furniture that provides quality at an affordable price. "There's a niche for folks offering pieces that fit in, things you can just take home and put in a room without readjusting your entire lifestyle."

When I asked what Gilpin thought of my returning to the workshop, there was a long pause

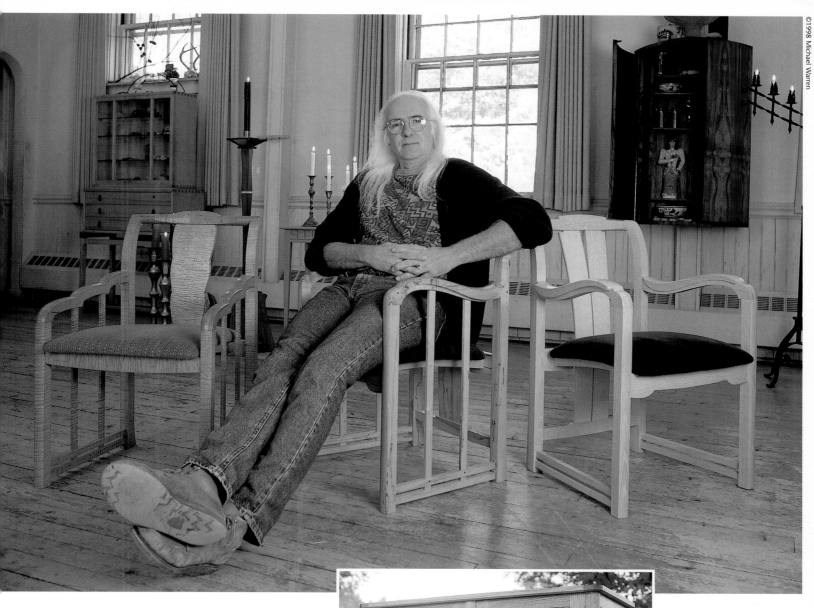

©1998 Michael Warren

on the line. But later in the conversation I was heartened to hear him say he feels there's room for people of modest talent to succeed, "if they are hard working, well organized, good with people, and good with money." Nevertheless, after all these years Gilpin still knows only a handful of people making a real living from craft woodwork; most supplement their income in order to live more comfortably or put the kids through college.

Bob Erickson lives and works on a homestead in Northern California remote enough to require a generator to produce his electricity. It is a lovely spot, graced by a house, shop, solar wood kiln, and other amenities Erickson and his wife, Liese Greensfelder, and various friends have built from scratch over the past twenty-five years. Each year Erickson and five assistants produce about 100 pieces, 90 of them comfortable, handsome chairs.

It isn't difficult to get caught up in the romance of the surroundings, or to assume from them that Erickson's woodworking is a counter-cultural dream come true. Some months ago, Erickson

Hank Gilpin (Lincoln, RI) enjoys a moment in one of his chairs, variations among which constitute an attractive, efficient line. A former photojournalist, he shoots most of his pieces, including the wire-brushed curly red oak armoire at left, on cloudy days immediately outside his shop. His secret as a furniture maker is not to do too much to the wood.

Hank Gilpin

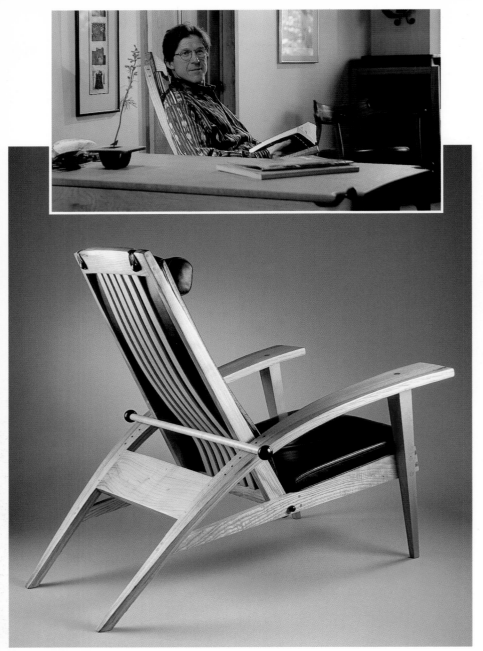

Robert Erickson (Nevada City, CA), along with his five assistants, produces about 100 pieces of furniture each year, 90 of them comfortable, handsome chairs.

found himself at a dinner in Berkeley for Wendell Berry, farmer, poet, philosopher, and advocate of small-scale, low-tech local enterprise. "My work fulfills some of Berry's ideals," Erickson told me, "the scale and hands-on connection with materials, for example. But not others. We couldn't survive selling chairs locally. My market is national. My business depends on the interstate system to get me to shows all around the country and then to deliver the orders those shows generate."

Erickson is a thoughtful, low-key fellow so the scale of his enterprise came as something of a surprise to me. The six to eight shows he does a year take him to places like Philadelphia, Atlanta, Denver, San Francisco, and Evanston, IL. Each show requires at least a week's effort, including preparation, shipping, travel, and manning the booth, and costs $3,000 to $5,000 in out-of-pocket ex-

penses. Five employees, $20,000 to $40,000 dollars in marketing and promotion expenses—this, it seems to me, is serious business.

But it isn't business that Erickson talks about in response to my woodworking urge. He's been treated, successfully, for cancer during the past year, and he talks of how important woodworking has been to his recovery. After all these years he's still enthusiastic, still discovers new things in the work. He finds satisfaction in providing pleasant surroundings and fulfilling work for his employees, who work flexible hours that allow them to pursue other interests. His interests extend well beyond woodworking, and he isn't given to intellectualizing about design. "Woodworking is an honest way to make a living, and it does have political aspects for us old counter-culture folks," he says. "It's still a satisfying process, one that I can find interest in and feel good about at the end of the day."

So, what have I learned? Craft woodworking has undergone a remarkable development and maturation over the past thirty years, expanding its horizons and, it seems, the number of makers plying the trade. It is encouraging to see so much good work. In an odd way, it is also encouraging to see so much bad, or at least mediocre, work. If there's a market for all this, the bad and the good, maybe there's room for whatever I can produce.

It is reassuring to hear from long-time practitioners that they still enjoy what they do. We ask a great deal of our work. We expect it to interest and stimulate us, to provide emotional and spiritual satisfaction. We want it to mean something

David Harrison

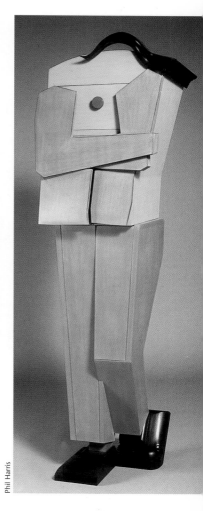

Stephen Webster

Phil Harris

in the larger context of our communities. Is this reasonable? I sometimes try to imagine the look I'd get posing these thoughts to a journeyman sweating away in Thomas Chippendale's shop.

What am I going to do? The question turns on much the same points as it did thirty years ago: woodworking's many rewards—tactile, emotional, even spiritual—held in balance by its uncertain financial prospects. My age adds an extra twist, but I suspect things appear much the same to many would-be or erstwhile professionals today. My recent work in the shop engenders a peace of mind that has been missing for a number of years from my office work, so I intend to pursue it. All that good work out there indicates that prospects for woodworkers are as bright as they've been in years. But recent experience reminds me that extrapolating from the general to the specific can be risky. Of the half-dozen potential commissions for which I've prepared designs and estimates in the the past three months, two have fizzled out, erasing some $7,000 I'd tentatively penciled in on the right side of the workshop ledger. My return to the business of woodworking will have to be gradual. Perhaps I'll never manage to muster the nerve, the determination, or the combination of skill, hard work, and business acumen of Bob Erickson or Hank Gilpin. But, though my younger, more idealistic self might not have agreed, there's nothing wrong with being a part-time woodworker. All things considered, having the opportunity to be a furniture maker at all is enough. ∎

COMMISSIONING

■

MARGARET MINNICK

■

The rewards of custom furniture are not about price, only partly about materials, style, or function — they're about shared values, personal relationships, and private pleasures

Eric Griswold Studio

Commissioned furniture can include nice touches like these carved wooden pebbles, added to an end table by Jennifer Schwarz to remind her clients of walks on the beach.

Many buyers find their initial attraction to commissioned furniture is purely practical. Frustrated by limited choices in the commercial market, clients are delighted to find that they can specify exact dimensions, material, or function in a piece that will be made to quality standards that mass production cannot match. Although practical considerations first bring customers into the world of studio furniture, these factors often recede in subsequent commissions. Clients simply fall in love with the wide possibilities offered by studio furniture, and as they do, practicalities move down their list of criteria to take a place alongside artistic expression and social relevance.

This essay summarizes interviews I conducted among buyers of custom-made furniture in the Pacific Northwest, with the goal of unearthing reasons that propel patronage. The interviews show that studio furniture reaches well beyond utilitarian needs, to embrace an enormous range of symbolic statements. A dining table carries a tableau of cultural connections that stretch well beyond the object itself.

Interior furnishings have always borne cultural connotations. In wealthy colonial households, carved mahogany Chippendale-style parlor furniture spoke volumes about the status of its owners. Printed pattern books from Europe helped householders communicate up-to-date styles to local craftsmen. Burgeoning world trade provided exotic hardwoods and prestigious imported furnishings. In typically blatant displays, visitors were able to assess a household via its furniture forms, upholstery, and the quality of carving on crest rails or chimneypiece. Clues carried by the

silver, porcelain, or wallpaper made the message ring clear as a trumpet.

Eighteenth-century furnishings set a stage for these owners in ways we might envy today. While a householder of our time might own a real tour-de-force of joinery and fine veneers, it wouldn't be enough to boost his social status. Our social barometers read a different set of props, a flashy Ferrari, for instance, parked out front. Yet people continue to commission handmade furniture.

Status surely is a factor in contemporary commissions, though it is more veiled than in earlier times. Status today implies value statements, which in turn reveal multiple textures in our social fabric. Furthermore, the matchmaking between client and craftsperson often embodies creativity of its own. At its best, it results in a pleasing partnership that balances the level of sophistication each side seeks in the project. It runs the gamut from pragmatic solutions to hopes for art in its purest form.

As the following examples show, the commissioning process is fluid, and all parties see their visions take tangible form. Like other matchmaking processes, it blends utility with hope, desire, and beauty incarnate. In so doing it reveals layers about ourselves and our society.

Practicality and Shared Social Values

Handmade furniture represents custom furniture at its most custom. This flexibility is what introduces many clients to studio furniture. After being frustrated by limited choices, lackluster materials, and uninspired workmanship, clients express grateful relief in finding a competent craftsperson who can build what they want. Usually the maker's portfolio acts as a springboard for the commission,

The Finish

Our furniture is finished with a special mixture of Tung, Linseed, and other penetrating oils. Application of this clear oil by hand brings the natural beauty of the wood to life. The oil finish is durable and requires little upkeep over the years. Some woods in this catalog may very in color. This is due to the natural aging process. You will find the wood acquires more character with time.

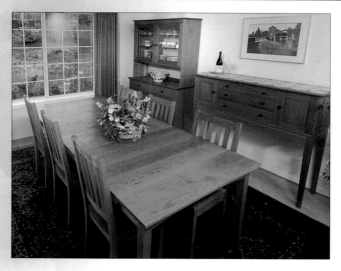

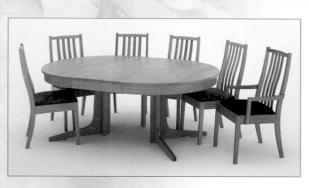

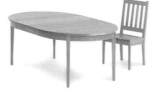

Top right: Arts & Crafts Chairs – Cherry; Shaker One Leaf Extension Dining Table - Cherry; Rubino China Cabinet – Cherry; Sheridan Sideboard – Cherry

Bottom left: Round One-Leaf Pedestal Extension Dining Table – Cherry; Contemporary Chairs – Cherry

Bottom Right: One Leaf Oval Dining Table – Cherry; Fishburn Chair – Cherry

Many small furniture-making firms publish excellent brochures and catalogs showing standard designs that clients can modify to suit their own needs. Such practicality often introduces people to the world of studio furniture.

Catalog courtesy The Joinery, Portland, OR.

which frequently incorporates variations of a previous design. Customers report high satisfaction with these works, citing integrity of craftsmanship, durability, and beauty of materials as major attractions. They take pride in their own good judgment for choosing the maker and the piece, which in turn feeds their pleasure of ownership. Important aspects of these commissions are accessible prices and reasonable delivery schedules. This kind of maker-buyer relationship rarely includes discussions of design theory but centers instead on more straightforward, utilitarian concerns such as size, finish, and materials. Makers who develop a line of limited-production furniture match this clientele very well.

A physician couple in Portland, Oregon, who own an extensive collection of studio furniture, provide a good case study. They continue to marvel at the straightforward beauty of the work by Marc Gaudin, who introduced them to handmade furniture and whose company, The Joinery, creates a line of streamlined, craftsman-inspired, solid-wood pieces. The Joinery manifests the best of the Oregon ethos: sustainable forest products, generous employee benefits, a high priority for community outreach, and a loyal, interdependent work force. Although the physicians' dining table and sideboard feature particularly beautiful Oregon walnut, their satisfaction springs not just from

the furniture itself. They also admire the socially responsible, common sense approach that permeates all aspects of its fabrication.

Many commissions are extremely personal. Satisfied patrons recall a creative spark in the process, a quality that took tangible form in the furniture itself. At its best, the finished commission expresses the artistic spirit and philosophic values of both maker and buyer, and becomes a pleasant reminder of all that went well in the process.

Simpatico

Commissioning furniture involves more than specifying and buying objects. A commission entails an interaction rooted in mutual respect. Furniture, particularly commissioned furniture, expresses the character and the relationship of the people behind it. Buff Winderbaum, a Seattle office furniture retailer, chose to work with furniture maker Judith Ames after studying her gallery portfolio, where rhythmic, lyrical lines characterize almost every design. During their preliminary interview he was struck by the way Ames looked at life and how she put heart into her work. He finds it a pleasure to have a piece of furniture designed by such a person. They collaborated on the ergonomic features of a chair, which has a wind-swept, cloud-like look. The components of the chair's maple

Art gives soul to a home, and furniture helps shape its very definition, showing who we are and how we view the world.

◼

Mary Chalker, furniture patron

frame curve both in profile and in section, the domed, swelling surfaces carrying through all the joints and transitional details. Ames wants her designs to be harmonious, to maintain a particular feeling that transcends technical solutions. Although the client stresses that the design is completely Ames', he nonetheless feels that his two cloud chairs and matching ottomans represent his own distinctive taste. By choosing the right artisan and giving her an appropriate commission, he reinforces his own identity. In this way commissioning adds another dimension to personal connoisseurship, the collector's connection with maker as well as object.

Buff Winderbaum enjoys the harmonious curves of the cloud chair and ottoman that Judith Ames made for him.

Another of Ames' clients, an architect, takes pleasure in the way the construction details of a commissioned desk echo furniture by Alvar Aalto. The desk also features cubbyholes and trays like those found on antique furniture.

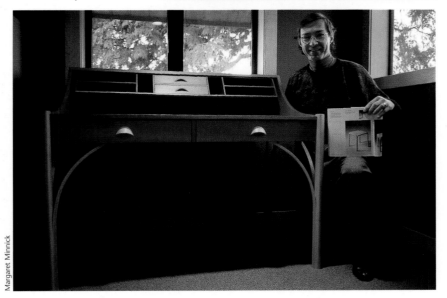

Historic Echoes

Some people commission because they like to play with an idea that echoes cultural history. Roger Wallace, a Seattle architect who admires Alvar Aalto, found in the split-mitered construction of Judith Ames' work an intriguing update of Aalto's laminated birch stools. He says, "I've always loved Aalto's ability to combine soft curves within rectangular buildings. Ames' desk is slightly concave, which she reinforces with bent laminations in a more pronounced radius in the legs." The desk he commissioned also has cubbyholes reminiscent of eighteenth-century secretaires. He enjoys how the piece skips across the centuries, linking several generations of design history.

Familiar, historical furniture forms can be a pattern for replication or a springboard for a contemporary interpretation, depending on the artist and the commission. People commission an object that is beautiful and meaningful for them. Its layered associations depend upon the background of the buyer and his or her own understanding of what tradition means.

Community Attachments

Furniture commissions build community. A Portland couple remodeled an old family house, keeping their mishmash of shabby furniture in the upgraded space until they could afford to commission studio furniture. This ongoing process has stretched across several years, becoming a backdrop for several joint commissions by a Salem woodworking team, Michael and Rebecca Jesse, and wood sculptor Tom Allen from nearby Silverton. Jesse Woodworks creates the casework, which features Allen's decorative panels. The clients are not interested in antiques, though they do want furniture that will last a long time, in accord with the emotional ties they have with their grandmother's remodeled house. By choosing local artists they make several strong statements. They feel they are strengthening community bonds, which are threatened by the frenzy of modern life. "Much of what connects a community is gone now," they say. "Yuppies drive from work into their garage, close the door into home. They don't go to church. There's no family day. Sunday is a way to extend your work hours or get your laundry done. So the connected things in a community—church, family day, things that are really critical to our nature—are dissolving." Commissions build social connections, they find, and they enjoy having things in their home that address this fundamental need. The clients also admire the values manifested in the lives of the artists. Living with the work brings that spirit into their home while at the same time supporting the woodworkers in theirs.

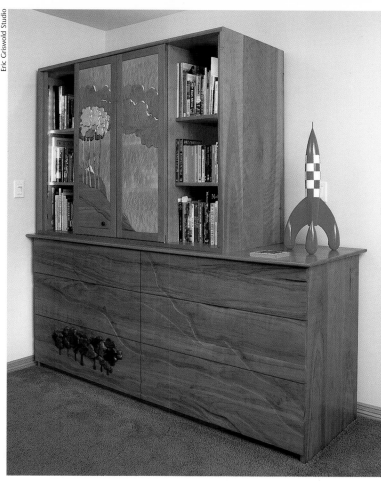

Sculptor Tom Allen sketches the imagery he'll inlay and carve across the front of the bedroom furniture built by Jesse Woodworks. The artists' comfortable collaboration reflects the clients' social values.

That their most spectacular pieces are in the most private space, the master bedroom, fits with another value of this couple. They eschew visible ostentation. Their house does not crown the hill or shout from the street. It is only when you step inside, particularly to the inner sanctum of the bedroom, that it knocks your socks off. All four walls have Jesse-Allen collaborations, a series of landscape rhythms in a variety of woods. Trained as a graphic designer, Allen uses the innate colors in wood to compose semi-abstract landscape scenes in a technique he calls "sculptural marquetry." The clients established functional specifications, but left the makers free to interpret the commission. The preparatory sketches reveal how ideas germinated and how open communication between all parties resulted in success. The clients feel they have their own personal treasure, on display to an audience of two.

Ebb and Flow

A number of clients find they get more from a commission by specifying as little as possible. They might give bare functional requirements but then happily step aside. A software designer voices this sentiment: "Everything I design is intangible, so I love furniture for its tangible elegance. However, if I were to inject my influence, I'd get a lesser product."

Jennifer Schwarz received a commission to make a set of end tables that would remind the owners of walks on the beach at low tide. This somewhat daunting assignment allowed Schwarz to push a creative solution that ended up meeting all requirements with humor and panache. The owners feel amply rewarded. They are delighted with her solution of three small tables that recall both the seashore and their affection for the artist.

Jennifer Schwarz was asked to evoke a walk on the beach in the design of this end table. She solved the problem with a soft shape like a tidal pool, with carved "rocks" embedded in the wood surface (see detail, p. 68).

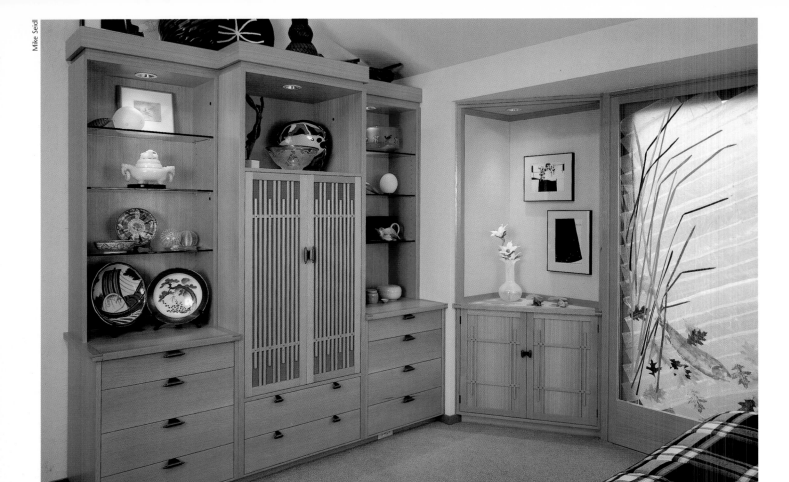

Mike Seidl

The understated elegance of this bedroom furniture by Ross Day creates a quiet sanctuary for the client.

Desk and chair by Stewart Wurtz sit quietly in the bedroom — a private gem.

Chris Eden

Good Design, One Room at a Time

Personal sanctuaries can counteract outside chaos. One Seattle client uses her bedroom suite by Ross Day as just such a refuge of calm. Built of maple and French oak, the meticulous craftsmanship reveals itself in delicate proportions and gliding drawers. The furniture is a pleasure to see and to use. The client finds popular taste profoundly unsettling. She deplores our culture's strip-mall mentality, because she feels people react unhappily to an ugly environment. Consequently, she has made her home a retreat, a place to reenergize and settle, where things are not whirling out of control but are focused in excellence. Rather than try to conquer all of society with good design, some commission it one room at a time.

Private Eye

Collecting reflects a personal aesthetic that's often quite private. A philanthropist in Seattle, who has been commissioning furniture by Stewart Wurtz for the past ten years, identifies his first purchase as a museum-quality work of art. It's a desk of figured maple and ash that stands in the master bedroom, crowned by a vase of flowers. The household art collection includes paintings, sculpture, and photographs. When the owner gives tours, he finds that only a few visitors notice his furniture, leaving him to enjoy his connoisseurship in private.

Wurtz's designs converse with Wegner chairs and Biedermeier antiques. The client enjoys these allusions, giving Wurtz the freedom to interpret without restraint, "because Stewart has always exceeded my expectations. It's incredible when he brings over his things."

Rewards of Risk

The nirvana of woodworking commissions is one that gives free rein to the artist. Most furniture makers could specify the exact circumstances and budget for this dream situation, although only a few ever get to do it. The client must have a lot of trust and faith to grant such freedom.

The wife of a computer software engineer in Medina, Washington, commissioned Jonathan Cohen to make a fortieth birthday present for her husband. Having worked with the artist before, she left the specifications to him. The couple feel that in Cohen they have found a modern master who does best without restraints.

Cohen says he paced and worried before sitting down at his sketching table. Knowing that the client liked dark wood, he drew in heavy black lines. The result is a large cabinet of ebony and quilted maple with gold hardware. It has secret locks and magnetic switches that control interior lighting. It embodies a number of things the artist had never done before. Cohen says the difficulty of the task lay in trying to make the piece powerful, lavish, and rich, without it becoming disgusting, gross, or gaudy.

Commissions engender opportunity. At an introductory meeting, Stewart Wurtz found his clients had only vague ideas for a dining table. He risked showing them a rough sketch of an idea that had been rattling around in his head. They could see the spark, so they took the chance: they gave Wurtz complete freedom to explore. As a result, the artist pushed further and feels his clients got much more. The design combines the sculptural play of the top's offset segments with experimental stretcher details that express tension and movement. The clients were richly rewarded for taking the risk of allowing Wurtz to try a new idea. ■

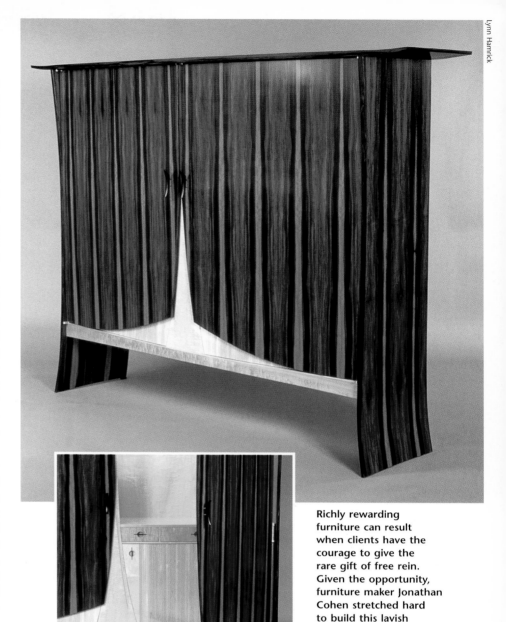

Lynn Hamrick

Richly rewarding furniture can result when clients have the courage to give the rare gift of free rein. Given the opportunity, furniture maker Jonathan Cohen stretched hard to build this lavish cabinet, made of ebony and figured maple with gold-plated hardware.

Terry Reed

The client of Stewart Wurtz bet on a simple sketch, and received this handsome table of curly maple, bubinga, and ebony.

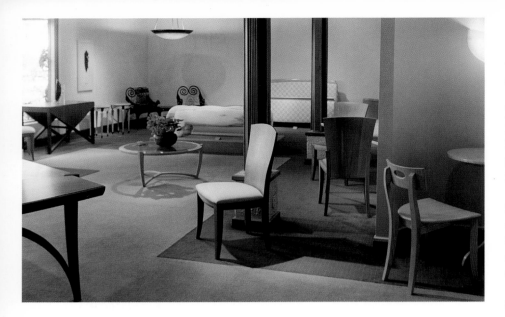

WHERE TO FIND IT

JOSH MARKEL

■

All of a sudden, it's a lot easier to buy furniture that might speak to you

Galleries represent a traditional venue for studio furniture. Above: showroom at Pritam & Eames in Easthampton, NY, features the work of William Walker and Thomas Hucker, among others.

Aside from hunting down individual makers, there are three primary ways to purchase studio furniture: through galleries, at shows, and via some interior designers. A new path, through the Internet, is also emerging.

Galleries

Ever since the renaissance in furniture making began during the 1960s, new galleries have sprung up devoted either to studio furniture or to a mix of studio furniture and other crafts. Rick Snyderman, a Philadelphia pioneer who is now selling furniture and art objects as the Snyderman Gallery, sees his role as educational, to develop interest in handmade objects. Once potential clients have had their interest stimulated, the gallery director matches each client with the artists he represents, usually by studying photos, but sometimes including visits to artists' studios.

Like a good broker or lawyer, the gallery helps create a sense of security around the purchase, Snyderman says, and adds order to the marketplace by helping set prices, deposits, and design fees. Galleries must feel confident that their artists aren't also selling their work directly for lower prices. As a result, clients can be confident that

when they spend $1000 here, they won't see the same piece elsewhere for half or double the price.

Warren and Bebe Johnson run the Pritam & Eames Gallery in Easthampton on Long Island. In its nineteen years of existence, Pritam & Eames has championed functional elegance in studio furniture, while many other galleries have moved toward furniture that doubles as sculpture.

The Johnsons feel that galleries built the market for studio furniture by creating a permanent display space for it. "Clients have to see and learn the language," Bebe Johnson says. "Furniture is never a quick sale, so you need a place people can return to."

The Johnsons also note that most clients are more comfortable negotiating with someone other than the maker. This distance allows clients to compare the work of one artist with that of another, and to ask questions they fear might seem simplistic or insulting if put directly to the artist.

John Elder of John Elder Gallery, a successor to the Peter Joseph Gallery in New York, mentioned the role of galleries in assuring the collectibility and worth of the work represented. Galleries keep close track of trends in the art market, as well as of the price history of work by artists they represent.

Galleries earn their commissions (usually in the neighborhood of fifty percent of the retail price) by investing time that the artist doesn't have to market the work, and by making appropriate marriages between artists and clients. From the client's point of view, the gallery is being paid to arrange for and vouch for many aspects of the sale, including such details as shipping and adherence to deadlines.

Furniture Shows

Jack Larimore, a furniture maker for more than seventeen years who has marketed his furniture in many ways, says there has been a shift in the way people buy studio furniture. In the pioneering days, part of the joy of collecting came from finding new, unknown artisans and helping them launch their careers. Adventuresome clients were willing to endure uncertainty about the very matters that gallery directors pride themselves on eliminating. For clients who still feel this kind of self-confidence, shows have become a new route to purchasing studio furniture.

A few general craft shows, like the Baltimore Craft Show sponsored by American Craft Enterprises, have become so large that a significant number of studio furniture makers take part. The 1998 Baltimore show saw retail and wholesale furniture sales of close to $360,000 by some twenty-five artisans. While some furniture makers have found showing at craft shows to be a vi-

able way to market, many have felt swamped in a sea of ceramics, jewelry, and wearables.

The last ten years have seen the birth of shows that more specifically attract customers for studio furniture, and offer them the critical mass of goods necessary for making intelligent selections. In May of 1989 the International Contemporary Furniture Fair opened at the Javits Center in New York. This annual show combines studio furniture makers with design-oriented foreign manufacturers, in roughly equal proportions. It is targeted largely at interior designers and architects, with one day of the five-day event open to the public.

In 1995 the Philadelphia Furniture and Furnishings Show became the first retail show in this country dedicated to studio-made objects for the home and office. In 1998 about 250 exhibitors sold nearly $3.3 million worth of work through this three-day show.

A smaller but similar show, Fine Furnishings Providence, seems to be carving out a niche for contemporary interpreters of traditional furniture design. In 1998, the show's third year, there were 120 exhibitors.

In San Francisco, the California Contemporary Craft Association holds juried shows of work by its members and friends. This show of about seventy-five artists is held every other year and is predominantly furniture. The association is the successor to the Baulines Guild, famed for its furniture apprenticeship programs.

Shows have several obvious advantages. Nowhere will the potential client find a broader selection of work to choose from. Most artists represent themselves, so shoppers can meet them and discuss the furniture with them. For buyers willing to trust their own tastes and who have good instincts about the reliability of the maker, this setting is ideal. The downside is that shows are here for a few days, and then they are gone.

One interesting difference between shows and galleries is the type of objects each tends to encourage. While there are no rigid boundaries, galleries tend to show work that is more like sculpture, which legitimates its collectible place in the art world. Shows seem to be more about objects that emphasize the aesthetics of use and function.

Studio Open Houses

Individual furniture makers and small firms have always held periodic open house events, and lately small groups of artists who share shops or have access to gallery space have banded together to do local shows. For example, in May of 1998, the Chicago Furniture Designers Association took over the display windows of a major Loop department store, showing furniture groupings, suites, and office ensembles. In the fall of 1998,

a dozen makers showed together at a shop in Philadelphia known by its address, 1102 E. Columbia Ave. These kinds of shows often emphasize a theme—the Philadelphia show featured drawings and photos illustrating the evolution of objects being made.

San Francisco has supported this marketing model by sponsoring "Open Studios" tours every fall for the last fifteen years. The city gets funds for this effort from a hotel tax, which is used to promote tourism. The event spans five weekends.

Richard Judd, a Wisconsin furniture maker who specializes in formally elegant modern design integrating parquetry, has gone one step further than the studio show. He has turned a 12-by-30-foot office space connected to his workshop into a gallery featuring both his own work and that of other artisans.

The Internet

The Designer's Source Book is a sales vehicle published by a Wisconsin company called The Guild. Approximately 200 craft artists pay for photo spreads and recently the Guild has added free print listings for another 500 artists. Perhaps twenty percent of those shown are furniture makers. As the name implies, the Guild's source book is marketed primarily to the design community.

Now these same publishers have launched www.guild.com, the same kind of visual resource on the Web, but with the difference that items displayed will be available for immediate purchase via secured credit card transaction. Toni Sikes, head of the Guild, believes that people soon will jump to Internet sales in the same way they once turned to catalog shopping.

An increasing number of individual makers have their own websites. These feature pictures of current work as well as contact information for sales or commissions. To locate these, besides the general search engines, there are a number of linking sites, not least of which is the website maintained by The Furniture Society. ∎

The internet represents the newest venue for studio furniture. Above: a snapshot of maker John Hein's website. A listing of galleries and contacts for current information on shows, as well as an extensive listing of furniture makers, is published in The Furniture Society's Membership and Resource Directory and at www.avenue.org/Arts/Furniture

EMBEDDED ENERGIES

■

LOY D. MARTIN

■

*An illuminating tour of
the Dorothy and George Saxe
collection reveals the manifold
relations between art and
everyday life*

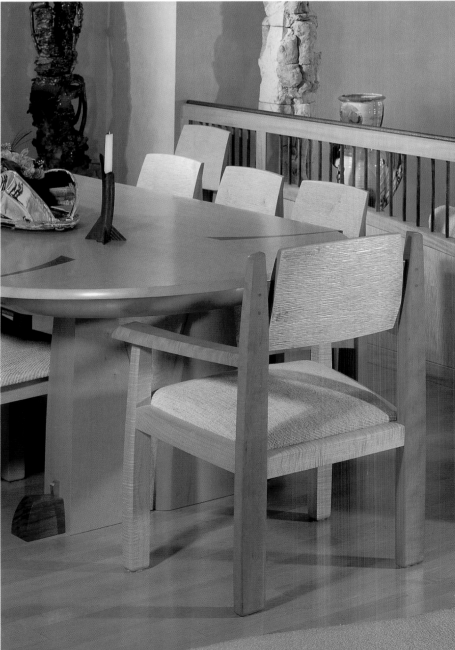

Mention the names of Dorothy and George Saxe to anyone conversant with the world of art and craft and you are likely to get a predictable response: "Oh yes, they're the people who collect glass." It puzzles the Saxes that so few know of their collections of ceramics, fiber art, turned wood vessels and studio furniture, but it seems the world has given them an identity: "The Glass Collectors." If you want to see the Saxe glass collection, you must go to their apartment in San Francisco; the rest you will find in a spacious house thirty-five miles to the south, where they now spend most of their time. If you are especially interested in studio furniture, as I am, that house provides one of the best venues anywhere for understanding what this art form is all about and how it fits into our culture's main mode of art consumption: the art collection.

For the Saxes, it seems there is virtually no separation between life and collecting. Collecting is what they do. Large, spectacular pieces of ceramic sculpture preside over a home filled in every corner with smaller ceramics, beautiful textile hangings, wood turnings, and hand-crafted furniture, each piece chosen with passion, deliberation, and focus. Their art chronicles a life at all times fully attentive to the present moment: selecting, sensing, evaluating—according the highest seri-

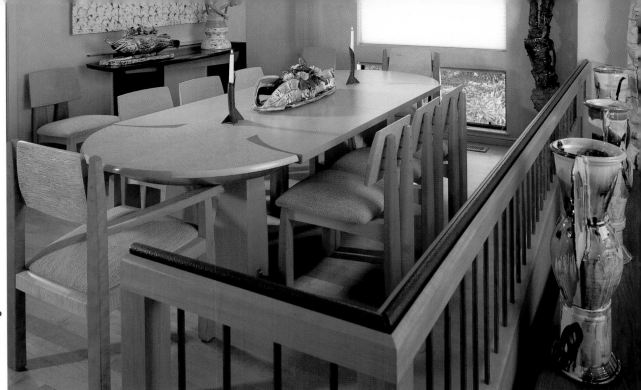

The door to the Saxe home, made by Al Garvey (Fairfax, CA), opens into a large entry space flanked on the left by a formal dining area. The dining table and chairs, by Gail Fredell (Aspen, CO), are complemented by railing, also by Fredell, and a colorful sideboard by Wendy Maruyama (San Diego, CA). The sunken living room includes "Conservation" chair by John Cederquist (Capistrano Beach, CA), a coffee table by Garry Bennett (Oakland, CA), a chair by Sam Maloof (Alta Loma, CA), and a coffee table by Wendell Castle (Scottsdale, NY).

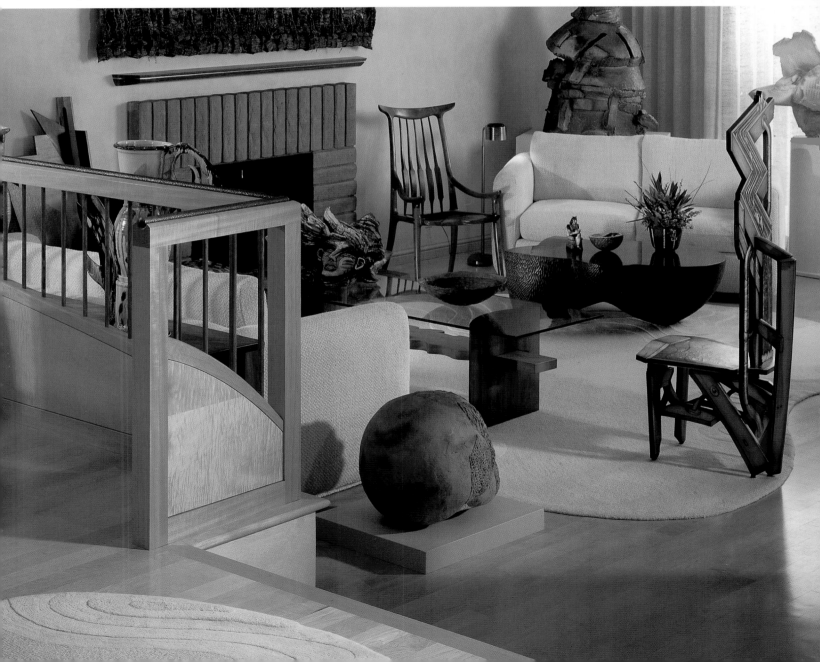

Viola Frey's ceramic "Observing Man II" stands watch over the stairs to the living room and lower floor.

■

Relationships among objects help us to recognize the different "kinds" of art, and those relationships are created as much by the culture of consumption as by the culture of production.

■

ousness and respect to makers and their work. I went to their house to see furniture and other crafted objects. What I actually experienced was something much more complicated, a subtle set of interactions among works in different media and between those works and the daily events that flow around them.

An Aesthetic Disposition

The door that opens to George Saxe's big warm handshake was made by Al Garvey. You might not even notice that door, it seems so much a part of the house, an unpretentious brown-shingled structure settled comfortably into the low hills of suburban Menlo Park. The house makes no particular architectural statement; it was built by carpenters and plumbers and electricians like any other house. But the door was made by Al Garvey. His name is not exactly common currency in the sophisticated art world, but if you're a woodworker, and you've lived in Northern California, Al Garvey is as familiar a name as Art Carpenter or J.B. Blunk or Dale Holub. So right away you're introduced to a simple principle: distinguished works of art are inseparable from the house itself.

Step inside. Art is everywhere, and its presentation is dramatic. The first thing that caught my eye was a nine-foot-high cartoonlike ceramic sculpture of a man in a suit and tie by Viola Frey. The figure stands slightly off to the right in a small enclosure created by a railing separating the entry hall from the well of a descending staircase. Straight ahead, two steps lead down to the living room where, even from a distance we can already recognize a chair by John Cederquist and, all the way at the far end, another by Sam Maloof. Slightly to the left, open to and on the same level as the entry, lies the Saxe's dining space which features a massive dining table and sturdy, almost totemic, chairs by Gail Fredell, complemented by a colorful Wendy Maruyama sideboard. The railing that separates this dining space from the living room continues the design of the stair railing on the right side of the entry. These railings were also made by Gail Fredell as part of a single commission that included both the furniture and the architectural detailing.

It's worth pausing here, as an important principle of the way the Saxes "collect" studio furniture unfolds. For them, a furniture acquisition is not necessarily an event defined by one individual object. It may chiefly be concerned with the relations among several pieces, and that logic may carry even beyond furniture. The French word for furniture, *les meubles*, reminds us that a piece of furniture is, in its essence, a discrete movable object as opposed to a building (*immeuble*) which is fixed, attached to the earth. But in the Saxes'

house the boundaries of furniture as art cannot be confined to "movable" tables and chairs, beds and chests of drawers. As the Garvey front door intimates and the Fredell commission confirms, the work of artisans freely denies the traditional distinction between the art object and the architectural structure that contains it. Gail Fredell's choices in design vocabulary, arrangement of positive and negative space, materials (light woods complemented by details in copper) and technique (the contrast of polished with textured surfaces on both the chair backs and the hand rails) make an unmistakable claim that we are not to view the furniture as a wholly different kind of thing from the structures that define rooms and outline staircases. When I chatted with George and Dorothy Saxe about how their interest in studio furniture grew, I began to understand some of the meaning of this implicit fusion.

The Saxes collected glass and art in other media before they began collecting studio furniture. Indeed, it is with some hesitation even today that they refer to their furniture as a "collection." Dorothy Saxe recalls, "I don't think we ever intended to 'collect' studio furniture like we did the other material." They first enlisted the services of a wood craftsman to display their ceramic objects. After that they began to replace their mass-produced furniture with pieces that they regarded as works of art, eventually concentrating on the work of well known studio furniture makers: Sam Maloof, Wendell Castle, John Cederquist, Judy McKie, Art Carpenter, Thomas Hucker, Garry Bennett, and others. Their pieces from these makers are extremely fine. I can think of at least four cases in which the Saxes own the best example I have seen of a particular maker's work.

So perhaps we can say that the Saxes' interest in furniture evolved out of the need to solve a practical problem toward what Pierre Bourdieu has called an "aesthetic disposition." For Bourdieu, this aesthetic disposition is essential to the practice of collecting, a form of play, and is antithetical to what he calls "urgency," the mode of acquisition primarily driven by material need:

The aesthetic disposition, a generalized capacity to neutralize ordinary urgencies and to bracket off practical ends, a durable inclination and aptitude for practice without a practical function, can only be constituted within an experience of the world freed from urgency and through the practice of activities which are an end in themselves.

In conversation, the Saxes insist on the requirement that their furniture be "functional," yet it's clear that, for them, the process of acquiring furniture has progressed from a condition of "ur-

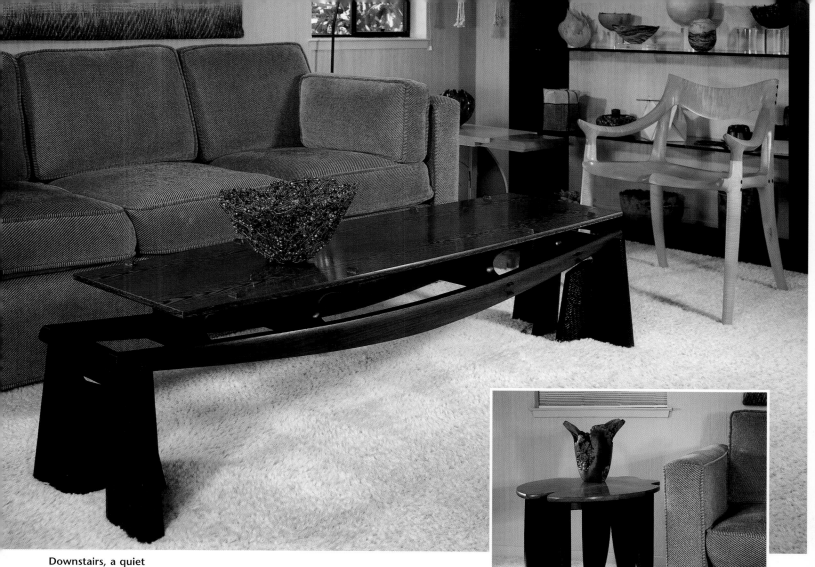

Downstairs, a quiet sitting area is furnished with a coffee table by Thomas Hucker, a side chair by Sam Maloof, a colorful table by Billy Al Bengston and a table with five legs (inset) by Roseanne Somerson.

gency" to one in which collecting itself has become, in Bourdieu's terms, "practice without a practical function." While the Saxes' display cases present their collection more effectively than available mass-produced shelving could, the tables by Thomas Hucker, Rosanne Somerson, and Billy Al Bengston that surround the sofa in the downstairs den perform no service that a mass-produced table would not perform equally well. The former acquisition was directed largely by "urgency," the latter by "aesthetic disposition." If this is so, however, why does the same aesthetic disposition that distinguishes the studio furniture from the mass-produced sofa and the turned bowls from their showcase not equally separate the tables and chairs in the dining room from the "practical" front door and architectural railings nearby? Why is the entry/dining room a different kind of scene? The reason is that we have moved away from the familiar (and by now impoverished) questions about "function" as a defining attribute of the furniture object itself to a discussion of "practical function" as a part of the motives or intentions of the collector. This tactic complicates matters by bringing the psychology of acquisition—or what Wolfgang

Iser and others have called the "aesthetics of response"—into our notions of artistic genres. But it also liberates us to investigate a new set of terms for relating studio furniture to other art forms. It allows us to say that relationships among objects help us to recognize the different "kinds" of art and that those relations are created as much by the culture of consumption as by the culture of production.

Embeddedness

When my tour of the Saxe's home arrived at the master bedroom, I discovered what I consider the finest piece in their furniture collection, the king-sized bed designed and made by Colin Reid. For some years I have admired Colin Reid's work, his fine sense of proportion and weight, his sensitivity

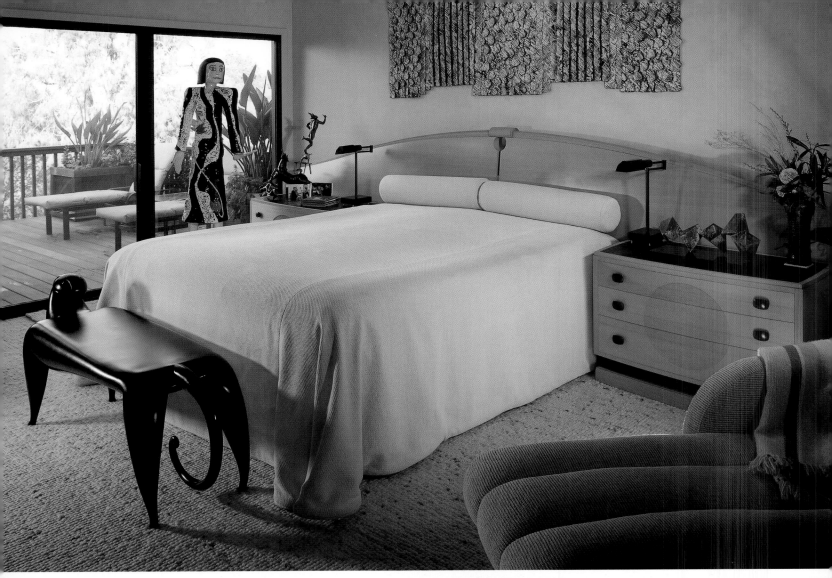

Colin Reid's (Berkeley, CA) design and technique are "a kind of insurance against complacency. While his command of form and proportion yields furniture that soothes and quiets the mind, his crisp detailing continually realerts the senses and feeds the kind of sharpened awareness that delights in small discoveries."

Detail photos: Rick Mastelli

to understated materials, his signature use of delicate texturing to reinterpret subtleties of line and plane, and his unfailing commitment to every detail of workmanship. As a maker myself, I have also long considered the bed to be among the least rewarding forms of furniture in which to work. I couldn't have been more wrong. Reid's bed, with its vast sweep of headboard that frames both the mattress and a small chest on either side, restates, extends, and celebrates all that was best in his earlier work. His choice of beech with its tiny ray fleck brilliantly resonates with fields and edgings of texture in varying scale. The carved circles spanning the horizontal lines of the drawer fronts suggest hazy sunrises and enhance the sense of calm generated by the entire piece. No detail has been neglected. Each cast-bronze pull is textured in a different pattern, as are the feet that separate the chests from their plinth. Reid's restrained mastery of the carving tool makes every transition from horizontal to vertical surface or from curve to flat into a visual and tactile event. Even the top edges of his beautifully dovetailed drawer sides reveal a touch of this carving theme. For the viewer, especially on repeated examination, Colin Reid's design and technique have become a kind of insurance against complacency. While his command of form and proportion yields furniture that soothes and quiets the mind, his crisp detailing continually realerts the senses and feeds the kind of sharpened awareness that delights in small discoveries.

The central magnificence of Colin Reid's bed is not lost on its owners. Their choices of the kimono-like hanging by Neda Alhilali for the wall over the bed, the dark and mysterious bronze bench by Judy McKie, the bright but peaceful standing sculpture by Leslie Safarik, the wall opposite the bed with its shelves of ceramic art and the colors and textures of walls, carpet and upholstery all honor and interpret the massive grounding power of the bed. The Saxes recall with pleasure the process of commissioning this piece and understand that they have enabled the artist to create a true masterpiece. As George Saxe said to me, "[Colin] made us a part of the process."

For them, as collectors, I think this piece satisfies, as thoroughly as any other, the aesthetic disposition; it certainly communicates a rich sense of freedom from the constraints of "urgency." And yet there is still something that separates this bed from the ceramic pieces on the wall shelves or, for that matter, from the room's sculpture or the textile hangings. It has a kinship with Gail Fredell's stair railings and Al Garvey's front door, even with the carefully designed cabinets in the master bathroom. It feels almost built into the house. Of all the explicitly "collected" furniture, the bed is perhaps the least *mobilier*. As a commissioned piece (about half of the Saxes' furniture was commissioned) it conveys an almost proprietary sense of its own proper place. We might say (with some tolerance for accidental puns) that, in relation both to the process of its creation and the conditions of its use, Colin Reid's bed is more contextually embedded than most objects in the Saxes' various collections.

Stillness

Quite apart from the personal preferences and attitudes that make the Saxe collection unique, I think this quality of being embedded can tell us something important about studio furniture in general. I want to expand the notion of embeddedness beyond its implications of fixed position and continuity with architecture, but first I want to clarify it by contrasting furniture with the small objects arrayed in display cases throughout the house. One such case in a downstairs study contains one of the finest collections of turned wood bowls by Bob Stocksdale that I have ever seen. The longer you gaze at each bowl the more you see: new and always subtle interactions between the forms that come from within the wood and those gently imposed by the craftsman. Standing and looking and talking about these lovely things, Dorothy and George Saxe were still making new observations after years of living with them, and in doing so they were fulfilling a purpose intrinsic to the genre of the turned vessel. These are, above all, objects for visual contemplation. They can be picked up, to be sure, and they offer a certain pleasure to the touch. They can be hefted, turned and examined from different angles. They can even be used. But in the end, the essential experience of a Bob Stocksdale bowl is that of the stationary eye placed in a position slightly above the rim for whatever duration is required to savor all the elusive visual qualities of the piece. And to a great degree the same is true of most of the objects in the Saxes' collections. Each piece has its place and its orientation on a shelf, in a cabinet, on a table, in a niche, and each one is where it is for a single purpose: to be viewed in a moment frozen off from the normal continuities of time and space. These bowls and busts, audacities and jokes and tours de force are all stationed for the admiring eye, much like the roses in T.S. Eliot's imaginary garden where

> ...the unseen eyebeam crossed, for the roses
> Had the look of flowers that are looked at.
> There they were as our guests, accepted
> and accepting.

The many works of art collected by the Saxes all have this look of objects that are looked at. There is a formality about them, a sense of alert

The Saxe home is filled with "points of stillness," as in this portion of their extensive collection of Bob Stocksdale (Berkeley, CA) bowls.

comfort in the manner of contented guests, "accepted and accepting." This is a hard feeling to describe, but it contrasts usefully with the sense of what I'm calling embeddedness. Eliot's roses occupy what he calls a "stillness," a place of mysterious calm sequestered from the constantly moving world. This stillness is not "fixity"; rather it is movement circumscribed by form and pattern. Eliot himself represents it with a ceramic vessel:

> *Only by the form, the pattern,*
> *Can words or music reach*
> *The stillness, as a Chinese jar still*
> *Moves perpetually in its stillness.*

The Saxe home is filled with these points of stillness in the form of things to be looked at, but that is only a part of the whole domestic scene. It is the part that can be caught in a still photograph. The other — and in the end the largest part — is the flow of daily life through the house. This flow is open-ended movement in real time and space, continuous with the world beyond the house. It is cooking and eating and sleeping and writing letters and talking on the phone. It is thinking and arguing, enjoying a glass of wine, taking a shower. Since the material house itself limits and directs and enhances this manifold practice, it is finally temporal and spatial life itself in which architectural structures can be said to be "embedded." And in its alliance with the house the furniture, too, becomes permeated by lived experience.

Imagine that another kind of photograph could be taken, something like those time-lapse images of freeway traffic where the lights of cars turn into pure pathways of energy. In the Saxes' breakfast room, these pathways would loop and pause around each of Art Carpenter's wishbone chairs and the fine little walnut table by Jeffrey Dale. They would bunch at Al Garvey's front door and diverge around Gail Fredell's railings. They would

■

The work of the furniture maker is both a free-standing thing called furniture and an intimate process called furnishing.

■

pause and chatter at the dining table, hover methodically over Wendy Maruyama's graceful sideboard, circle and snuggle into Sam Maloof's chairs, and finally cool and soften as they approach Colin Reid's bed. All of these objects continually shape and direct the energies of daily life and in turn are challenged and changed by those energies. This is what I mean by embedded. This intimacy with the flow of household practice is what contrasts furniture with the stillness of art works meant to be contemplated and savored in timeless moments.

A Spectrum of Relationships

I think these observations can lead us to understand something fundamental about studio furniture as a genre of art, but they cannot do it by themselves. Embeddedness is a term of relation and, as such, it needs help from some balancing truths that emerge from the objects themselves. The various pieces of studio furniture in the Saxe collection might never have revealed their intimacy with domestic processes if each had been separately viewed in a gallery or a museum or a catalog, and yet each one would surely still have been itself there. Indeed, after attending the recent Oakland Museum exhibition of John Cederquist's work, I am inclined to say that Cederquist's furniture might even be understood better by examining many pieces in a museum than by viewing them one or two at a time in a private collection. To understand what this actually implies, I would like to return to the Saxe home and look briefly at Cederquist's "Steamer Chest."

When you walk downstairs from the entryway and enter the den (with the Thomas Hucker coffee table off to your right), the "Steamer Chest" stands straight ahead in the left-hand corner of the room, flanked by a window and a comfortable leather chair. Initially, there is only one point from

which to view it: straight on from the front. By its placement, the Saxes have instinctively enforced a principle that was intrinsic to the museum installation: that is, there is one best position from which to observe the piece. Cederquist, himself, delights in this when he says, "It's interesting to watch people walk around furniture and locate themselves in the correct spot." Move to either side creating an obliquely angled sight line and the 3-D illusion on the flat surface begins to weaken, a transformation that worried Cederquist "until I realized 'Hey! that's a positive.'" As you move farther to the side and the unadorned body of the chest comes into view, the eye's absorption in the image of coiling pipes and jumbled boards largely gives way to a new focus on Cederquist's staining and veneering technique—the means of producing the image rather than the image itself. And finally the opening of a drawer completes the process of fracturing and demystifying the original image.

The viewer, in other words, has journeyed from "what does this represent?" to "how is this done?" to "what is this object in itself?" This journey of demystification—from illusion to real practice—is, therefore, a psychological process and lies at the center of Cederquist's work. His images render ordinary objects doing impossible things and assuming impossible configurations through exaggerated conventions of perspective and shading. This de-familiarizes both the world of real objects and the painter's tricks of realist representation. It is no accident that, many times, the object represented is, itself, a piece of furniture. Cederquist presents an image of furniture (or in this case, of pipes and boards) that confuses us, that we cannot take for granted as we do the many real and imaginary images we see every day. He then allows us to reinterpret these pictures as woodworking technique and finally to rediscover them as furniture, this time simplified down to their three-dimensional essence, divorced from the delineations of the original illusionist image. We end up with a refreshed sense of what, say, a chest of drawers "really" is, a set of storage boxes inside a larger box, quite apart from what a chest of drawers—or for that matter the term, "steamer chest"—might symbolize or "represent" ideologically.

These observations about the work of John Cederquist have more implications than it is practical to look into here. For now, the important point is that a Cederquist piece actively positions and directs the viewer. Its relationship to that viewer is its principle meaning, and this allies it with the turned bowls and ceramic sculpture I discussed earlier. The way you fully experience the "Steamer Chest" is no different in the museum than it is in the Saxes' home. It is not embedded in the life around it in the manner of the Maloof

chairs or even a "sculptural" piece like the living room coffee table by Wendell Castle. As if sensing this difference, the Saxes have placed the chest in probably the most untrafficked space in the house, a virtual niche of its own. Indeed, when I opened the drawers...there was nothing in them.

Studio furniture, then, is not a single kind of thing. Even within this collection it describes a spectrum, from Cederquist's "Steamer Chest," or Alphonse Mattia's "Hors d'Oeuvres Server," so like painting or sculpture, through variously embedded small tables by Castle, Judy McKie, Thomas Hucker, Billy Al Bengston, Garry Bennett, Rosanne Somerson, and others, through chairs and dining tables and Colin Reid's bed until, like the rainbow touching the earth, it disappears into built-in cabinets, stair railings, and the architecture of the house itself. Even in the work of a single artist, we can see gradations along the continuum I'm describing. While the illusionist image of the

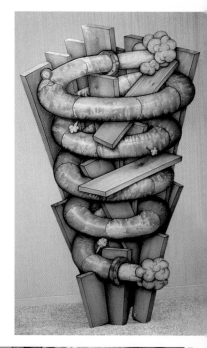

"Steamer Chest" places and defines its viewing subject along a single, disembodied, ocular axis—an "unseen eyebeam," as Eliot would have it—Cederquist's "Conservation" chair in the Saxes' living room has no exclusively "correct" point for viewing. Rather it projects a viewing subject with a whole body that walks around it. One cannot take in the whole chair at once, so the piece introduces a dimension of time and physical movement even into the initial illusion. And the de-familiarization so central to all of Cederquist's work extends here into the tactile realm as the hard surface on and against which one sits contradicts its own visual representation of a waterfall and pool. This chair is one of Dorothy Saxe's favorite pieces,

John Cederquist's "Steamer Chest" actively positions and directs the viewer. Seeing it from an angle that reveals the cabinet's side or opening a drawer disrupts the illusion designed for "an unseen eyebeam."

Photos: Rick Mastelli

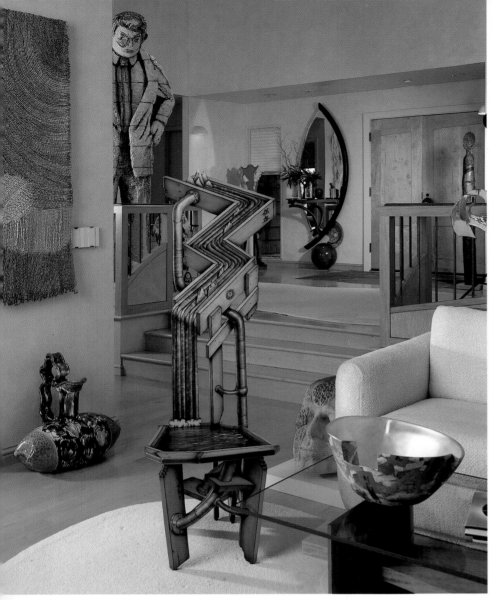

One of Dorothy Saxe's favorite pieces, Cederquist's "Conservation" chair is a focal point of the living room and entry area. It "projects a viewing subject...that walks around it," thus adding a dimension of time and physical movement to the initial illusion.

The Saxes have recently donated 400 pieces from their collection to San Francisco's M.H. deYoung Memorial Museum. An inaugural show runs June 6 through October 17, 1999.

in part because she continues to discover new details from different viewing points and in part because, although it's usually the last chair to be sat on, people do sit on it in reasonable comfort for conversation in the living room.

A Dynamic Balance

In the end I do think it's important that we as makers, along with those who acquire our work, know what differentiates our art from painting and sculpture and works in other craft modes. Otherwise we may continually strive to make our furniture into sculpture or, more vaguely, "art," an attempt which, if successful with gallery owners and art critics, risks leaving us as perpetual second class citizens in the art world. We can recognize studio furniture not by a set of features that all pieces share but by the fact that each piece can be described according to its place along the arc I have been describing between "stillness" and "embeddedness." Its stillness or formal autonomy is signified by its relations to its maker and to its

ideal viewer, relations that tend to spring the finished piece free of immediate contingencies of time and space. Its embeddedness is precisely its participation in the intricate flow of life around it at any given moment.

In other words the work of the furniture maker is both a free-standing thing called furniture and an intimate process called furnishing. Every piece of studio furniture has both of these components in balance. In some cases the balance is very symmetrical; in others much less so. In the best work, the piece somehow interprets this balance to generate new layers of available meaning. But the balance is not a static proportion like a recipe. We should better think of it as a kind of force field or dialectical tension of valences continually oscillating within a certain range characteristic of each piece. I choose these dynamic tropes in part because I think the tension I'm describing translates into a familiar struggle for the actual furniture maker in the studio. Whether at the drawing board or with tools in our hands, we are continually making decisions that are driven by powerful imperatives from either side: our allegiance to the aesthetic object and our commitment to provide a service in someone's real life. Each piece can well be understood as a unique resolution of these forces.

Some of our work, shown in galleries or acquired by museums, will never find its way into the stream of life within a home or office or public space. By contrast, some pieces will be the only examples of studio furniture in homes otherwise furnished from the furniture stores or designer showrooms. In the gallery setting it may be difficult to see what differentiates a cabinet as a separate kind of art from a piece of sculpture or a tapestry or a lithograph, while some of our clients who are unused to buying or collecting art may refer to our work as "custom furniture," commissioned because no mass-produced piece would quite "fit the need."

In a home like the Saxe's, though, where museum-worthy collections line the pathways of daily life, we can finally see studio furniture as it most essentially is, an artistic form singularly fitted to the varying space between art and life. As makers, we need collectors like Dorothy and George Saxe. We need them because they can enlarge our sense of how we relate to one another and to artists in other media. We need them because their practiced discrimination can help us sharpen our sense of quality in the work yet to come from our studios. Most of all, we need them because, by placing our work in the dual context of their collections and their homes, they offer to all who see studio furniture there the fullest available interpretation of what our labors finally mean. ∎

Garry and Sylvia Bennett have been collecting paintings and furniture for as long as Garry has been painting and building furniture, that is, for more than thirty years. The Bennett collection, which includes prominent as well as little-known furniture makers from all over the U.S., fills both their 100-year-old Victorian house in Alameda and their contemporary studio in Oakland, California. In several different styles of interior space, the collection reflects a unique combination of sensibilities, bringing together making, collecting, and daily life. In September 1998, furniture maker Loy Martin and editor Rick Mastelli interviewed Garry and Sylvia at their studio. The photo above includes "Lizard Table," bronze and glass by Judy McKie (Cambridge, MA); "Pony Footstool," painted wood, by Bennett; and "Root Stand," sculpted steel by Lehman Ptasnik (Tuscon, AZ) with padded leather seat by Bennett.

COLLECTING, WITH A MAKER'S EYE

■

A discussion with Garry and Sylvia Bennett, who have amassed on a budget a most eclectic collection of studio furniture, and who know how to serve guacamole

■

Rick: When did this become a collection? Was that a conscious decision or did it just evolve?

Garry: I know we have a collection, but we're not like people who collect specifically — all woodturning or glass. Ours includes paintings, sculpture. We have more art than craft, well, maybe not now. But it's never been conscious, we just like these things. And we use them. We've got quite a bit of Bob Stocksdale's work. You should have seen the look on his face one night when I put out one of his big beautiful walnut bowls full of guacamole on the table. The other bowl had the chips. I know it's lacquered, it ain't gonna hurt it.

Rick: When did it become a collection for you, Sylvia?

Sylvia: When someone called it that. I didn't realize it was until one of the museum groups that was familiar with the house said, we'd like to bring a group through to see the collection. I'm thinking: Collection? What collection is that? And I realized that actually it was. In 1990 the book *Art for Everyday* featured our house and that was when it was first referred to as a collection.

Rick: If your motivation wasn't to collect per se, what was the motivation?

Sylvia: We needed furniture. Garry had come into the field very early, when things were just starting to happen. Prices were not — well, it was always dear but certainly not more than going out and buying a factory-made piece. And prior to that we'd acquired things at flea markets and such.

Photos, except where noted: Rick Mastelli

Garry: And we had collected paintings through friends of ours, through purchases, gifts, and trades, and things like that. So, our collection really started with paintings and sculpture.

Loy: Did the first acquisitions of furniture come from people you thought of as friends who were furniture makers? Or did you go and find work by people you hadn't known before?

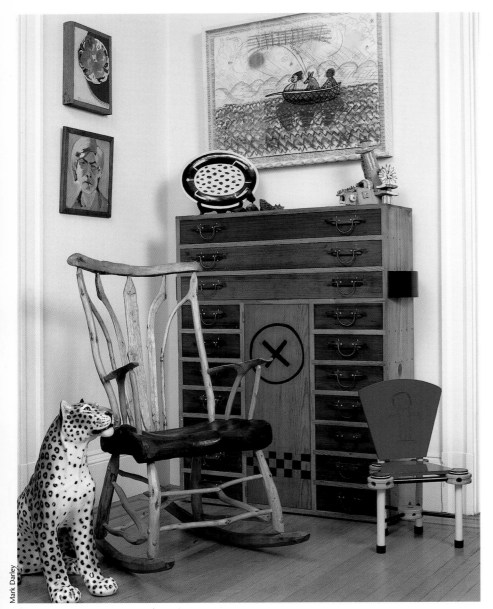

Mark Darley

Rocking chair by John Coonen (Napa, CA); child's chair by Joann Shima, (Newtown, PA); tansu-style chest and ceramic sculpture by Garry Bennett; ceramic plate by Judy McKie; pastel drawing by Roy DeForest (Benecia, CA); paintings (on left) by Peter Neufield (Berkeley, CA); and ceramic leopard from Italy.

Garry: Wendell Castle and I knew of each other for some time after I started making furniture, though it was several years until we actually met. Wendell and Judy McKie were some of the first furniture acquisitions. Although we have done some trades, most of the work has been purchased from galleries or from the artists themselves.

Sylvia: The only thing that stops us is the cash flow. Whenever we have extra money, that's where it goes.

Garry: Since we've been married, we've been collecting.

Sylvia: We like surrounding ourselves with it. And Garry doesn't really like filling the house with his own work. I have to fight to keep his pieces.

Rick: What's the relationship between collecting and making? Are you inspired by this stuff?

Garry: Oh, I'm inspired by that old tansu there. Or by one of Wendell's pieces. But personally I try to avoid—this sounds crazy, but I want to remain a little pure. I'm not a historian whatsoever. I know my contemporaries, I know their work, and we all borrow from each other I'm sure.

Loy: But you don't like to think that you're profoundly influenced by other people's work.

Garry: No, probably only by the Japanese. Artistically, that culture is the one I admire the most. The Koreans and the Chinese also have just marvelous stuff. I don't read those books or anything, but I'll see something and say, "Ooh, there's a good shape."

Rick: Inspiration from other people's work can take many forms. I wonder if the fact that other people are out there doing stuff is encouraging. That it's a good thing, and that your acquiring it is part of that good thing.

Garry: Oh yeah, yeah, it would be hard to acquire in a vacuum. I just love it. We just got a piece, a desk and chair, from a guy named Jonah Meyer, from Woodstock. It really doesn't fit with Paul Sasso's coat rack, but I think we like arranging interesting pieces and bringing diverse things together.

Rick: Do you find that things have the one right arrangement, or do you move things into different arrangements?

Sylvia: [laughing] I like to move them. Garry would never move another thing. I'm the one who loves to play with the arrangements. Growing up with *Better Homes & Gardens* as I did, you see these perfect rooms, everything is color-coordinated, everything matches. And I think the fun of acquiring this stuff has been to find a wonderful piece and bring it home and make it work. And that to me is far more challenging than either hiring a decorator or doing a thematic sort of thing, because once you've seen it, it gets really boring.

Loy: The whole subjective experience of being in a space like this is movement. Your attention is moving around all the time. My experience with decorators is they always want the thing to cohere in such a way that your attention settles. It wants to be a tableau, almost like a stage set.

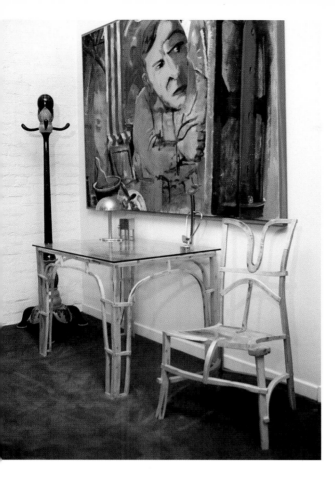

Sylvia: Finished and complete.

Loy: And when I'm here, I think "Do I want to look here or there or…" I almost expect things to be in different places when I walk out of the room and back in again.

Sylvia: I've had curators walk through that know us, that have been in and out of here, and they have a trained eye, and say, "Oh, that's new." It's always been there. No it's not new. It makes people use their heads and their eyes because the work demands it. Every piece has an interesting persona.

Garry: Yeah it's not a whole bunch of antiques of a certain period.

Rick: Well, this is of a period, it's just that we're right in the middle of it and it looks more various than it will in a hundred years.

Garry: I think it will still look pretty broad and various. I mean, you see people who collect 50s stuff. They have whole houses full of it. But it looks very cohesive now to my eye. Maybe you're right, maybe a hundred years will bring this stuff together. But I'm afraid it would be brought together with a certain look, maybe a lot of wood or mostly metal, and then, yes, it would start looking of a type.

Rick: What is the relationship between wood and other materials in what you're collecting? It's predominately wood, isn't it?

Garry: Yeah. For me as a maker, wood is bigger and cheaper and faster. You can just make it quicker. At home, most of our furniture is wood. These guys are mostly woodies, even Wendell's a woodie. But he can think in metal, he does, and it's damn good. I think if you scratch me deep enough, I'm basically a woodie, too.

Rick: I wanted to ask you about the chairs in particular. Let's take Meyer's chair, do you sit in this chair?

Garry: I don't sit in this one, but it will be sat in. This was intended to be a desk chair someday. Maybe when we move here to the studio and Sylvia has an office.

Sylvia: I've pulled the chair up to the dining table. When we have people over, I'll pull all of the chairs up. You probably wouldn't want to sit in some forever, but they're handy to pull up.

Garry: I think the construction is crazy. I mean everything is totally wrong. It sits well and it looks good, and that's the main thing. We have a Windsor chair by Michael Dunbar. People think it isn't comfortable, but it's an amazingly comfortable chair. It's a real winner.

Sylvia: The one that's surprising is the twig-like rocking chair by John Coonen. It's a tiny little rocker. It has a very small seat, but Garry, who's six-foot-nine, can sit in it and it's very comfortable and it rocks, the balance is wonderful on it. Chairs do need a little extra. I mean they can be purely decorative — almost sculptural. It's as much

Glass-top table and chair by Jonah Meyer, (Woodstock, NY); coat rack by Paul Sasso, (Almo, KY); lamp by Garry Bennett; vase by Reynaldo Terrazas (Oakland, CA); painting by Jack Ogden (Sacramento, CA).

Table by Colin Reid, (Berkeley, CA), vase by Allen Miesner (Sausalito, CA); wood bowl by Bob Stocksdale (Berkeley, CA); sculpture and two chairs by Garry Bennett.

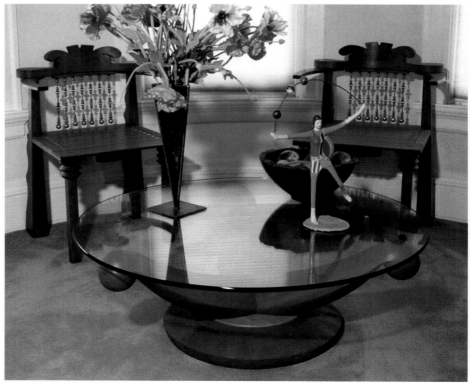

fun just looking at them. They don't really have to sit well, but it's nice if they do.

Rick: The show of your collection at the Oakland Museum last summer — why chairs?

Garry: I suggested chairs because this was going to be a brief exhibit quickly done, and the chairs would be easy to move. Plus we had a lot to select from. Suzanne Baizerman, the museum's decorative arts curator, felt that the chairs would relate well to The Furniture Society's '98 conference.

Sylvia: It was quick and easy. And it was focused.

Garry: It turns out that we had even more chairs than we thought we had. I mean forty-four chairs were selected, that's a lot of chairs. But the best were there. I really enjoyed seeing them like that. I think there's a continuity to them, and it made a good-looking show.

Loy: Have all the pieces you've acquired stayed with you? Have you ever sold anything?

Garry: No, I couldn't imagine.

Loy: Is that also true of your own work in the collection?

Garry: Sylvia puts the grab on those. They're hers. She will every once in awhile say, "I want that."

Loy: How are they selected? Are they just the pieces that you think are the best? Do you say you can't sell that because it's the best example of your trestle tables or such?

Sylvia: I wish I had done that more.

Garry: I think that what happens is that it goes into our house for a while, and then I say, "Okay we've got to sell this," and Sylvia says, "No, that one stays."

Sylvia: There are pieces that I would have preferred to keep. Sometimes work is sold before I think to speak, I'm always sorry when that happens.

Garry: I always like to put my best work out. I don't think I've ever put pieces I don't like in a show. Occasionally work comes back from shows, and usually we try to keep those pieces, or share them with our children. The kids have quite a bit of my work.

Sylvia: When the infamous nail cabinet was made [*Fine Woodworking* back cover, September 1980], it was in a show that year, and it sold, and I kind of regretted that. Then the gallery said "The woman is going to buy it but you have to replace the door" — the one with the nail in it — and I said "Great, tell her it's not for sale." So, it came home. And I was so pleased to have it back, and

I thought we really should be keeping a few important pieces. Each time Garry moves through one of these series of desks or tables or whatever, I try to remember to put the grab on a piece, just because I think we should have his work, and we do now, we have work over his whole career. A couple of early pieces we bought back when they became available because I didn't have something from that particular time.

Rick: Have you gotten any feedback from people whose work is in your collection — any good effect for them in exposure through the collection?

Sylvia: Sure, because we get a lot of people through, not only people who are looking for Garry's work.

Rick: Why *do* you collect the pieces you do?

Sylvia: It changes. It's not a consistent thing at all. We'll go to a show — we usually go separately because I like to really look at things and Garry takes a lot less time. And then we'll get back together and he'll say, "Did you see anything you liked?" "Oh, yeah, this and that." And lots of times our views will coincide. There'll be a piece that we both think is just superb and then we'll talk about it. Occasionally, there's something visual about a piece that just clicks and I can't tell you what that is.

Rick: And, more often than not, there's complete agreement?

Sylvia: Yes, usually. I don't think either of us has ever said "I can't stand that thing" when the other liked it.

Rick: Has there been the experience of you coming to see something in a different way as a result of Garry's perspective on it, and vice versa?

Sylvia: I'm always interested in what he likes about a piece. It's a dialogue. And it's about people. Garry's a people person. And I think that relates to what we do here as well. It's part support. You know, if nobody buys this stuff, there'll be a few who will keep making it regardless, but most would just go find something else to do. So, it's about financial support in a way, that's important. And it's about interacting with people that he appreciates or admires.

Rick: You're a maker yourself. You make jewelry.

Sylvia: Yes. I studied painting and ceramics, but most of my work has involved jewelry. I'm working on some new techniques now, after exploring materials in Indonesia, Eastern Europe, and India.

Rick: Do you see collecting as a creative activity?

Sylvia: I guess it could be called that. I don't know.

Chair by Jon Brooks (New Boston, NH); "Ice Bucket Lamp" by Garry Bennett.

Rick: I mean, a lot of collectors are not creative in terms of making the kind of things they collect. And I've heard more than one of them say that they see the acquisition, the placement, the creation of a context, as a creative activity that continues the original making of the object.

Sylvia: Well, I think everyone likes the idea of being creative. It has a very positive sound to it. Our dentist used to refer to himself as an artist. And he actually was a very talented dentist. People still look in my mouth and say "Who did that?" Obviously he had some skills that he brought to his trade. I think creative activity is something that people really want to participate in and if they have no apparent talents, they could certainly call collecting creative, though I don't know that I would agree.

Loy: You clearly see your own collecting as more than a hobby and also integrated with the obviously creative side of your lives.

Rick: It's a complete circle, isn't it?

Sylvia: I think so. Because to my mind — and I can remember I've said this more than a few times — if I had a goal it would be to have everything that I come in contact with made by an individual. Each of these pieces has a story. It comes with its own background and history. I find that intriguing and enhancing, and it becomes a part of your life. It brings meaning.

Loy: Would you make a broad case for that way of living to people in general? To say, "Your life will be better if you collect studio furniture?"

Sylvia: I believe that. Or surround yourself with things that have had some thought and passion involved in them. You see an exciting piece and it excites you. It's a rich environment. I used to be in a group at the Oakland Museum that supported art and then craft. And they would, as adjuncts to fund-raising, have tours of collections in the Bay area. I can remember countless times going through these magnificent homes. Beautifully appointed. No money spared. Fabulous paintings. Gorgeous sculpture. And crap for furniture. You know, it would be some decorator's idea of putting a couple of slabs together and setting them here, and it's lovely, but — Maybe they feel that if the furniture were too interesting it would detract from the walls, but I don't think that's true. I think it all plays together.

Rick: That was going to be my next question: Can you go to an extreme and have stuff that calls so much expressive and individual attention to itself that it detracts from the life you want to live?

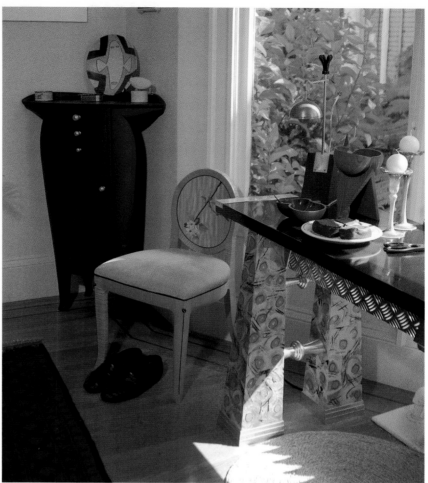

Corner cabinet by Chris Vance, (San Francisco, CA); ceramic plate by Todd McKie (Cambridge, MA); marquetry chair by Wendell Castle (Scottsville, NY); sideboard, Jerry Carniglia (Emeryville, CA); two turned pieces by Stephen Hogbin (Wiarton, ON); ceramic brownies.

Sylvia: I think there's a danger of that. I find that there is some so-called furniture that's truly nonfunctional. It should be called sculpture or something else. That to me would interfere with my life — if I wanted to pull a chair up to sit down in and I was a little concerned. The same thing happens with antiques. You can barely sit in many of those chairs. And to me, it's sort of dishonest.

Loy: You talked about wanting to surround yourself with things that have been made by actual human beings. Does your collection tend to exclude things that are designed by the person with their name on it but not made by —

Garry: Not really, but yeah, we do have a lot of Wendell's stuff. [laughter]

Loy: I could have been more straightforward, couldn't I?

Garry: Well, he doesn't make everything. Cheryl Riley doesn't physically make everything either, but that certainly would not exclude their work.

Loy: Right, so that's my question. How much of the feeling of the pieces you collect, their soul, comes through your sense that there's a person — either a person you know, or a person that catches your imagination — who's actually had his hands on this thing and turned it out?

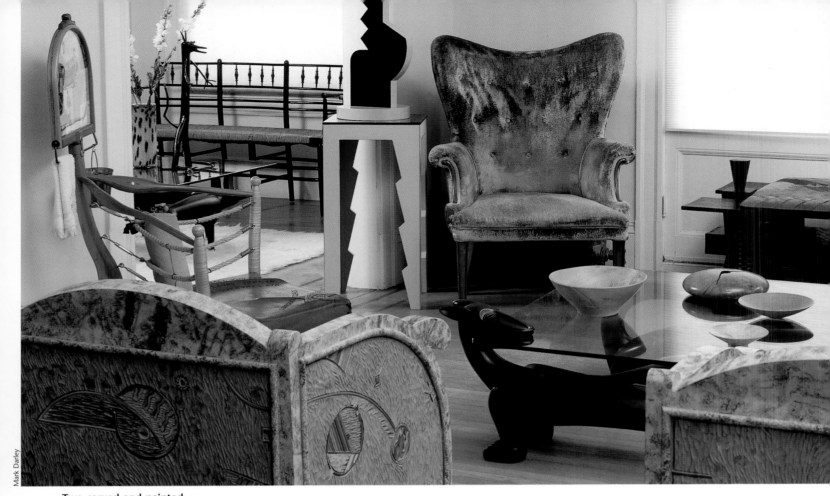

Two carved and painted chairs and "Boxing Chair" by Tommy Simpson (Washington, CT); table and sculpture by Allen Miesner; bench by Garry Bennett; bronze and glass coffee table by Judy McKie; wood bowls by Bob Stocksdale, David Ellsworth, and Wendell Castle. In the room to the left are another McKie coffee table ("Dog Eat Dog"); sculpture by C. Cooper; and a Sussex settee by William Morris.

Sylvia: I think that's as much part of it as the workmanship. There are only a few pieces for which we've never met the actual maker. Very few. Occasionally when we've been to a show and found a piece that we liked, we end up meeting the person who does it and getting to know them. Sometimes the piece actually works independently of the person. Most of the time, as you network and meet all these people and see their work, you really want something that they've done. Then you wait for the proper piece to bubble up and you move on it when it does.

Rick: Does acquiring a piece deepen your personal relationship with the maker?

Sylvia: I think it works that way. You have a vested interest in them then. And I think most artists appreciate someone that purchases their work. There's a communication there — "You like my work and vice versa." It enhances the relationship.

Rick: Is your collection a personal expression of yours?

Garry: I think so.

Sylvia: Yes. It has a focus and we've committed to a particular type of thing so far.

Rick: You talked about believing that life is better if you surround yourself with things that have been made with thought and passion. Will collecting studio furniture change the world?

Garry: Definitely. We're going to pull Russia out of the doldrums with this. They'll be making really good studio furniture — What do you mean "change the world?"

Rick: Well, when I first set up this appointment, it seemed to fit for you, Sylvia, as if you didn't think it would be a bad idea if more people were doing what you are doing.

Sylvia: Yes! Absolutely. It's something that should be supported because of the effort on the part of the individual artists. There are a lot of very talented people that deserve to pursue what they're doing. Only a percentage of the population will possibly get interested in collecting. But it's also okay to buy one or two pieces for a home. You don't have to extensively furnish your home to benefit. You know, people collect the damnedest things. I think human beings have a passion for surrounding themselves with things they consider comfortable or lovely or whatever.

Loy: But is it only a thin slice of the economic stack that this is all relevant to? The idea of collecting really is different for somebody who —

Garry: — who makes 600 a week. Yeah. So they collect Beanie Babies or soda pop bottles.

Sylvia: But then there's the mailman in New York who collected all the Rauschenburgs and Jasper Johnses. He and his wife lived in a tiny little apartment. And they both had a passion for art and so on a modest budget they allocated some amount per month for art, and started buying when these artists were relative unknowns. And they had a good eye. They were totally unguided. They didn't work with a gallery or anything. They just walked the galleries and fell in love with what they saw. So anyone can do it. And you can do it on many many levels. For what you go out to, say, Macy's and buy a table for, you could afford to get something handmade by someone. I have friends who bought a manufactured dining room table and paid $7,000 for it. Now, you can get a pretty decent handmade table for $7,000 to $10,000. There's room to start from anywhere.

Rick: Tell us more about what kinds of recommendations you would have for people who are starting to think about collecting.

Sylvia: I think they should seek out whatever galleries are showing furniture and go and look at it and ask questions. And then go to the open studios in areas where those are offered.

Garry: Of course, there's always commissioning, too. I would bet that's how it starts. They've gone to Macy's, or wherever, and it doesn't work. So they get some local guy and commission a piece. Then pretty soon, "Hey, this is pretty good stuff." And he says, "Well, I'm having a show or my buddy is having a show..." Again, taste kind of goes along. You don't have to have money, but money helps.

Rick: So, what do you make of the inclination to see studio furniture as impractical, unrealistic, or self-indulgent?

Garry: Price. It seems they don't like the price. If you follow that line of thinking, you would not have much of the elaborate antique furniture that fills museums and private collections, either. Those pieces were often impractical, unrealistic and self-indulgent, not to mention really expensive.

Loy: When you're working, being yourself a collector now, do you think of the pieces as pieces for collectors rather than—

Garry: No, I don't. I can look you right in the eye and tell you I make everything for myself. That's why I don't do commissions. I haven't done a commission since 1981.

Loy: It sounds like you feel that if the process of making furniture has a future, that it's linked to collecting. Rather than some kind of an ongoing commission process in which great pieces are made in order to fulfill domestic needs of people who aren't necessarily collecting studio furniture.

Garry: That's right. And I think it's always been done, always will be done.

Rick: You say you make everything for yourself. Is that something in common with the pieces you collect? Do those pieces have an integrity with the person who made them?

Sylvia: If we were serious collectors, number one we wouldn't have editions, and we have a lot of editions. Or I should rephrase that—

Rick: What's wrong with series?

Sylvia: Generally if you're going to build a collection, you want drop-dead pieces. You want the best that an artist can produce. If you're going to collect, and you're going to collect specific people, you want to wait for that absolutely fantastic piece that all of them come up with periodically.

Garry: But we're not bottom feeders. We're in the middle—you know, we can't feed on the top.

Sylvia: A, we couldn't afford to do that; and B, that's not where we come from. So if we were to really develop a collection for collecting's sake, we would have to start over.

Rick: Which doesn't make you any less appreciative of your collection.

Sylvia: Not at all. I feel it's as important. It's just different. It's coming from a little different perspective. Serious collectors collect for the long haul, they collect for either dollar appreciation, or for good representation from a particular area.

Rick: Is studio furniture any kind of investment?

Garry: We've never bought anything as an investment. There's not enough history for that. Or not enough awareness. Antiques have a cachet or pedigree. People don't want to take a chance. They're just loathe to have somebody come and say "Geez. Where'd you get that? It looks like hippie woodwork." So, Macy's is a familiar label.

Rick: What's the solution to that?

Sylvia: Education.

Garry: There's no solution because people are always going to do that. That's why you have McDonald's.

Sylvia: It's why people buy designer labels or wear somebody's name on their clothing. It's that mentality that isn't real sure of itself. "This is easy. They'll know it's a Vuitton or —"

Garry: And there's a continuity of everybody having bought it before. It's safe.

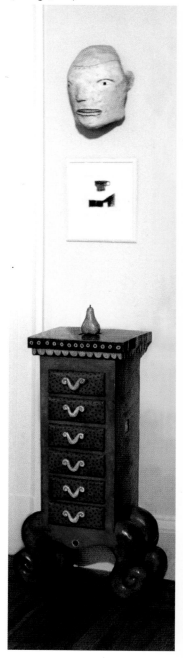

Cabinet by Fabian Garcia (Oakland, CA); mask by David Sedaris (Raleigh, NC).

Rick: And the other side of that is self-reliance, is people having confidence in their own taste.

Sylvia: Yes. People that grow out of Sears or Levitz start looking at the name Ethan Allen. And they look at some of the magazines and see that this is rather nice furniture. And so they're stepping up—I think these things are often stair steps, if people are open and they're curious. And I think that comes down to basic education.

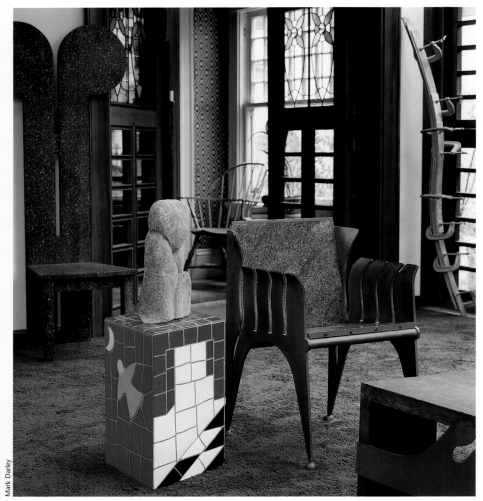

Chair of steel and granite by Norman Petersen (San Francisco, CA); "Floating Table" of ceramic tile by Joseph DiStefano (New York, NY); granite sculpture by Garry Bennett; "Mickey Mackintosh" chair by Wendy Maruyama (San Diego, CA); Windsor chair by Michael Dunbar (Portsmouth, NH); "Glue Lam" sculpture by Allen Adams (New York, NY).

Rick: You don't think it's an economic issue?

Sylvia: Certainly economics falls into it. Yes, anyone who is working for a living and making a set amount of money, they've got only so much to budget for furniture, for furnishings. And if they move into a house and they have to furnish it all at once, the easiest thing to do is just go and get it by the roomful at Macy's or wherever and pay a few dollars a month. If they're aware of what's going on, they can start maybe more modestly, just picking up odds and ends and getting one good piece of furniture, or a couple of good pieces of furniture, and adding one every time they get a few dollars ahead.

Loy: Then it becomes a hobby. It becomes a hobby rather than spending your money on fishing trips or whatever. But don't you think that it becomes supportive of our field only when it reaches the level where the comparison is not with Macy's, but with some mass-produced designer label showroom? That's where you've got to ask whether you can educate the public to be able to tell the difference between a dining room table by a designer like Dakota Jackson versus one by Garry Bennett? When people start having discretionary income for shaping their environment, then are enough of them going to care to do it this way?

Sylvia: Well, I like both those guys' work! There is growing interest. But it'll always be only a segment of the population. On the other hand, anyone who develops an interest in this contemporary work, I don't care how much money you make, at some level you can buy. You can start. It isn't closed off, but like anything fine, everybody isn't going to have it. Everyone isn't going to understand it. Nor even want to. But there are those out there, they don't know it, but they're really looking for these things. How do you find those people? Something has to click. They have to walk into a shop that has a couple of handmade pieces—there's something that will turn a person around. We've seen it happen.

Garry: Oh, yeah. A lot.

Rick: I think the biggest thing to help turn people around is to see this furniture in a domestic context.

Sylvia: That's why we open our house. I will not open it to public house tours, but I will open it to any museum, any organized group with an interest and a focus. I want people to see how these objects can work. It's a modest collection, there's not a great deal of money here.

Rick: That's what helps make it accessible.

Sylvia: Yes. I want them to see that the work functions, that we live with it, that it integrates with anything and everything. This collection has a personality, it has a consistency, and it's not contrived. A decorator once walked in and said, "Legs. Oh, too many legs." But what do you do with a chair collection? You've got a lot of legs. So, I find it very challenging to work with these pieces.

Garry: Wealthy people are putting up these big edifices, and they are just lost. They've made money, and they ask "What do we do now?" They're not going to do it the way we've done it, one piece at a time. You know, "Plunk. Well, that looks pretty good there." Then we go on about our business until we see another thing, "Plunk.

Mark Darley

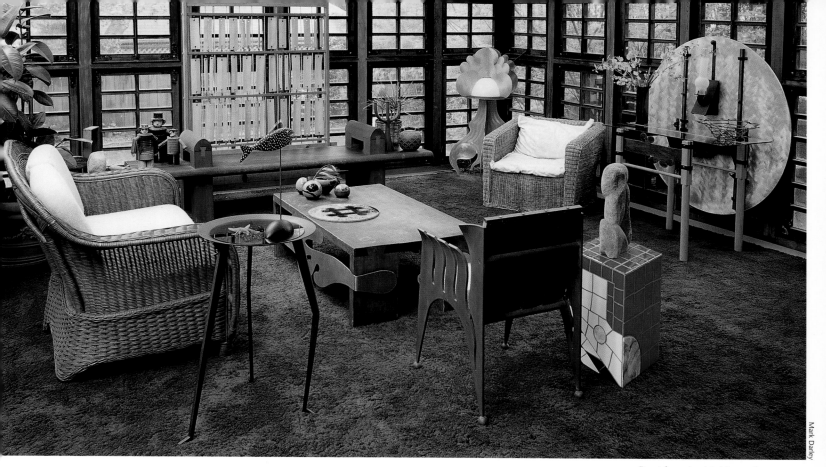

Plunk. Plunk." And pretty soon it takes on its own character. It has its own thing going for it. The interior designer promises to shortcut all that, but it doesn't always work.

Rick: You integrate all kinds of things here, commercial furniture as well as sculpture, paintings, and studio furniture.

Sylvia: Yes, the commercial furniture is sort of a foil. We have a couple of overstuffed pieces in critical places. Soft is always good. I always like a few soft pieces. I've been in houses that were very contemporary with a lot of metal and wood, and it starts to get cold. The other extreme is when it gets all soft and mushy. I like the combination of the two. I think they play well against one another.

Rick: Don't interior designers work this way?

Sylvia: Interior design has changed a lot in the past ten or fifteen years. There's more attention to the client's own style of living. I'm encouraged by how some interior designers and showrooms include one-of-a-kind, custom, and artist furniture. But I don't feel there's anywhere near the support this field deserves. Anyone who can afford to work with an interior designer can afford to support the wonderful things being done by the many talented people making studio furniture today. There's an important relationship missing, one that would

benefit all parties. We've all heard stories about people who come into a show or gallery, fall in love with a particular piece, they love the piece, but they have to "run it by their decorator." Well, we know what happens to that purchase.

Rick: Why is that?

Sylvia: My gut feeling is that it's partly financial. When a designer deals within the trade, there is a consistent commission structure in place. And partly I think it's a reluctance to share the spotlight with a piece of work that might overshadow the "concept" of the designer's work.

Rick: Doesn't it begin with hiring a designer in the first place?

Sylvia: Well, I think things are richer when various perspectives are brought together. Many people using an interior designer don't have the courage to integrate their personal ideas. Again, there are relationships that can be developed. Some people want a particular designer's look rather than something more personal. I feel that objects being made today have the potential to give any home a very individual look. They can add so much excitement and interest well beyond just another pretty room. The magazines are full of pretty rooms, and they all look alike! Is it just too scary to stand apart?

Garry: Some people can't help it. ∎

Bent-leg steel table and fish sculpture by Michael Hosaluk (Saskatoon, SK); screen, bench, coffee table, lamp, drop-leaf table, and granite sculpture by Garry Bennett; chair by Norman Petersen; "Floating Table" by Joseph DiStafano.

A retrospective of Garry's Bennett's work is scheduled for January 2001 at the American Craft Museum in New York. It travels to the Oakland Museum in May of 2001.

FURNITURE GALLERY

■

The Furniture Society's 1999 juried competition, the rest of the best

■

James David Lee, Indianapolis, IN

Contemporary Arts and Crafts Chest of Drawers 1998
Solid cherry, hand-hammered copper hardware
72"w × 18"d × 47"h

Commissioned. All material selected and matched cherry. Gustav Stickley reproduction hardware is handmade. Professionally finished with lacquer.

Photo: Bill Cale/Cale & Whyte Studio

John Dodd, Canandaigua, NY

Foyer Greeting Planter 1998
Lacewood, concrete, mirror
10"w × 9"d × 80"h

Concrete pier presenting/displaying a plant in a pot cast into the pier and reflected in the mirror. The concrete pier provides stability and contrast to the smooth lacewood panel and mirror.

Photo: John Dodd

Richard Ford, Jr.
Portland, OR

You're the Money Baby 1997
Polychromed poplar, fabric
51"w × 33"d × 32"h

Photo: Phil Harris

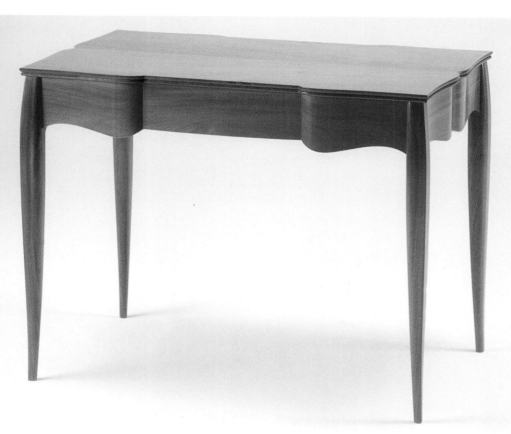

Timothy S. Philbrick
Narragansett, RI

Tea Table 1997
Swiss pear
38"w × 20"d × 28"h

Paris meets Newport in Narragansett.

Photo: Ric Murray

Joseph Godla
Topanga, CA

My Mother, My Wives 1997
Basswood, maple, mahogany, ebony,
aluminum leaf
17"w × 17"d × 62"h

This is a hat rack/hall table.

Photo: J. Godla

Robert Spangler
Seattle, WA

Bubinga Buffet 1997
Bubinga, wenge
59"w × 34"h × 17"d

*I have built only one of these
with the bent top. The
negative space in the center,
for display, draws my eye in
much the same way the
giant escutcheon plates on
ancient Asian furniture do.*

Photo: Mark Van S.

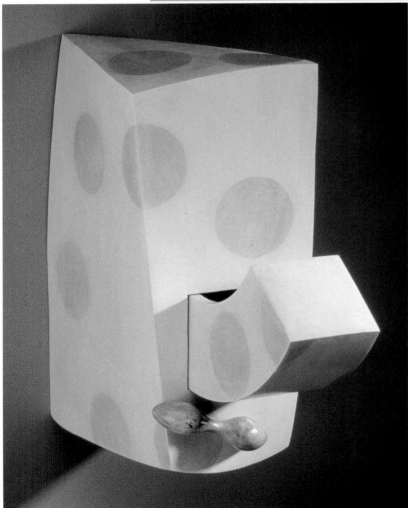

Aaron Hyman, Philadelphia, PA

K and Gumballs 1998
Wood, paint, 10"w × 12"d × 20"h

*This is a wall box with a curved drawer. The drawer opens by
gravity when the latch is released. The piece is meant to change its
appearance when open.*

Photo: Bill Fritsch

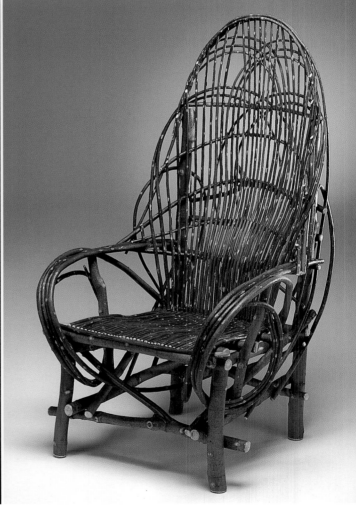

Bill Perkins/Sleeping Bear Twig Furniture
Cedar, MI

Side Chair 1998
Willow, maple
24"w × 24"d × 60"h

Traditional bent willow techniques.

Photo: Don Rutt

Romeu Richard Furniture
Gabriel L. Romeu and Janet E. Richard
Philadelphia, PA

Cleo's Chaise
in production since 1995
Anodized aluminum, hand-printed
velvets and silk
72"w × 17"d × 26"h

*The premise of the piece is to combine
Neo-Classical imagery with Post-Modern
furniture elements, thus our namesake:
"Future Antiquities."*

Photo: Gabriel L. Romeu

Charles R. Caswell Design, Seattle, WA

Bedroom Sideboard (shown open) 1997

Quartersawn cherry, redwood burl, ebony
36"w × 18"d × 36"h

*Inspired by Biedermeier furniture,
which I have long admired.*

Photo: Richard Nicol

Po Shun Leong, Winnetka, CA

Writing Desk (shown open) 1997
Mainly mahogany, 36"w × 24"d × 84"h

*The desk has American themes, slightly reminiscent
of the cultures of Mesa Verde, Sierra Madre
Mountains, Aztec cultures, and modern cities. This
furniture accompanies another desk based on the
civilizations of Europe.*

Photo: Po Shun Leong

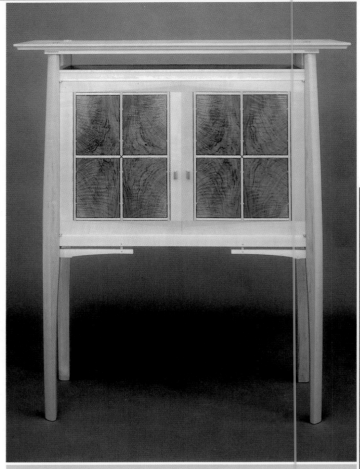

Charles Radtke
Cedarburg, WI

**Ford Cabinet
(Inner Light #3)**
1997
Hard maple, curly
English walnut
43"w × 16"d × 51"h

*A commission in the
Inner Light series.
The intent of this piece
was to let light filter
through the cabinet
via the open top and
the floating-panel
arrangement in
the doors.*

Photo: J.W. Weissmann

Phillip Tennant
Indianapolis, IN

Thrones for the Heartlands 1997
Mixed hardwoods
14"w × 14"d × 78"h

*These two chairs (thrones) examine the
ritualistic nature of the chair icon.*

Photo: P. Tennant

Richard Prisco
Savannah, GA

Lamp '98 1998
(edition of 5)
Mahogany (floor lamp),
cherry (table lamp),
anodized aluminum,
stainless cable
19"dia × 72"h (floor);
19"dia × 25"h (table)

*My work explores
structural solutions to
traditional furniture
design, investigating
their potential for
aesthetic expression.
Influences from bridges,
architecture, and other
structures proudly reveal
supportive methods
which then become
major design elements.*

Photo: Paul Nurnberg

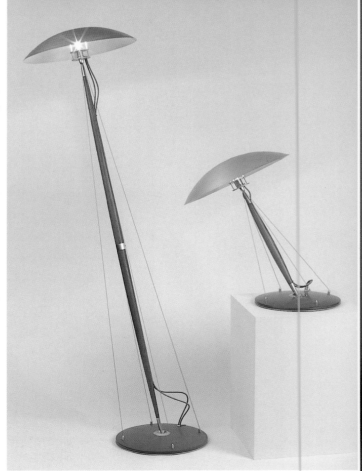

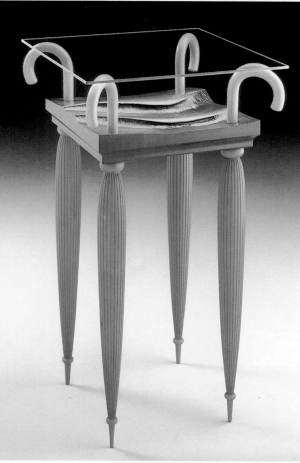

Mitch Ryerson
Cambridge, MA

Water Table 1998
Swiss pear, walnut,
umbrella handles, glass, paint
17"w × 17"d × 32"h

This piece started with the umbrella handles. On one windy day I found thirty umbrellas in the trash cans around the subway entrance in Harvard Square. El Niño was in full swing. The waters everywhere seemed to be rising. Global warming was becoming a reality.

Photo: Dean Powell

Kevin P. Rodel
Mack & Rodel Studios, Pownal, ME

Glasgow Sideboard 1997
White oak, green art glass, copper pulls, 32"w × 19"d × 42"h

This is a short version of a longer four-door sideboard made two years earlier, expressing the early "Glasgow style."

Photo: Dennis Griggs

Peter Danko, York, PA

Europa Chair 1998 (production)

Laminated maple plywood
17.75"w × 23"d × 38"h

A cascade of compound curves for comfort, and the cross sections vary in thickness as needed for strength and economy.

Photo: Peter Danko

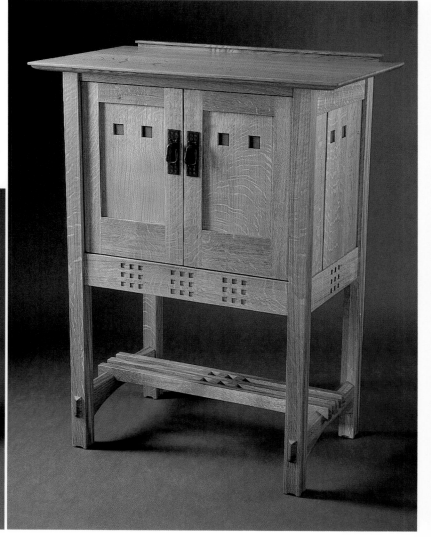

Tim Stewart
Crozet, VA

Xeno Table Lamp
1998 (production)
Birdseye maple
19"w × 31"h

One in a series of lamps combining aluminum, wood, and 12-volt halogen bulbs. Wiring in a lamp is usually concealed; here wiring is eliminated beyond the power cord—the innards of the lamp are exposed and transformed into a design element. The aluminum both supports the bulbs and conducts the electrical current.

Photo: Tim Stewart

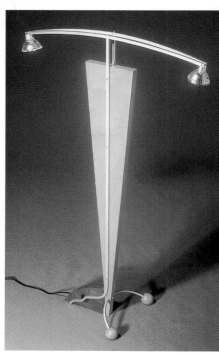

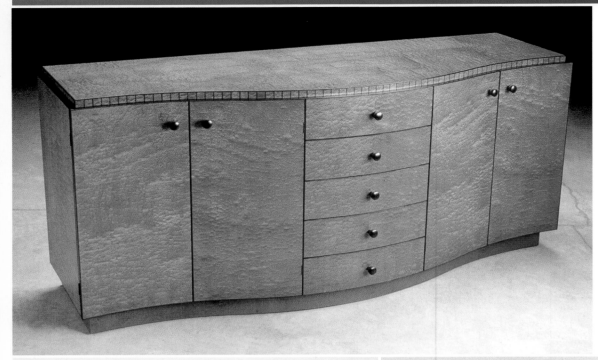

Robert Diemert
Dundas, ON

Campbell Buffet 1997
Pomele sapele with Macassar ebony
pulls and edging
80"w × 24"d × 36"h

*Commissioned by a couple who like
Art Deco style. I use curved veneered
panels a fair bit in my work — this
was made using two-part forms and
multi-curved ply. The top edge of the
cabinet has ebony lines separating
pomele rectangles. Top two drawers
contain removable silverware trays
made of ribbon strip sapele, as is the
interior of the cabinet and drawers.*

Photo: Peter Hogan

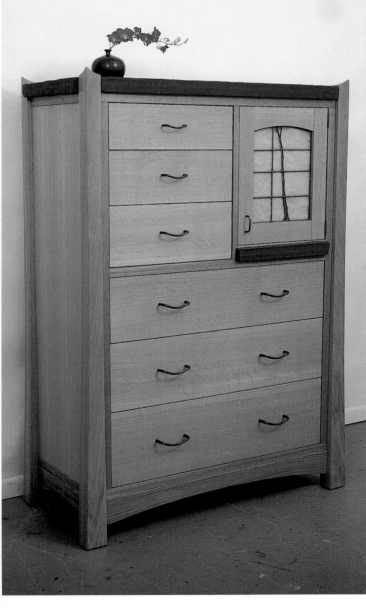

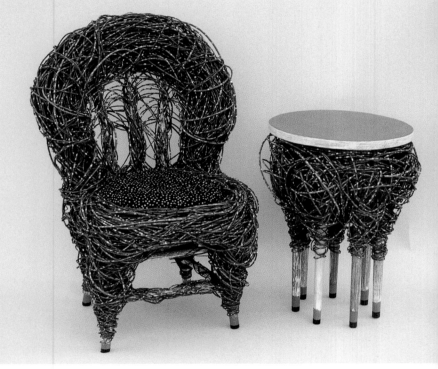

Chris Sell, Kingston, NY

Dresser 1998
White oak, bluestone, stained glass
44"w × 20"d × 63"h

*The bluestone in this piece is
incorporated as a sill to the stained
glass door, and doubles as a front for
the secret drawer which is released
by a hidden latch behind the door.*

Photo: Chris Sell

Margot Proksa, Pocatello, ID

Tot Throne with Table 1997
Old wood chair, dotted willow,
custom cushion
27"w × 22"d × 40"h

*Gathering willow and using it
sculpturally is one of my passions.
One day it dawned on me that it
would be fun to engulf and devour
an old wooden chair with willow.
Then I came across seven old legs
at a thrift store and added the sink
cutout from a remodeling project
for a companion table.*

Photo: M. Proksa

Peter S. Turner
Portland, ME

Game Table with Stools 1997
Birdseye maple, grenadillo
26"w × 18"d × 35"h (table); 12"dia × 25"h (stools)

Checkers of birdseye maple and grenadillo complete this set.

Photo: Dianne & Dennis Griggs

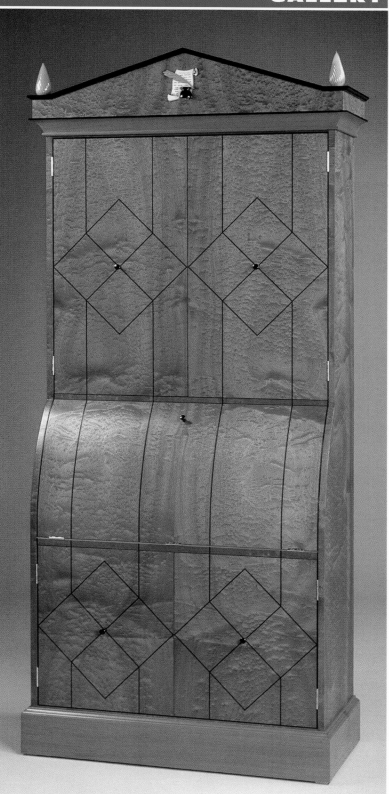

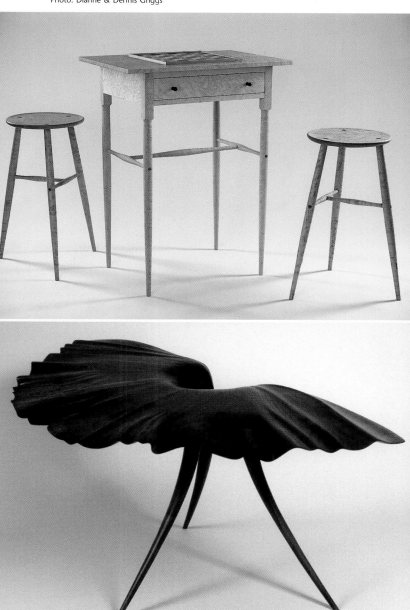

Mark Levin, San Jose, NM

Leaf Table #18 1998
Walnut, 52"w × 24"d × 28"h

*I have worked with this leaf series for years. I am fascinated
by it and have plans to build several more variations.
The largest one was over six feet wide, commissioned by
a jewelry store, and the smallest were a pair of leaf tables
to go by the ends of a couch.*

Photo: Mark Levin

Dale Broholm, Wellesley, MA

Secretary 1998
Pomele mahogany veneer, mahogany, ebony,
satinwood, leather, glass finials
40"w × 22"d × 92"h

*Built for a journalist who wished for an understated yet
contemporary feel.*

Photo: Dean Powell

IT'S NOT ALL WOOD

∎

The quest for meaning leads some makers away from everybody's favorite furniture material, and toward the visual and tactile delights of glass, metal, stone, leather, plastic, and rich fabric

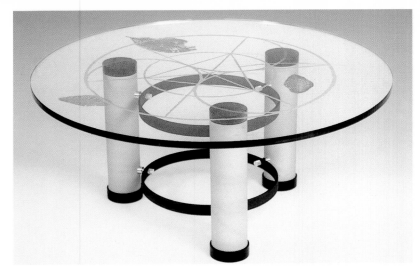

Gabriel Romeu (Allentown, NJ) has taken his childhood love of Erector Sets™ and transcended the limitation of predetermined elements and visually predictable resulting constructions. Skillful at tooling metal and integrating other materials, including stone, glass, fiber, and even wood, he has produced a harmoniously precise, architectonic line of furniture. ("Ring Table," steel rings, ebonized oak caps, anodized aluminum base, etched copper and silver-leafed glass top, 36"dia x 18"h)

Furniture is loaded with meaning. Even at its most humble, it is never merely functional. The ubiquitous tubular-steel and laminate-top kitchen table of the 1950s, for instance, evokes a generation's childhood memories. Whether simple or elaborate, layered with ornamentation or structurally self-evident, furniture can speak volumes about its owner, the culture that produced it, and the historical period from whence it came.

Today's studio furniture makers understand this. Whether analytically or intuitively, they recognize their work as layered with meaning. At the end of the twentieth century, ours is a maturing field, in which makers work with sophistication to bring together concept, technique, and materials. The choice of material is indeed a fundamental one, and for many that choice is not wood. The decision to work with metal, leather, glass, clay, concrete, plaster, or cardboard may come from a love of material or a direct vision of a concept which that material best serves. This survey of work by studio furniture makers working in materials other than wood includes our sense of what we do and why we do it. —*Peter Handler*

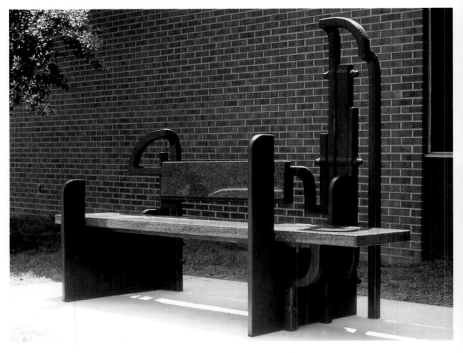

As a blacksmith, **Fred Crist** (Waynesboro, VA) has always been intrigued by the direct process of shaping and manipulating hot iron. "The plasticity of the metal when hot is much like clay," he says, "malleable and yielding under the direction of eye, hand, and hammer. Once completed, the forged object reflects this process, its own structure, and the will of the maker." ("Memorial Bench," forged steel, stone, 84"w x 36"d x 60"h)

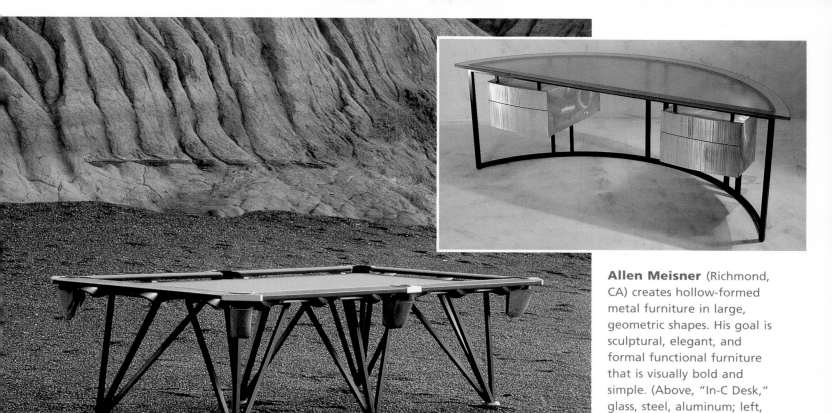

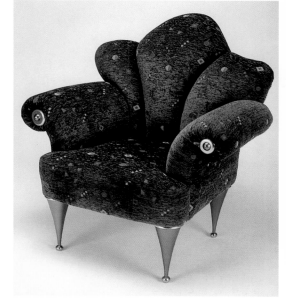

Allen Meisner (Richmond, CA) creates hollow-formed metal furniture in large, geometric shapes. His goal is sculptural, elegant, and formal functional furniture that is visually bold and simple. (Above, "In-C Desk," glass, steel, aluminum; left, "Too Pool," aluminum, steel, wood, bronze)

Peter Handler (Philadelphia, PA) believes that the art and design that any culture leaves behind tell more about who the people who created it were than any other artifacts. Combining an interest in historical forms and a fascination with technology, Handler, working primarily with anodized aluminum as well as with fabric, glass, stone, wood, laminates, and solid surface materials, strives to create work that is challenging and harmonious, balanced between whimsy and formality. "I use anodized aluminum because of its lightness, great strength, ease of machining, and ability to take color. It allows me to create almost any form I can imagine, making strong furniture out of seemingly flimsy components. It lets me speak." His hope is that his clients—or their children—will look at his work in thirty years, still receive joy from them, and say, "Nice 90s design." (Chair, anodized aluminum)

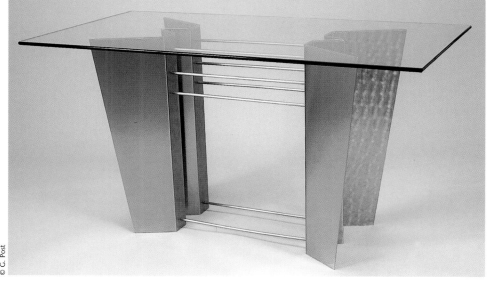

© G. Post

As is true with many metal furniture makers, **Marsha Lega** (Joliet, IL) started out as a jewelry designer and graduated to furniture. Lega loves "the stability of metal and the intrinsic beauty waiting inside ready to be translated" into furniture. ("F Table," 40"w x 18"d x 30"h)

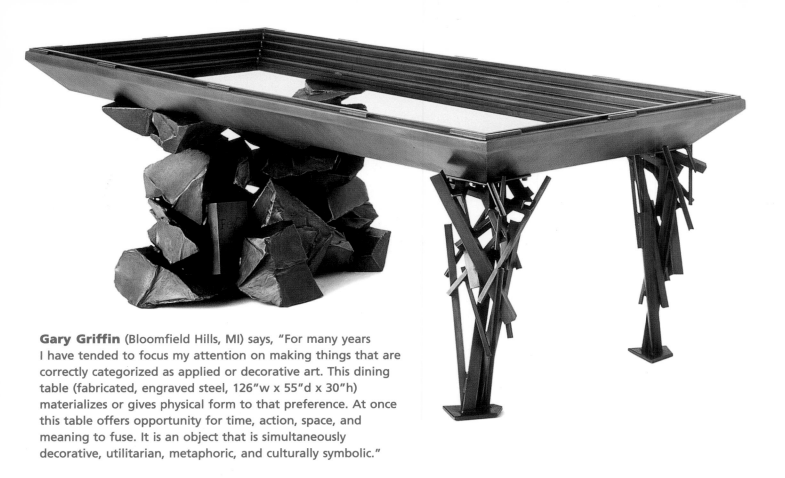

Gary Griffin (Bloomfield Hills, MI) says, "For many years I have tended to focus my attention on making things that are correctly categorized as applied or decorative art. This dining table (fabricated, engraved steel, 126"w x 55"d x 30"h) materializes or gives physical form to that preference. At once this table offers opportunity for time, action, space, and meaning to fuse. It is an object that is simultaneously decorative, utilitarian, metaphoric, and culturally symbolic."

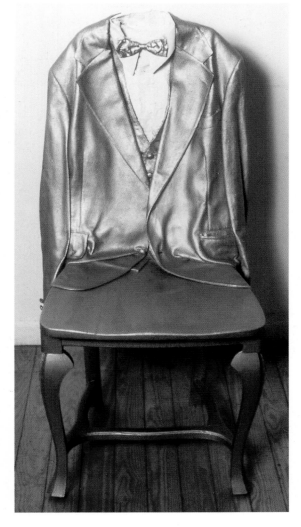

"Historically, a chair is furniture," says **Johanna Goodman** (Philadelphia, PA), "just a place for people to sit. Yet to me, it is much more than that. It's a place to think, relax, and dream. It's a place to look across the table and see another person. The chair helps us be social. Through its comfort and support, each of us approaches others at eye level. The chair is a three-dimensional canvas upon which I can express my ideas. As I build and paint on the chair, I use acrylic paint with fabric, leather, metal, found or used objects, wire, beads, feathers, etc. I use whatever material the idea requires, which adds to the tactile enjoyment of the artwork." (Left, "Gold Suit," suit jacket, gold powder, acrylic, wood chair, 40"h; right, "Frida II," mixed media, 43"h)

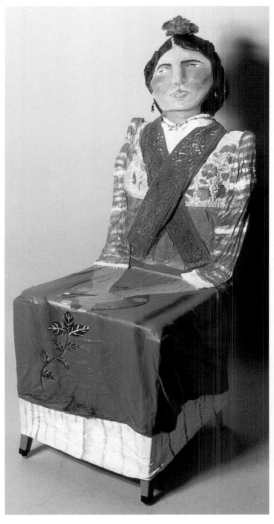

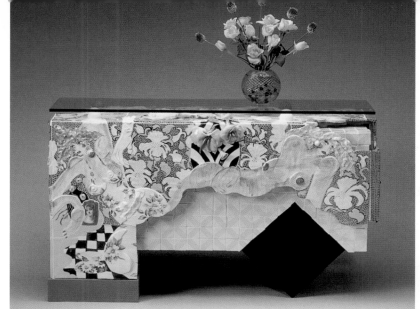

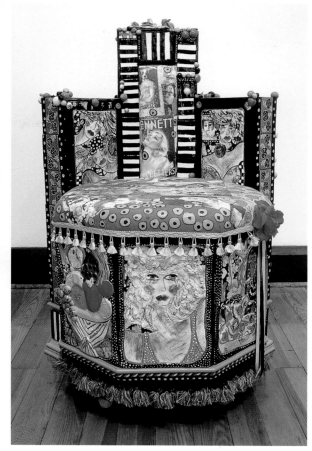

The furniture of **Laney K. Oxman** (Hillsboro, VA) is made primarily of clay, incorporating marble, glass, and hand-printed fabrics. Humor, whimsy, and dense, often erotic imagery are hallmarks of her work. "In my 'perfect world,'" she says, "I would wish for art, design, and beauty to be an integral part of every functional object we use. It would be wondrous to enter a room and actually stop, admire, and enjoy the form, colors, and patterns before sitting or piling it with stuff." I know it is superbly idealistic, but it is why I create furniture." (Above, "Girl Table"; right, "I'm a Little Princess")

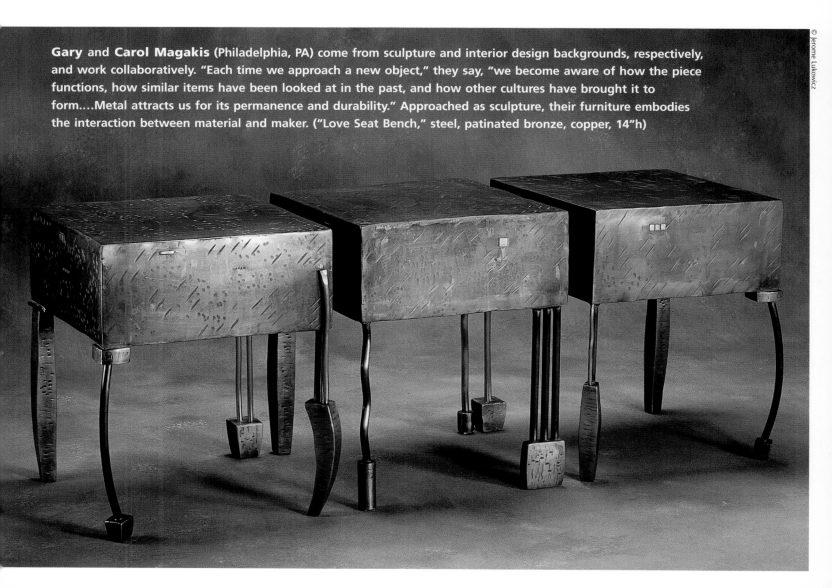

Gary and **Carol Magakis** (Philadelphia, PA) come from sculpture and interior design backgrounds, respectively, and work collaboratively. "Each time we approach a new object," they say, "we become aware of how the piece functions, how similar items have been looked at in the past, and how other cultures have brought it to form....Metal attracts us for its permanence and durability." Approached as sculpture, their furniture embodies the interaction between material and maker. ("Love Seat Bench," steel, patinated bronze, copper, 14"h)

Linda Sue Eastman (Winona, MN) is a furniture maker who uses leather, sometimes in combination with wood: "For surface designs I have three primary sources of inspiration: nature, ethnic pattern, and period design. I abstract designs that nature provides, for example, the back of a horseshoe crab, the interior of a paramecium or a pine cone not yet opened. For ethnic design I look mainly to the Japanese use of color and pattern. From period design I am fond of the Arts and Crafts Movement and Art Nouveau. The materials I use have their own appealing textures—the impressions and cuts in tooled leather, the softness of suede, the flow of horsehair, the hardness of wood—that all contrast and complement each other but combine into a unified whole."

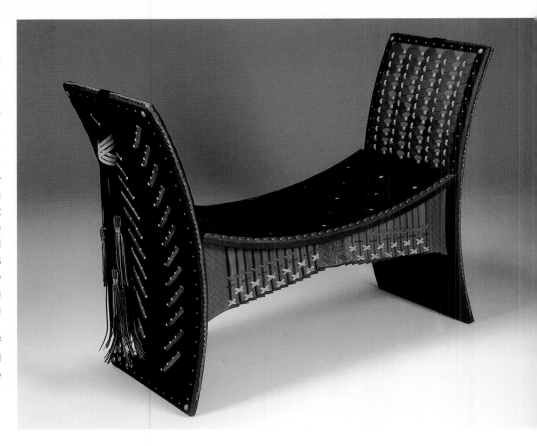

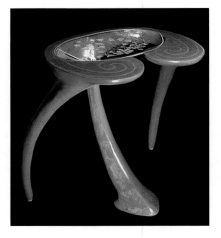

About his concrete furniture, **Charles Streshley** (Ashlan, VA) says, "My response to the Information Age is the manipulation of mundane and archaic materials into seamless functioning sculptures. Natural and organic forms are created from elements of the urban environment. I address this dichotomy by designing furniture that does not seduce the viewer with exotic woods, intricate inlays, and clever joinery but is driven by concept. Works are titled to provoke satirical commentaries on power, sex, and technology. Graceful arcs of steel bars are drawn in space and wrapped in woven wire. A primal ooze of fluid stone is pressed by hand over this armature. The creative struggle continues through the tearing down and building up of layers." ("E-Table," 26" x 23" x 18")

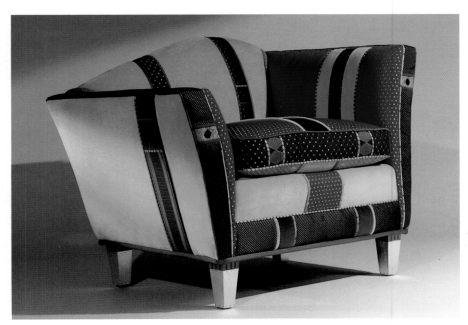

Robert Harman (Bloomington, IN) is an upholsterer who makes furniture designed in response to his materials. "It is hard to describe how I work. It is definitely not an intellectual process but a visual one wherein I spend lots of time comparing three fabrics to see how they react together until the most appealing combination jumps out at me. I then proceed to the next part, always in threes. I repeat the process until I'm finished, all the time looking and squinting and observing my reaction to what I'm seeing. Starting over if necessary. Mostly I spend my time stepping back, looking and squinting, aware that I don't really know what I'm looking for but trusting that I'll recognize it when I see it. For me creativity is a guided meditation of a very high order."

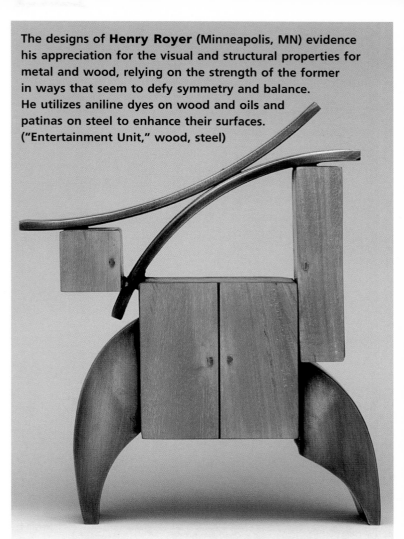

The designs of **Henry Royer** (Minneapolis, MN) evidence his appreciation for the visual and structural properties for metal and wood, relying on the strength of the former in ways that seem to defy symmetry and balance. He utilizes aniline dyes on wood and oils and patinas on steel to enhance their surfaces. ("Entertainment Unit," wood, steel)

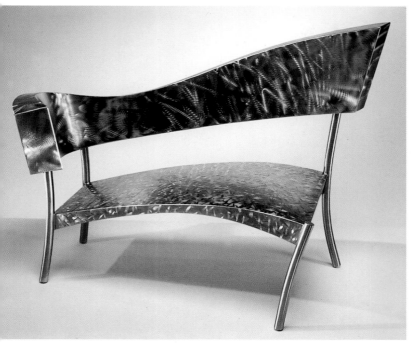

Paul Freundt (Talking Rock, GA) sees himself as a sculptor whose format is furniture, principally seating—sculpture made accessible to the human form. His minimal, flowing, volumetric forms are made possible with hollow-constructed ferrous metals, ornamented by surface texture and patination. ("Andromeda," stainless steel, 53"w)

Charles Swanson (New Bedford, MA): "After twelve years in Catholic schools, acute guilt and self-punishment are second nature. Having spent many years causing myself technical difficulty, I turned forty, saw the light, and ceased running on automatic pilot toward techno-torment. These pieces are examples of the new directness in the way I've begun to work. The steel structure is made and the plaster cast in between. The steel rusts a little and bleeds into the plaster. Wood parts are added where appropriate, with hinges that are integral to the structure. A nice warm little package, directly done, without too much pain, and that's all right." ("Open Ended Series #7," plaster with acrylic, steel, 76"l)

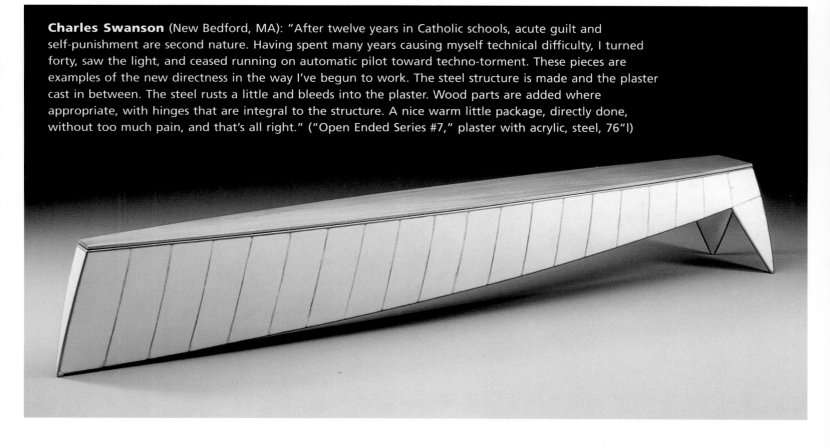

Tim O. Walker (Miami, FL) has made leather furniture over a matrix of wood: "As with much of my work, it was intentionally referential in the use of color, pattern, motif, and shape, but in the end, it really didn't accommodate any of the immediate references. Which is why I think I'm interested in patent leather. The visual cues that it presents are counter-intuitive to what it in fact is. It appears hard, almost ceramic-like in its color saturation and wet-gloss finish, yet it is soft, bendable, curvable, contourable, sewable. The surface seems vulnerable in its glossy depth but is in fact extremely tough and durable. So the material, in many ways, is ideal for furniture....But technically it's really difficult to achieve these effects. So, I guess that's why I do it, as well as why I don't do it anymore." (Right, "Steamer Chair"; below, "Apostrophe Chair")

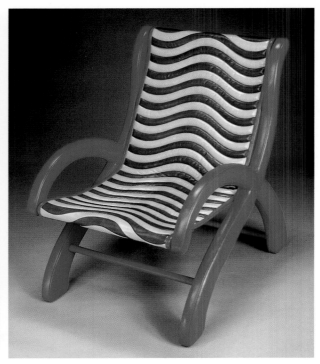

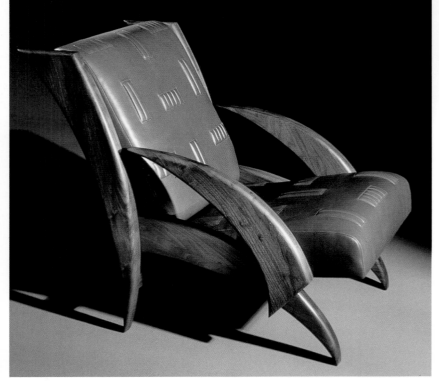

The work of **Stephen Schock** (Macomb, MI) and the Detroit Chair Company has visual irony and puns at its core. "All of the work has been about challenging preconceived ideas about what furniture is and what can be possible if we just look at our resources and production from a different point of view, and, as often as possible, with a sense of humor." ("Bertoia/Detroit," 40"h)

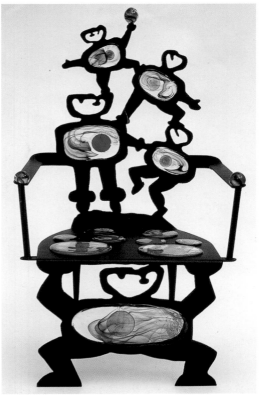

Coming to furniture after a long career as a glassblower, **Drew Smith** (Tampa, FL) now works with his wife, **Kirsi Smith**, "expressing the positive, optimistic values of life" through colorful, spontaneous pieces, often inspired by pre-Mayan cave drawings. ("Man Juggles Family Throne," steel, glass, epoxy, 50"h)

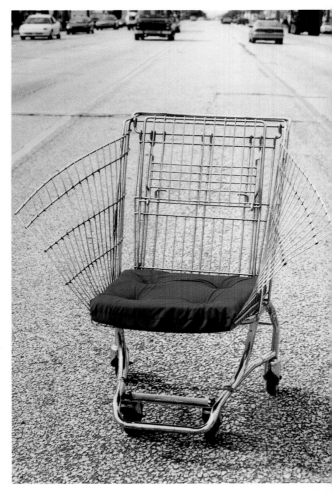

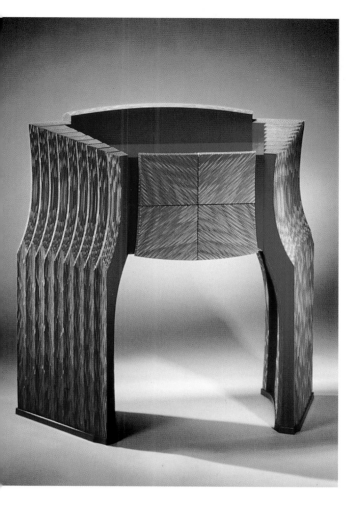

Brian Gladwell (Regina, SK) began his work in corrugated cardboard alongside his regular work in wood. "I was looking for a way in which furniture could move beyond its role as an affirmation of social status or traditional moral and personal values, and function in a self-critical manner. I used a humble and ephemeral material to create work that exercised all the craftsmanship and design sophistication of high furniture, but is unlikely to last for generations. This enabled me to develop a critique of furniture conventions such as the hierarchy of materials and the relationship between ideas and permanence in assessing lasting value in contemporary culture." ("Console Table with Drawers," cardboard, lacquer, 34"h)

J.M. Syron and **Bonnie Bishoff** (Gloucester, MA) are primarily wood furniture makers, with a twist. A major visual and functional element to much of their furniture is Bishoff's use of polymer clay—as table surfaces, chair backrests, lampshades, and totally whimsical details. She introduces a material and imagery unusual among today's studio furniture makers.

Philip C. Cannata (Boston, MA) is a landscape architect who makes furniture out of slot-assembled multiple layers of corrugated cardboard. "My training in landscape architecture has infused my approach to furniture design with a conscious effort to be a custodian and conservator of our planet. This unique aesthetic is integrally related to its construction technology, but the sculptural pieces are as much defined by the material itself." ("Crozier III" chair and ottoman with "Y-knot Table")

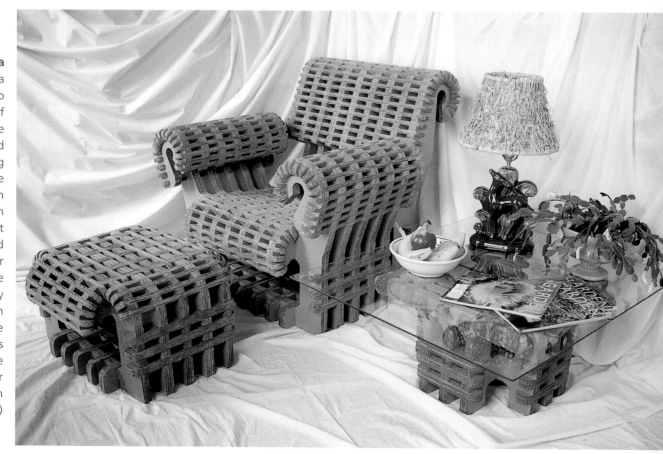

BOOKING PASSAGE

AMY FORSYTH

■

Meaning begins most easily with words, and this architect-turned-maker shows how a literary vignette can generate a sea of ideas that culminate in a mutable table for two or ten

Men at Sea

You can come to the end of talking, about women, talking. In restaurants, cafés, kitchens, less frequently in bars or pubs, about relatives, relations, children, men, about nuance, hunch, intimation, intuition, shadow; about themselves and each other; about what he said to her and she said to her and she said back; about what they feel.

Something more definite, more outward then, some action, to drain the inner swamp, sweep the inner fluff out from under the inner bed, harden the edges. Men at sea, for instance. Not on a submarine, too claustrophobic and smelly, but something more bracing, a tang of salt, cold water, all over your callused body, cuts and bruises, hurricanes, bravery, and above all no women. Women are replaced by water, by wind, by the ocean, shifting and treacherous, a man has to know what to do, to navigate, to sail, to bail, so reach for the how-to book, and out here it's what he said to him, or didn't say, a narrowing of the eyes, sizing the bastard up before the pounce, the knife to the gut, and here comes a wave, hang on to the shrouds, all teeth grit, all muscles bulge together. Or sneaking along the gangway, the passageway, the right of way, the Milky Way, in the dark, your eyes shining like digital wristwatches, and the bushes, barrels, scuppers, ditches, filthy with enemies, and you on the prowl for adrenaline and loot. Corpses of your own making deliquesce behind you as you reach the cave, abandoned city, safe, sliding panel, hole in the ground, and rich beyond your wildest dreams!

What now? Spend it on some woman, in a restaurant. And there I am, back again at the eternal table, which exists so she can put her elbows on it, over a glass of wine, while he says... What does he say? He says the story of how he got here, to her. She says: But what did you feel?

And his eyes roll wildly, quick as a wink he tries to think of something else, a cactus, a porpoise, never give yourself away, while the seductive waves swell the carpet beneath the feet and the wind freshens among the tablecloths. They're all around her, she can see it now, one per woman per table. Men, at sea.

— *Margaret Atwood*

Literature is a rich source of furniture design ideas. Writers of fiction have always used furniture and furnishings to set scenes, establish characters, and activate plots.

In *The Magic Mountain*, for instance, Thomas Mann describes the chair in which patients lie outside to "take the cure," establishing a tone for his novel set within a tuberculosis sanatorium. Such a description is rich in detail and effect that could provide inspiration for designing furniture of the period. "The frame—a little old-fashioned, perhaps, a mere matter of taste, for the chair was obviously new—was of polished red-brown wood, and the mattress was covered in a soft cotton material; or rather, it was not a mattress, but three thick cushions, extending from the foot to the very top of the chair-back. There was a head-roll besides, neither too hard nor too yielding, with an embroidered linen cover, fastened on by a cord to the chair, and wondrously agreeable to the neck."

Another approach, perhaps more challenging, is to distill and amalgamate furniture ideas that are inspired by the theme, concept, or form of a piece of literature. That's what I did with Margaret Atwood's vignette, *Men at Sea*.* The text becomes a subliminal organizational guide that influences anything I might see throughout the duration of the project. It establishes the basic motif, though it is not taken literally.

One reason this little story so effectively catalyzes form-making is that it vividly describes places and physical artifacts that are used to represent otherwise invisible concepts. In this story, as in her novels, Atwood calls forth emotions that are engendered within the body through physical conditions and experiences, such as claustropho-

*Published in Atwood's collection *Good Bones and Simple Murders* (New York: Doubleday, 1994).

bia, isolation, containment, confinement, and the less spatial, but still visceral, adrenaline rush of danger. Finally, the story turns back to the contrast between two gender perspectives, not unlike the unsettling experience of speaking a different language from someone with whom intimacies might otherwise be possible.

December 30, 1997

The indoor space is a physical manifestation of the feminine interior, where the daily routine of conversation over coffee might turn suddenly threatening with the revelation of a betrayal. Furniture inspired by this part of the story might be enveloping, evoking a place where too many lives have been lived and examined.

translucent scrim

wheels – can move outside like a tent (w/ a big door!)

canopy bed – two heads, one foot

sliding panel doors w/ scrim

cherry top, legs, apron

maple veneer strips

bent laminated legs

illuminated tables

glass top

stacked, carved cherry

turned maple legs

translucent scrim w/ opaque objects sandwiched between & attached to surface

translucent scrim panels

red velvet upholstery

dark figured veneer – wenge?

peephole chair

illuminated screen with internal objects that make shadows, objects mounted on panels

Enveloping Furniture
December 30, 1997

perforated metal light

bent laminated cherry cabinet

maple legs

whitewall tires?

Trenchcoat cabinet

travel stickers

leather alligator – embossed?

briefcase nightstand

"one night stand"

dyed, carved mahogany

brass found object parts

carved drawer

"tatoos" inside – hieroglyphic

maple sides & shelves

nightstand
one of a pair – anatomically different

carved mahogany tops

tubular metal legs

world's fastest TV stand

Action Furniture
December 31, 1997

December 31, 1997

The exterior is evoked by vigorous masculine phrases reminiscent of childhood swashbuckler tales. Furniture arising from this part of the story would have the capacity to move at great speeds, or perhaps to be of a wiry substance that bends, but only because it must, to accommodate its function.

The deck of the ship is analogous to the table top, the site of explorations that can turn claustrophobic or life-threatening depending upon the atmospheric or emotional climate. The gap between physical things and their capacity to indicate interior meaning leads to a misunderstanding between inhabitants of the interior and exterior realms.

carved
stack-
laminated
mahogany
w/ lamp

painted

January 5, 1998

January 2, 1998

January 2, 1998

The first sketch that evolved from the story is a single illustration—an overall impression of action and relationships. The furniture is not only a table but also the deck of a ship, upon the surface of which the action takes place.

January 5, 1998

If the table had been a literal interpretation of the illustration, it might have looked something like this. However, I think a better table results once it travels some distance from the story itself. The story is a point of departure for the table, not its sole inspiration.

I am not so interested in the division of the genders in the story, as I am in their unspoken sim-ilarities of circumstance. The parallels between a table and the deck of a ship become important to the characters in the story, as well as to those who will sit at my table. Comfortable routine threat-ened by danger, and the way spatial relationships can mirror these conditions, become something more universal, since they can be experienced physically. My design process spins forth many dif-ferent threads of thought that I attempt to weave together. The story provides the initial inspiration, and then becomes a gauge to test the components to make sure they work together. I generally find that design is a system of distillation. The initial venture assembles many relevant ideas, then grad-ually eliminates those that don't contribute to the strength of the scheme.

February 21, 1998

Sometimes an idea that is borrowed from another source and woven into the scheme seems at first to disrupt the process but later becomes important. For example, a visit to an art gallery at first yielded a literal reinterpretation of the physical structure of a painting that appeared to be drawn in chalk on a piece of slate or chalkboard. The painting invited the viewer to investigate its edge to determine the material of the surface. Exploration revealed an elegant truss system that held the painting surface (plywood?) away from the wall, and created a mysterious shadow space behind the painting. So, the painting, which already seemed to be about the illusion of space, also created the illusion of the material on which it was painted, and moved into real, three-dimensional space. The painting became a sign for all the associations one might make about a chalkboard, even though the actual materials were other than what they appeared to represent.

February 28, 1998

I imagined what might occur if the truss structure I had drawn held a representation of water, carved of wood and dyed a liquid green or blue, and how the solid surface of the "water" might be perforated to connect with the space beneath the truss, which resembles a pier. I thought about water as a substance that conforms to gravity and to the shape of solids that surround and invade it, such as a floating bottle that displaces the water in favor of the message it carries. I imagined a table-like construction that could also explore abstract ideas about representation and depth. The next question was spatial orientation. If a carved surface can represent a section of water cut from its surroundings, should it be oriented horizontally or vertically? Horizontal, it represents water almost literally—the sea could take this rolling form on a windy day. Vertical, it's like a painting that recognizes its own artifice, since real water could not actually remain upright. So, being vertical further abstracts the piece. It also implies the danger of water in a storm or tidal wave.

Vernon Fisher painting

paint continues

truss

chalk-board-like surface

February 21, 1998

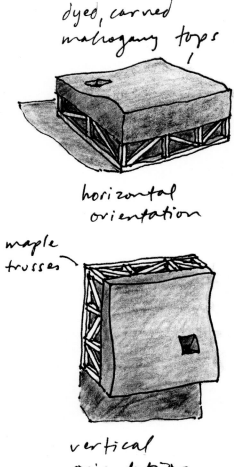

dyed, carved mahogany tops

horizontal orientation

maple trusses

vertical orientation

February 28, 1998

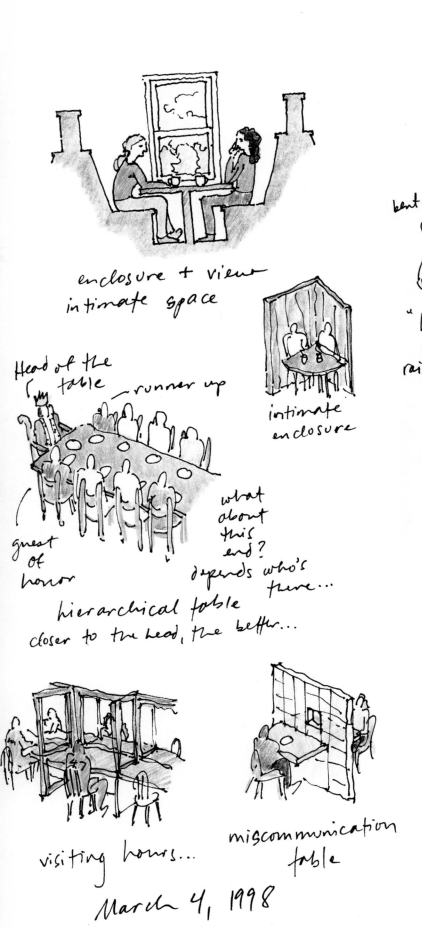

enclosure + view
intimate space

Head of the table —runner up

intimate enclosure

guest of honor

what about this end?
depends who's there...

hierarchical table
closer to the head, the better...

visiting hours...

miscommunication table

March 4, 1998

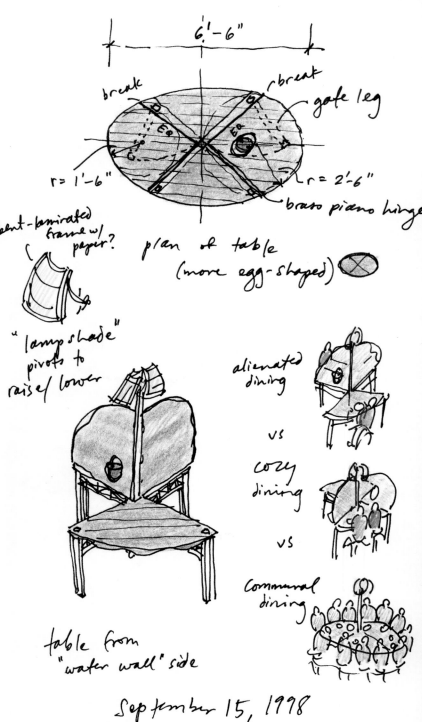

6'-6"

break break
gate leg

r = 1'-6" r = 2'-6"
brass piano hinge

bent-laminated frame w/ paper?

plan of table (more egg-shaped)

"lampshade" pivots to raise/lower

alienated dining

vs

cozy dining

vs

communal dining

table from "water wall" side

September 15, 1998

March 4, 1998

The variety of spatial experiences defined by the action of the story also affects the design. These sketches recreate the intimate enclosure of a restaurant booth as experienced by the women in the first part of the story, while the men of the second part occupy a space around a communal table strictly regulated by a naval hierarchy. Unfortunately, the couple in the third part of the story is imprisoned by their inability to communicate, as might be represented by a drawing of visiting day at a jail. Paradoxically, physical separation can encourage intimacy, as in the case of a confessional, but it also can exacerbate alienation.

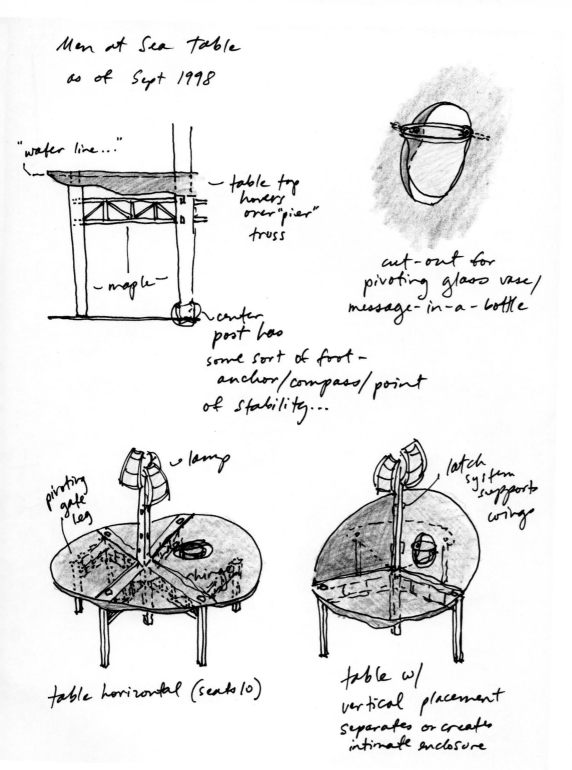

Men at Sea table as of Sept 1998

"water line..."

— table top hovers over "pier" truss

— maple —

center post has some sort of foot-anchor/compass/point of stability...

cut-out for pivoting glass vase/ message-in-a-bottle

pivoting gate leg

lamp

hinge

latch system support wings

table horizontal (seats 10)

table w/ vertical placement separates or creates intimate enclosure

September 15, 1998

These ideas intertwine to create a version of the table that is much too complicated, but has many interesting components. Too many! Some elements were hard to justify. Why was the table egg-shaped? Every explanation sounded contrived. The mast/lighthouse/anchor piece seemed important as a structural element, since it provided stability and was a latching post for the hinged tabletop. However, it also barricaded the people on opposite sides of the table even when the top was com-pletely horizontal, which was not part of the idea. It created a pool of light where everyone gathered, but it competed with the message-in-a-bottle vase that already broke the surface. The most problematic element was the truss, which had become a pier that supported the table surface. I didn't mind the fact that it was underneath the "water" because I had already imagined that the water and the deck of the ship had merged into one two-sided surface, but a stolid pier really had no business in a tale of tables and ships, intimacy and risk. I liked the way the mahogany tabletop floated above its maple undercarriage, but the legs were still undefined. Should they be ma-chinelike, as a part of the lost pier? How does one make vertical sup-ports in a floating world?

At this point distillation begins. Despite the difficulties of this de-sign, there were some aspects I liked. The tabletop is deck-like, then meets a "waterline" partway down the side edge, then becomes a wa-tery undulating surface. Raising the leaves reveals this surface. I liked how the table seemed to have more than one persona, because it could protect and contain two people inti-mately when the leaves were vertical, or allow a large group to occupy the entire surface when hor-izontal. I also liked how this hinging represented water in its resting and turbulent states, symboliz-ing the routine and danger inherent in the story. The other element worth preserving was the glass vessel suspended within a cavity in the tabletop. It pivots as the tabletop rotates from horizontal to vertical, always remaining level, like a floating bot-tle or a nautical compass.

October 4, 1998

At first, I considered making the mast of the lamp removable when the table was in its horizontal position, to create a kind of exterior lighthouse, but this was too complicated. I simplified the hinging system so that there was only one pivoting panel, but the shape of the table and its structure were still undetermined.

November, 1998

I resolved many of the remaining issues by focusing less on the nautical imagery and more on the human relationships of the story. Rather than adhering to a nautical rationale for the understructure, I thought of it metaphorically, like the frame for a painting, a construct external to the narrative that nevertheless contributes to understanding.

The understructure is maple, and the legs are anthropomorphic and paired. Two pairs separate as gate legs to support the hinged panel as it descends to its horizontal position, while one pair is fixed. A turned central post stabilizes the gate legs. I resolved the shape of the tabletop by emphasizing the dual nature of the table as a place for two, screened by the vertical panel, or for up to ten with the top in its horizontal position. Like the ocean's horizon, the arc that defines the opposite edge of the table originates from the viewpoint of a confidant during an intimate exchange. A shift in the curve at the point of the hinge disrupts symmetry to accommodate the suspended vessel. When the table is set for two, the vertical plane shelters the diners, excluding those outside its protective domain. When the table is horizontal, seating many, complex hierarchical relationships between diners ensue. The region above the tabletop is the public realm, visible to all, while the territory beneath the table becomes private and covert, sheltering clandestine activity. The tabletop reveals its order through embedded brass symbols that imply a map for the navigation of concealed relationships. One of these archaeological icons is a brass arm that emerges from its crevice to support the hinged panel in its vertical orientation. The others reflect intangible patterns above and beneath the tabletop, such as the motion of the gate legs or the relationship between the pair of diners that generated the shape of the tabletop.

. . .

The most intriguing aspect of this design method is its capacity for a variety of directions. Another reader would interpret the story in a different way, and design something correspondingly diverse. This design stems from my own reading of the essay as a set of concurrent spatial and emotional circumstances between the interior and exterior

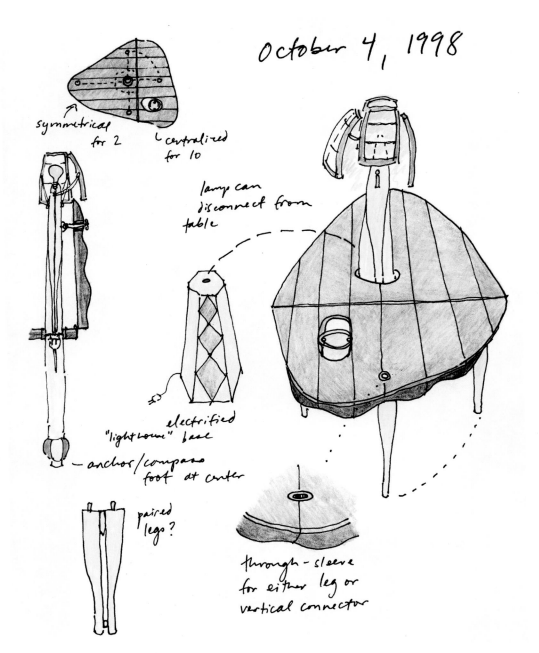

October 4, 1998

symmetrical for 2

centralized for 10

lamp can disconnect from table

electrified "lighthouse" base

— anchor/compass foot at center

paired legs?

through-sleeve for either leg or vertical connector

November 1998

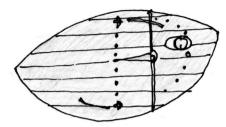

table top, with
brass inlay - inlay marks
geometric order of the table -
marks like constellations

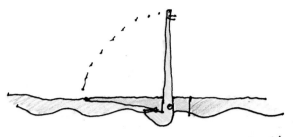

brass arm to hold
leaf vertical

table horizontal

table top "floats" on
brass pins & sleeves
machine screws allow
for wood movement

November 30

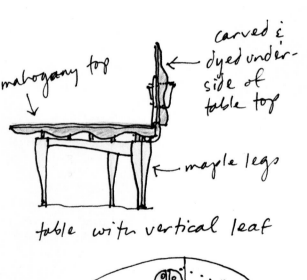

mahogany top

carved &
dyed under-
side of
table top

maple legs

table with vertical leaf

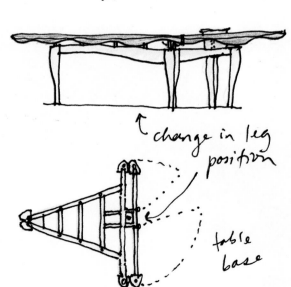

change in leg
position

table
base

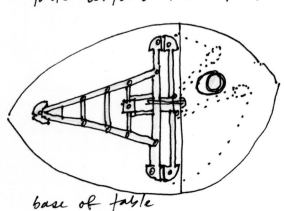

base of table

realms. The table becomes a changing surface that symbolizes the repetition and danger inherent in both the physical and emotional worlds. Although the story inspired the design of the table, and provides an additional layer of meaning should anyone be interested in contemplating the table as a designed object, the built object should also have its own strength. It should contribute to the lives of those who use it without demanding that these ideas be omnipresent, and it should ultimately be a beautifully crafted and useful artifact. ■

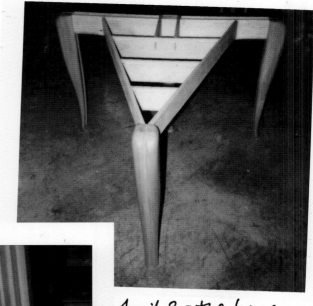

April 2 - the base

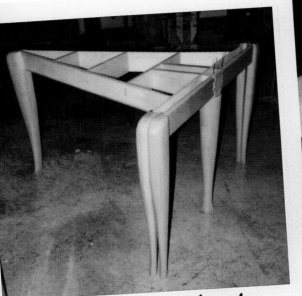

April 2 - base w/ gate legs closed

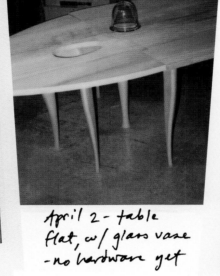

April 2 - table flat, w/ glass vase - no hardware yet

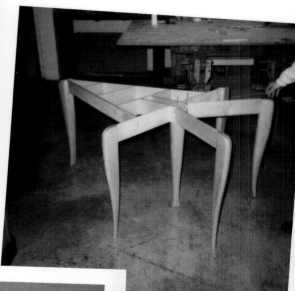

April 2 w/ gate legs extended

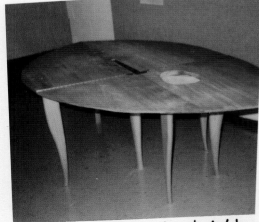

April 25 - assembled table w/ hardware - "table for 10" position

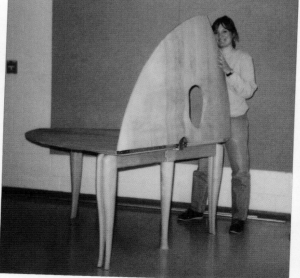

April 25 - assembly prior to sanding & finishing - "table for 2"

The author would like to acknowledge, with great appreciation, the advice, support, and assistance of Charley Farrell, Tom Fahrbanich, Anthony Ulinski, Tim McInnis, John Dunnigan, John Kelsey, Rick Mastelli, and the College of Architecture: Dean Hight, Ken Lambla, the students, faculty, and staff, and especially Greg Snyder and Rich Preiss.

PUTTING IT TOGETHER

BRIAN GLADWELL

■

■

*Furniture making might seem
a stolid career, but it has unexpected
promise, as shown by the continuing
adventures of Michael Fortune*

The designer/craftsman has the potential to be an agent for change: to improve the mainstream furniture industry, to broaden the variety and increase the quality of furniture in the marketplace, and to affect the very culture of making and consuming objects. One furniture designer/maker who has grappled with all of these challenges is Michael Fortune. Endowed with formidable technical ability, he has combined a successful studio furniture career with an active engagement in the furniture industry and also in economic development projects, at home and abroad. Since the early 1980s, Fortune has served as a teacher, mentor, and inspiration for many furniture makers in Canada as well as throughout the world. In 1993, Fortune won the country's highest award for craft, the Saidye Bronfman Award, for his sharply conceived tables, chairs, and case furniture.

In a series of conversations from his home near Peterborough, Ontario, Fortune articulated his perspective on the kind of social and economic contribution that studio furniture makers can make. "The arts community has an incredible level of creativity and skill," he told me, "which often goes into one-a-of-a-kind pieces that virtually disappear once they go into the clients' homes. Much thought goes into resolving those projects, and I'd like to see it get broader exposure." Fortune sees working in industry and in the community not as a contradiction with one-of-a-kind work, but as as diversifying. "Greater artistic and financial accessibility would advance the whole studio furniture movement," he suggests.

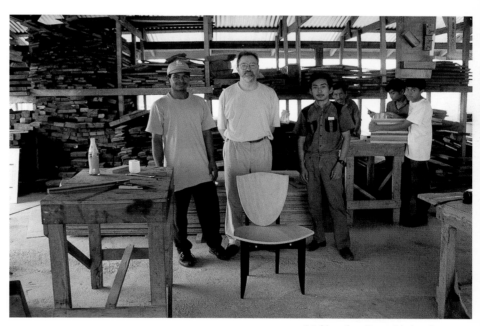

Designer/Craftsmanship in Industry

Fortune says studio furniture makers can make two significant contributions to the furniture industry: design innovation and production savvy. Decorators and stylists usually have a good idea of what the market wants, Fortune says, but they aren't much help in working out how to make the product. Industry engineers know how to make the thing efficiently, but with no eye for aesthetics. The designer/craftsman can bridge these two professions, and may also be able to compress the time it takes to go from concept, through production, to marketing—particularly

Making furniture for local markets as well as for export offers a path to economic development in forested countries around the world. Michael Fortune, center, with the shop foremen at New Hope Trading in Belize, shows off the chair he designed for export to Europe and the Americas. At home in Canada, Fortune makes tables like the one detailed at top left (full view, p. 120).

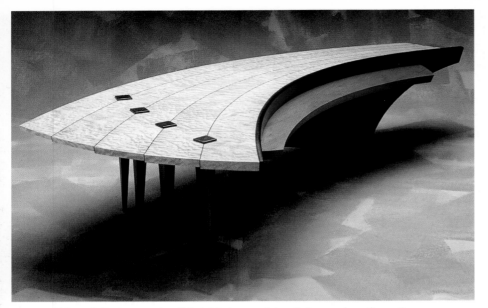

Although Fortune makes this table in a variety of sizes and configurations, they all come off the same set of jigs. The materials are blistered maple veneer and ebonized, steam-bent cherry.

Photos: David Allen

Commissioned to stand in front of an antique kimono, this table's folded planes indicate the influence of Fortune's teacher, the late Don McKinley. Macassar ebony and curly maple.

The visual lightness and delicacy of #1 Chair approaches the strength limits of wood, a feat made possible by carefully engineered production jigs. The sequence of 38 jigs is so complex that Fortune videotaped the process as a reference for future runs. Macassar ebony with sterling silver inlay.

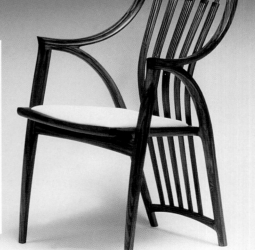

Photo: David Allen

for small or start-up businesses. Timing is important because new products can be introduced only at certain times of the year, through furniture markets and shows. "If you miss your market introduction window, then you've got to wait for next year," Fortune notes, "because furniture is becoming more of a fashion industry with each passing season."

The other strength that studio makers can bring to furniture producers is the ability to resolve details. "Large companies don't have the expertise or the time to resolve small details the way they should, and that's often what small businesses can do extremely well," Fortune says. Industry is often tied to what it already knows how to do; studio makers can access, debug, and integrate a broader range of experiences. Fortune cites German marquetry artist Ulrike Scriba's work with BMW as a good example. In addition to her own studio work, Scriba designs dashboards for the luxury car maker. She contributes original designs and also solves such production problems as getting the veneers to mold around complex shapes.

Similarly, during Fortune's early career he adapted industrial steam-bending techniques to the studio. Now he can take that knowledge back to industry. Craftwood Industries, a specialty manufacturer in Toronto, once asked Fortune to produce the back legs for a Josef Hoffmann chair. The legs required an extremely tight bend, then a transition into a bend in another plane. Fortune went into the factory, made the prototype jigs, and trained the employees to steam-bend the parts. On another occasion, Craftwood came to him to resolve production of a Ward Bennet chair with a steam-bent part that was too complex for the traditional metal backup strap. "First I went to a fire hall and tried a piece of fire hose, which was getting there," Fortune recalls. Next he went

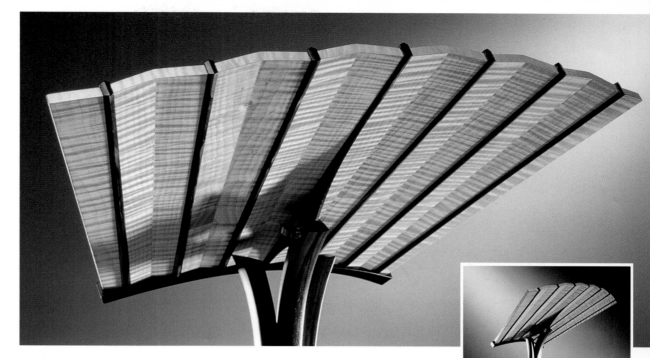

Prima ballerina Veronica Tennant takes this knock-down lectern with her when she travels to narrate dance performances. The design, in curly maple with accents of Macassar ebony, reflects Fortune's interest in sketching gingko leaves and other plant forms.

Photos: David Allen

to a construction supply house for a three-inch-wide nylon strap, which enveloped the part and did the job.

Fortune sees his own studio work and his design work for industry as mutually supportive. Solving design problems for Craftwood gives him access to their much larger facilities, and also exposes him to new tools and techniques. For example, Craftwood has a flow-through hot press, "exactly what I needed for making a table that was too large for our veneer press." Fortune and two helpers spent five days cutting and taping the veneer together, then took it to the factory to press, "when the damn thing tore down the middle. What were we going to do now? The glue was already on it. Then this woman came over with a hand-taper and just taped it back together with incredible speed, and we got it into the press. Without that taper, which was new to me, there would have been days and days of work ruined."

Exporting Expertise

Fortune has found that his broad experience equips him to work on economic development projects in the Caribbean and Central America. In 1992, for example, he joined an economic development project in the village of Tres Garatis, located in a forested region of Mexico near Cancun. A small sawmill and workshop there had been producing export lumber and furniture for a local market. The project's goal was to take the pressure off mahogany by diversifying into lesser known species, and to provide local employment by moving into value-added production. Fortune researched the local species and designed an export product line of outdoor furniture that could be manufactured efficiently using the existing machinery. He delivered a comprehensive manufac-

Arm chair and side chairs commissioned for a grand and formal dining room resemble a line of furniture Fortune designed for a factory in Trinidad (next page). Steam bent and ebonized cherry.

Photos: David Allen

Outdoor shots: David Allen

Because major resorts were being built nearby, the line Fortune designed for Tres Garatis in Mexico included low tables, armchairs, loveseats, and basic upright furniture for outdoor restaurants and hotel patios. Fortune steered the project toward outdoor furniture because the local hardwoods could not be thoroughly dried.

turing package that included building the production jigs and training the workers in machine maintenance and safety.

The situation in Tres Garatis was typical of other development projects in which Fortune has been involved: basic woodworking machinery, all very old but sturdy, local timber, and a force of reasonably experienced workers. "I often have a sub-agenda in that kind of country to improve working conditions, to make them not only more efficient, but also safer," Fortune says. "I make safety issues integral from the conception of the product. I like to know that I am helping someone out that way."

Adding Value in British Columbia

Fortune's experience with economic development, plus his understanding of the furniture industry, made him the right person for the British Columbia forest industry to tap. His presentation to a value-added wood conference in 1994 caught the attention of industry leaders and led to an invitation to draft the curriculum for a wood products design program. That was followed by a two-year contract to get the program up and running.

"I took as a model the development of the furniture industry in Scandinavia," Fortune says. "It came from the craft movement, which was woven into the Scandinavian economy and culture. In the thirties, they developed training programs for technicians and designers. This is what could happen in B.C. now." Established at the Kootenay School of the Arts in Nelson, B.C., the job of the program "right from day one was to generate business, generate employment. Money was tight, and if things got artsy, the money was gone."

Income from the endowment for the program, which is now called the British Columbia Centre for Wood Products Design, didn't even cover Fortune's salary, so the first year was a constant dog-and-pony show to stabilize funding, with nine provincial cabinet ministers and their press entourages touring the program. In addition to a thirty-hour teaching load with no support staff, he had to hustle non-stop for money. Fortunately, this is something that Fortune does well. In the program's second year the industry came up with enough operating money to hire technical staff and part-time faculty.

To develop the curriculum, Fortune contacted manufacturers and designers and asked them what product niches and markets students should be familiar with, and what were the key elements needed in a design-for-production environment. What came across the clearest was that a student should be able not only to design an object but also a full product line, to communicate verbally and visually, and to have a good sense of market trends. As one B.C. manufacturer said, "We know exactly where the market is now. What we need the wood products design program to do is show us what the market will want in the future."

The three-year program begins with a basic exploration of form, and takes students through to the development of full product lines for specific markets using indigenous B.C. material. There are now about thirty students in the program, and Fortune has moved on to new projects, leaving full-time faculty in place.

Community Links

While at the Centre for Wood Products Design, Fortune's duties included helping small manufacturers in the region, which he took as an opportunity to publicize the program and build stronger community links. The Kootenay Woodcrafters Association, a loose grouping of one- and two-person woodworking businesses whose products ranged from log furniture to kitchenware to coffins, wanted to develop a production item they could market outside the area. They asked Fortune to help select a product, design it, and develop the manufacturing jigs. He recommended

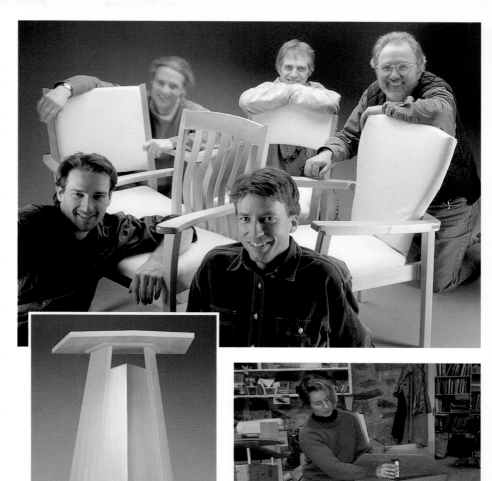

The first graduating class at the Centre for Wood Products Design in Nelson, BC, designed and made side chairs for senior citizen homes and a variety of knock-down lecterns for hotel meeting rooms.

Photo credits (clockwise from top): Michael Fortune, Michael Fortune, Jeff Sterling, Barbara Bell, Giuseppe Tambasco

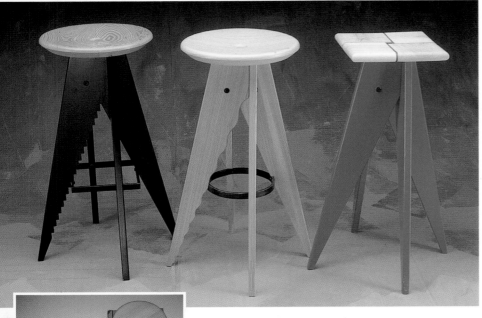

Fortune designed the "Cool-Hot Seats" line of stools (plus their packaging) for the Kootenay Woodcrafter's Association. They're made of local paper birch with metal footrests, they come in three sizes with a variety of finishes, and they knock down flat for shipping.

starting with a stool, and designed one that was straightforward to make, but sufficiently different to avoid competing with the rubberwood stools at Kmart. Production was divided up among several of the shops, one turning seats, others making legs and foot rests, and finishing.

The group's enthusiasm shone through in a conversation with Rob Burrus, one of its members. Fortune's work "is giving a small community a chance at getting something going," Burrus said. "He saw an opportunity to help out with the community. The stools are going well, there are eager and talented people involved, but marketing is the hardest part." Six months into the venture, the group is having modest success with a web site (www.netidea.com/woodcrafters) and is selling regionally. They'd like to find a representative in the U.S., but their volume is too small to interest anyone they've approached. Fortune gave them names of companies that sell stools to restaurants and bars, and suggested thinking about the next stool in the product line. Says he, "One stool does not make a product line. They need a bare minimum of six different stools, each one with a range of finishes, heights, and seats. That's enough to start an honest-to-goodness product catalog." The group is hoping to add to its line by working with students at the Centre for Wood Product Design, and eventually to establish a manufacturing facility.

Learning Your Lessons

When I asked Fortune how others might set foot on the same path, he began by pointing out that studio furniture makers bring a very diverse set of skills: a creative approach, a realistic and practical understanding of materials, and a fundamental command of the manufacturing process. "I've always got one eye on how I might do some-

thing faster, better, and in a production situation how I might do it cheaper. Anyone who is making a living as a designer craftsman can't be far off the mark in understanding the nature of building, and of sequence—what the various sub-assemblies might look like. You'd have a basic vocabulary that would allow you to converse with the people doing the work. It would also depend on how sympathetic you are to the production situation. If you're not sympathetic, it's not going to work."

He credits the late Don McKinley, his teacher at Sheridan College, with establishing his interest in industry. Today, Sheridan focuses on the designer/maker; in the early 1970s, McKinley was teaching product design. "As students, we did tours of businesses in Ontario and Upstate New York. We saw how things were made, and Don led discussions as to why they were made that way."

Fortune's advice to a students today is to "pay attention to what goes on outside the school, and get involved in activities outside the school." As a student, Fortune gained invaluable practical experience by working for the designer Thomas Lamb as on-site person at a molded plywood manufacturer, resolving and documenting production details so that parts from different batches would be standardized. The experience taught him not only about adhesives and veneers, but also about personalities and business.

After college Fortune spent three months working in the studio of English furniture maker Alan Peters, and then three months of independent study in Sweden at Stenebyskolen, a school that trains technicians for industry. Back in Canada he took a job as an industrial designer, but he could not forget the appeal of Alan Peters' approach. Like Peters, Fortune craved complete control over the process from start to finish, and within a year he had begun his career as a designer/maker.

Fortune maintains that industrial experience is not a prerequisite for a studio maker to work with manufacturers, though industrial-strength curiosity is a real asset. "Factory tours give you a sense of the type and scale of their equipment," he says, "and you'll usually see something you can use."

For example, Fortune recalled a trip that would pass near the headquarters of Thonet International in Statesville, NC. He telephoned the plant manager to ask for a tour, but was rebuffed—if he wanted to visit he'd have to get approval from the CEO of the parent company, Gulf Western in York, PA. Undaunted, Fortune called there and explained that he had done some steam bending and wanted to learn more. "If you're honest and say why you want to do this," he says,

"nine times out of ten you can get in. There is a camaraderie in the industry that you can work with." It worked in this case, and the plant manager gave him a full three-hour tour.

And indeed, the tour proved useful. Fortune noted how Thonet mounted the bending form on a free-standing fixture bolted to the floor. Years later, he applied this method when asked to design a production operation for manufacturing high quality hickory lacrosse sticks.

Since specific industrial experience isn't the key to success, I asked Fortune, what is? "Virtually anything works if you have confidence in your abilities and the flexibility to evolve as the situation evolves," he replied. "While you may not have been in that situation before, and may not be familiar with that product niche, you have the flexibility to pull other experiences forward. If you have the entrepreneurial spirit, then things tend to happen. And if you don't get immediate results, you've got to keep on trying."

What Now?

Fortune recently finished his British Columbia assignment and returned to his home in Ontario, where he is completing the restoration of an 1831 log farmhouse and building a new studio-workshop. In addition to returning to his studio practice and commissions, he's become advisor to an economic development project in the Haida community of Old Massett on the Queen Charlotte Islands, off the coast of British Columbia. The Haida Band Council, in partnership with a federal government agency, are proposing to use an old military base to establish a woodworking program modeled on the Anderson Ranch Arts Center in Colorado.

On the industrial side, Fortune is currently producing chair designs for two companies, one in Ontario, the other in Quebec. Since he won't face the technical constraints of the Central American operations, I asked him how these chairs would differ from the ones he makes in the studio. "Price will be the most obvious difference," he replied. "They'll clearly be Fortune chairs, by incorporating some of the curves, negative shapes, and so on. We'll need to get the most bang for the buck in terms of process, so they'll use more mechanical fasteners, and there'll be some over-engineering to compensate for having less control over manufacturing. But I like working with different aesthetic approaches and don't see this as a compromise."

What distinguishes Fortune's career is an unusual diversity of experiences, leaving him with an extremely broad vision for the field. "This is a very dynamic, interesting, fulfilling profession. People get caught up in their own little corner of

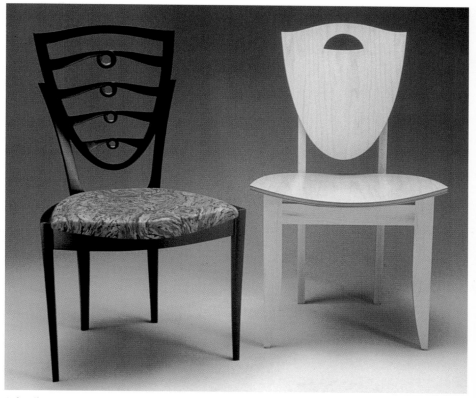

A family resemblance links two chairs Fortune designed for markets at the opposite ends of the scale. The residential commission at left is made of steam bent and ebonized cherry with carved detail. The low-price production chair at right was designed for use in cafes and manufactured by New Hope Trading in Belize.

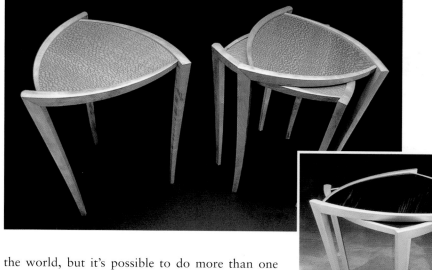

the world, but it's possible to do more than one thing, to look at making a contribution to some group that could use your skills as both a designer and a craftsperson. More people are able to benefit, than by just sending our work into private environments," he said.

"There is such a diverse number of roads you can take, it's not architecture, not interior design or graphic design, but there are elements of all of those, and it's possible to pursue it and survive a career. Furniture is such an amazing, important part of what happens in the marketplace in North America, there has to be a corner big enough for each of us." ■

Original nesting tables were hand-made of cherry with Australian lacewood tops. Fortune then adapted the idea for production in cast aluminum with Macassar ebony veneer tops.

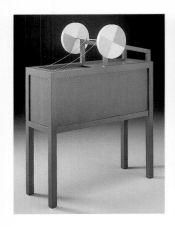

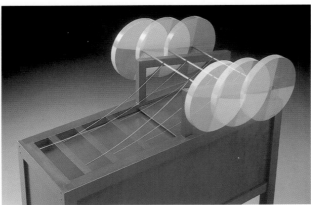

Emi Ozawa's (New Bedford, MA) work is about transformation. Through simple forms, attractive colors, and moving parts, she suggests play and evokes curiosity. She invites you to enjoy her work through hands-on participation — opening doors or drawers, turning latches, folding or unfolding panels. As toys appeal to children, simple pleasure and interaction are the keys.

Ozawa is particularly intrigued with the box form, and people often ask "what do you put in it?" But what a box can hold is not her primary concern. She's focused on how the box can be opened. If she gets you to act on the question, she is pleased.

"Cubic Circus," below, (mahogany, brass, 29"h) incorporates an elaborate method of holding open the lid of its box. Its structure suggests a specific but mysterious function. "Rolling Saucers," above left, (maple, plywood, steel, brass, milk paint, enamel paint, 45"h) takes this idea further, with a pair of boldly painted disks that roll down an incline as the door is opened. Its delicate construction and counteractive movement suggest some unspoken ritual function.

NEXT

■

RUSSELL BALDON

■

For these emerging makers, functional objects express concepts that stretch far beyond craft and utility

> I wouldn't be fulfilling my interests or the needs of my clients if my work were devoid of concept.

New work by emerging furniture artists simultaneously challenges and synthesizes our understanding of what furniture is. This new work references the past while propelling the concepts it embodies into the future and extending our understanding of the ongoing dialog we as a society have with our surroundings. This is what good design always strives to do. These new understandings are reflected in the emotional and intellectual concepts embodied in each piece. It is exactly the concepts behind these one-of-a-kind pieces that set them apart from readily available mass-produced objects.

In the past twenty years the study of history has moved from a cataloging of what was assumed to be empirical fact to more subjective reconsiderations, filtered through many different discursive frameworks — Structuralism, Post-Structuralism, Cultural Relativism, and Post-Modernism, to name a few. Furniture making, as with all creative fields, is no exception. The contemporary study of our field can not dismiss the larger influences that

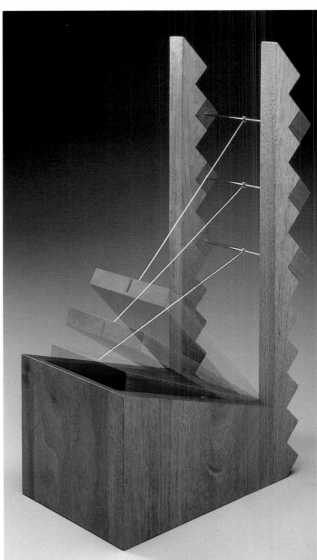

shape, motivate, and give meaning to new furniture objects throughout our culture. In a world filled with a multitude of furniture objects that are affordable, functional, and attainable we as makers search to find more meaning in our work. At the heart of this search is the drive towards personal expression, which reflects how we interpret our world. When our audience discovers and appreciates this expression, our work succeeds. Function and utility are still serious concerns, but furniture making now has the ability to address subjects ranging from familial relationships, to vice and virtue, to gender roles. Past furniture traditions show us what we've been and what we are now. By examining and interpreting new work we can uncover clues to what we will become.

With the rise of the academically trained studio furniture maker, functional objects increasingly have the ability to express concepts beyond their utility. I, myself, learned to make furniture in an academic context. While I now make functional furniture in the real world, I wouldn't be fulfilling my interests or the needs of my clients if my work were devoid of concept. Many of the emerging artists creating work today have a strong arts education, and their furniture reflects this. Additionally, members of the growing contemporary audience have become very savvy about reading objects and using this visual language to express themselves through the objects they choose to own.

People generally fear the unfamiliar. The attempt to create and interpret furniture within relatively new philosophical frameworks can generate confusion and unease. Judgement, which requires both familiarity and distance, is difficult. Our challenge as makers and viewers is to ask what we can get from each piece, not only in the traditional terms of function but also in terms of what it can give us emotionally, intellectually, or spiritually. What can a piece of furniture tell us about ourselves, our family, and our times? This, I believe, is how furniture on the cutting edge differs from its antecedents.

One concern I have recently heard expressed within the critical dialog of studio furniture is that much of the new work fails to associate itself with its traditional community. It is as if furniture is expected to continuously take on innovative forms and materials while still retaining its original, unchanging meanings. Some would have us believe that furniture makers are trying to defy furniture's philosophical traditions by attempting to enter a world better left to the fine arts, where personal expression has long been an integral part. New expressive directions are said to isolate furniture from everyday experience and use. Such a position resists the evolving theoretical content

Peggy Chung's (Oakland, CA) work revolves around life and personal events. She creates intimate seating arrangements, revealing a wide range of human relationships. In "Writing Table" (wood, plywood, chalkboard, paint), inspired by the secrets kept within a family, she wants to place "on the table" the subjects often kept "under the table." She explains: "Sitting in the center of the table, I write on a chalkboard surface which rotates around me, expelling my thoughts and feelings in a whirlwind of words. As I write my way toward the center, I am calmed by the experience, as though a burden of feelings has been lifted. What is left are the traces of layers of words, thoughts, and feelings." The table is thus a fully functional yet symbolic tool for examining personal relationships.

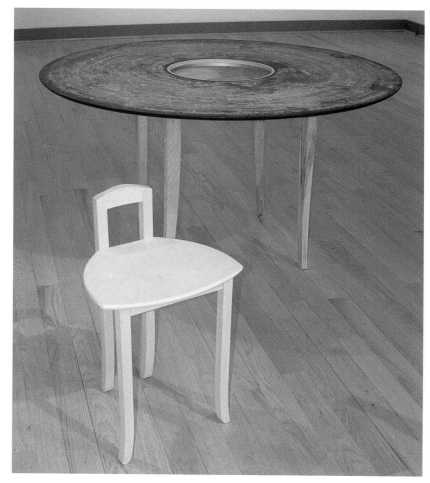

of furniture and inevitably bogs down in the deadly "art versus craft" argument. Is it really a chair if you cannot sit in it?

I argue that new work needs to challenge its audience in order to actively reflect the changing world we live in. Naturally, there are traditions in our field, but how does a tradition live except through examination, evaluation, and reinterpretation? There is room now to allow furniture into areas of theory not previously associated with contemporary furniture. Traditional forms and functions can be revisited using the same theories now being used to reinterpret history itself. The objects of our lives do reflect our values and ideas. Every chair may not be sit-able, but the visual language of furniture can be made to better seat our emotional, intellectual, and spiritual lives.

Objects can influence the way we think, and artists employ this influence to communicate ideas. Objects are powerful communicators because they can be associated with use, action, and feeling. Objects convey ideas and evoke emotions that would otherwise be lost to fading memory and death. As maker and writer Stephen Hogbin has said, "These objects are carriers, supporters, and enriching agents for our lives. They have the power to function as symbols."

The beauty of using furniture to express ideas is that people are naturally drawn to it through use, whether the object's utility is symbolic or actual. Lee Herrick, founder of the American Society of Furniture Artists, says, "Function draws us into these pieces the way nothing else can. They are incomplete without us—without a human being, literally present or implied. They require our touch, our use, our engagement. A seductive idea, material, and form act as invitations for the viewer/user's mind."

Hogbin points out that "technique can provide a way to bring something into existence, but it doesn't deal with the broader fundamental questions of conception, perception, and expression." This is not to devalue technique, for in technique, too, meaning is revealed. Studio furniture maker and teacher Gail Fredell puts it this way: "studio furniture…has finally gotten beyond using technique and wood as ends unto themselves, and is now producing pieces of aesthetic value and conceptual substance." Makers strive to broaden the range of ideas that furniture can address.

I culled the group of emerging artists on these pages from the recommendations of teachers and leading makers in the studio furniture field. This new generation of builders ranges from sculptors acting as object makers to traditionalists utilizing more formal methods to elicit a psychological and/or physical response. They promise to influence the forms of furniture for years to come. ■

Jim Dietz (Madison, WI) looks to the fine art world for inspiration, rejuvenation, and current trends, yet he is drawn to craft. He's now exploring the nature of his primary material, wood, coupling its rawness with refinements typical of traditional cabinetmaking. In "Logged On" (cherry, maple, 36"h), the finely crafted forms and drawer system establish a conversation with the rough log, the two idioms speaking to one another, as if in dialects.

Using furniture as a vehicle for personal expression, says **Christopher Vance** (San Francisco, CA), results in objects that "not only are familiar in form but can also be physically interacted with." Conceptual issues are thus made approachable and accessible. Furniture is art that can be touched. Vance says that his work "comes out of me not in a linear fashion but in more of a radius, with my head, heart, and hand in the center. I find that the functionality of furniture keeps me grounded in process and purpose, while at the same time letting me explore the more artistic aspects of craft, such as form, proportion, and color."

Vance's work often addresses the subject of vice and virtue. "Smoking Lamp" (70"h) is a parody on the social taboo currently surrounding smoking. The surfaces of the piece, including receptacles for matches and ashes, are refined and polished. But the shade of the lamp looks stained with years of nicotine. Fifty years ago, such a furniture form might well have been included in a major furniture line; today it would not be politically correct.

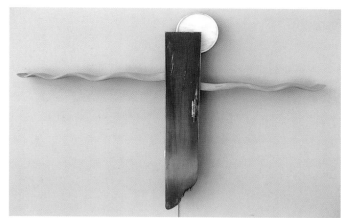

Yang Jun Kwon's (San Diego, CA) work speaks of the artist's journey and of the journey he believes an artist's work can evoke in others. Structurally, "Self Portrait" (mahogany, brass, leather, stained glass, 44"h) has two wings and a central body. The outstretched wings represent the two worlds in which Kwon lives: his homeland, Korea, and his adoptive country, the U.S. "I combine the two worlds in my own being," he says. "I hold the two worlds together and in turn I am held together by them."

Also by **Christopher Vance**, "Stair Case" (75"h) is an honorific, meditative piece, a metaphor for the virtuous pursuit he has contemplated of attaining his mother's sensibilities. Here Vance has taken the slow mental progression of trying to achieve the peace and serenity he associates with her and made it manifest in the progression of stair-stepped drawers. As they ascend, they become smaller, representing a journey becoming easier over time (or, perhaps, the end appearing further and further away). The lit vault at the top symbolizes the peacefulness of a life lived well.

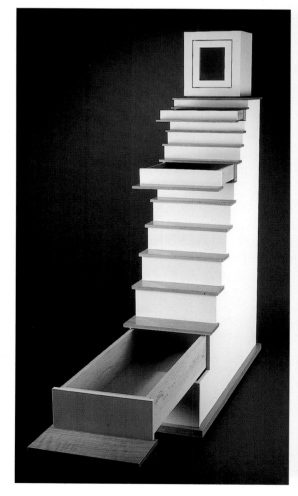

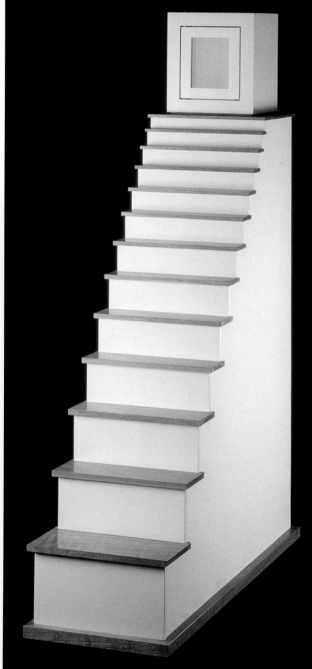

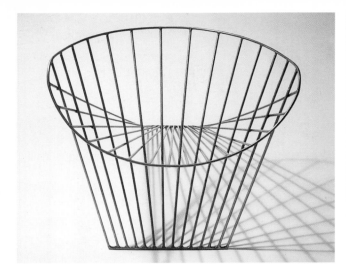

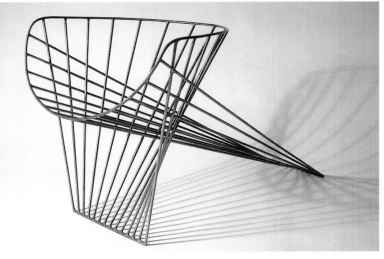

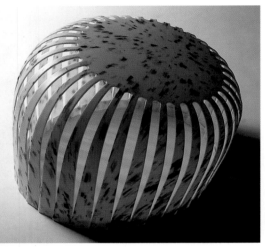

Isabelle Moore (Snowmass Village, CO) is fascinated and excited by materials, their sensual character as well as their structural possibilities, and she is constantly searching for new materials as well as new ways to employ materials in attractive load-bearing forms.

One result of her diverse explorations is "Humpty—low rest," left, (recycled UHMW plastic, 14"h). Through patterned removal and mechanical fastening of this sheet material, Moore achieves a seating form that comfortably balances resiliency and elasticity. Beyond its success as an investigation into the tolerances of a self-stabilizing structure of post-industrial sheet stock, this is a delightful piece of furniture.

Another seating investigation, "Series #1," above, uses common steel rod stock. This lounge chair juxtaposes two geometric forms with the clarity of plotted mathematical equations. Spare and minimal in appearance, this seat is nevertheless very comfortable; the thin steel rods flex to receive you, wonderfully confounding your expectations.

Julie Morringello (New Bedford, MA) practices a classic design approach on new materials and on familiar ones used in non-traditional ways, in order to breathe life into common furniture forms.

Her "S Chair," below left, (40"h) is about her love of woven surfaces. Having made a number of pieces incorporating her own weaving, she chose here to pair a pre-woven material, rattan, with another pre-fabricated sheet, plywood. The rattan, sold in rolls, mates well with the sawn and laminated plywood curves.

"Landscape Table," below right, (plywood, Arborite, stainless steel, maple, 24"h) sprang from an entirely different place. In mulling over the question of the essential "tableness" of a table, she saw the elevated landscape as a plane where events happen, as if on stage. This conception merged with memories from childhood, wherein a houseful of furniture is turned into a fantasy landscape. The result is a table with several abstracted moveable structures that mimic (and serve) today's fluid lifestyles.

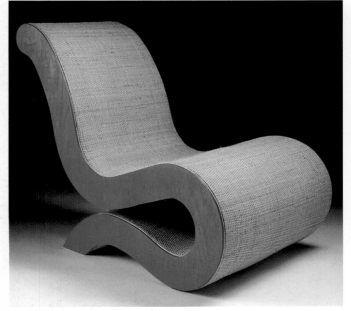

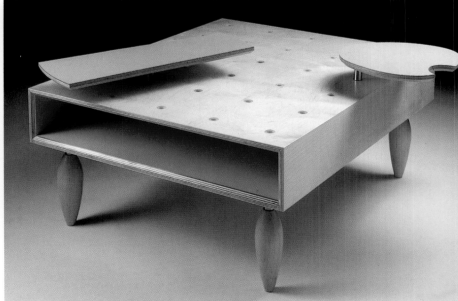

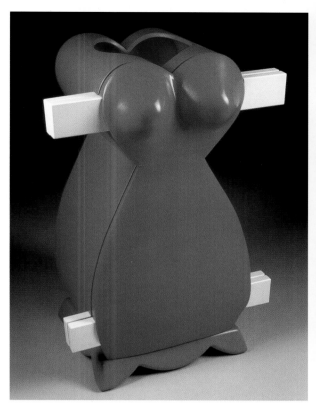

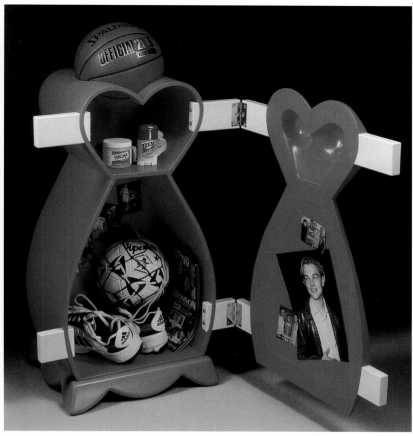

Sarah Coleman's (Elmhurst, NY) most recent work involves the character and development of gender roles. Her series of "Tomboy Furniture" reflects the need for furniture objects to address contemporary female life. Each piece represents a transitional phase, when one confronts the delicate balance between expected stereotypical gender roles and reality.

"Dolls and Balls" (bending ply, mahogany, poplar, hardware, enamel, 40"h), a small toy box or locker, blurs conception of the gender of its owner, evoking disparate male and female stereotypes. The case itself embodies the female form, which opens to reveal space for the daily paraphernalia of a tomboy. Coleman extends the disparity by incorporating handmade qualities with industrially fabricated components.

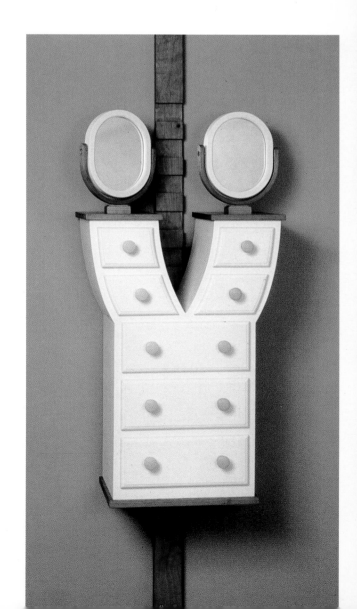

Duncan Gowdy (Needham, MA) explores the dimensions of family life, often through interpretations of traditional furniture forms inspired by the Shakers. His work is sensitive to the human body in proportion and function. Accommodating special physical needs has become a modern design challenge. As a commentary, Duncan created a dresser inspired by Abigail and Brittany Hensel, conjoined twins featured in *Life* magazine in 1996, when they were six years old. With a rare condition known as dicephalus, the Hensel twins share an undivided torso and two legs. "Love You Two" (cherry, maple, plywood, paint, mirror, 70"h) includes three lower drawers in a unified lower structure, just as the twins share their common body structure. The upper portion of the cabinet bisects into two "personal" drawer sections, a swiveling mirror on the top of each. Duncan incorporates a Shaker-like adjustable cleat on which the cabinet is hung, so the dresser can be repositioned as the girls grow.

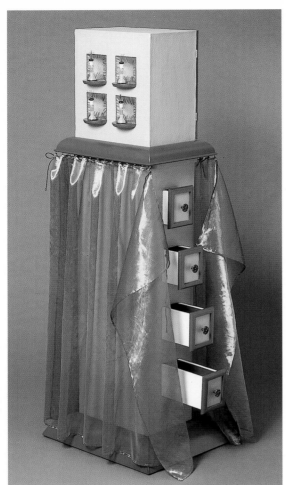

Christine Enos (Portland, OR) sees the furniture she creates as a metaphor for her own self image and her experience relating to others.

She draws from Gaston Bachelard's *Poetics of Space* in recognizing that furniture functions as a "model of intimacy," our responses to objects richly reflecting our thoughts and feelings. Furniture is thus representative, and we can see ourselves in it and through our use of it. According to Bachelard, furniture objects are "organs of a secret psychological life." The opening of a drawer or door can become an act of revelation. At the same time, Enos is attracted to furniture (and she ensures her own furniture's attractiveness) through its familiar qualities and functions.

"Perfume, Potions, and Poisons," left, (wood, mixed media, fabric) is expressive in its character because of what it hides and what it reveals. Its upper case is designed to hold a perfume collection, displaying it as we might display ourselves. Wearing perfume and other cosmetics can impart a sense of confidence and strength. Touching the feathers that frame this case parallels the sensation of smelling the perfume itself. The posture of the piece projects stature and confidence, while the veils covering the base suggest the desire to conceal what constitutes one's inner strength. The mystery is as important as the strength itself.

"Vanity," below, (wood, metal, photographs, fabric) addresses how we see ourselves. The piece incorporates a series of framed photographs that can be hung from the frame of the mirror itself. Each photo is intended to suggest a comparison with what the viewer actually sees in his/her own reflection. Enos has created a focal point to contemplate the balance between physical and mental self-images.

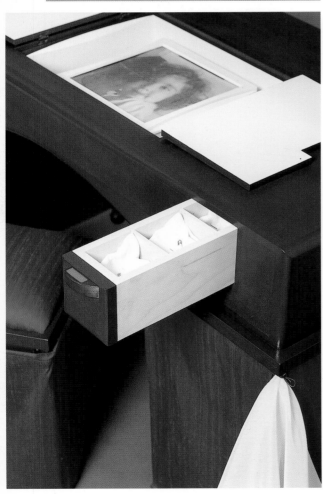

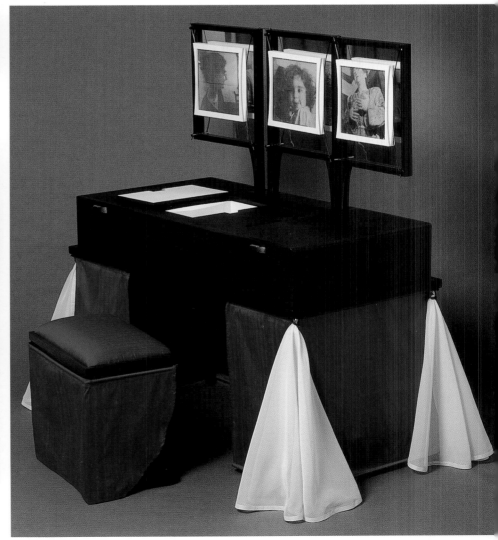

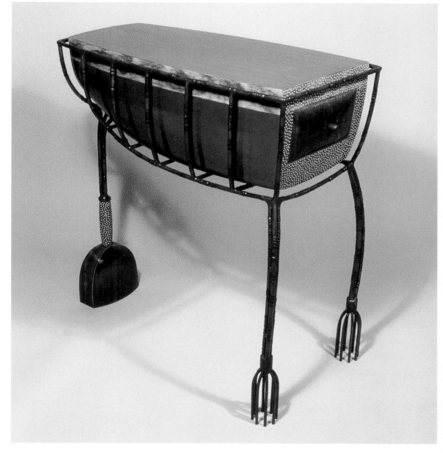

Brian Wilson's (San Francisco, CA) work is richly imaginative, though his attraction to furniture is fundamentally sensory. Purely conceptual works of art, he feels, risk denying the physical world we inhabit. What drives him to create is the human contact that furniture involves.

His "Boat Series" includes "Dry Docked," above, (polychromed wood, steel, 28"h) which uses the abstracted forms of a boat as a point of departure. The twisted, rusted outer frame evokes the structural ribs of a hull and are coupled with faded paint, suggesting years of travel and use. The back leg appears as a half-submerged oar.

"Up River Under Fair Sky," right, (polychromed and lacquered oak, steel, 70"h) uses clouded translucent coloring to embody the feel of sky and water. The suspended lanternlike lamp is fully adjustable. It lights the way, as the piece seems to be moving beyond here and now.

ICONS OF HIGH MODERNISM

■

Kristina Wilson

■

Sitting on the Edge: Modernist Design from the Collection of Michael and Gabrielle Boyd

San Francisco: San Francisco Museum of Modern Art and Rizzoli International Publications, Inc., 1998. With essays by Paola Antonelli, Aaron Betsky, Michael Boyd, and Philippe Garner. Softcover, $24.95.

Beginning in 1932, New York's Museum of Modern Art (MoMA) set forth a vision of Modernist design and architecture characterized by austere geometries, lack of ornament, supposed functionalism, and the use of industrial materials. The pieces of furniture made from tubular steel, plywood, and plastic that MoMA presented in exhibitions over the next thirty years, by figures such as Marcel Breuer and Charles and Ray Eames, have come to stand, at the end of the century, as icons in a particular pantheon of high Modernism. In the late twentieth century, this pantheon has become the whipping boy for such diverse furniture camps as post-Modernists, like Robert Venturi and the Memphis design group, and studio furniture makers, such as Wendell Castle and John Dunnigan. These various furniture makers have chosen to read the forms of MoMA's Modernism as rigid, even coercive, and have condemned the commitment to abstract, industrial constructions as a sacrifice of bodily comfort. Such attitudes are still popular today, leaving the status of MoMA's tradition in an embattled position and perpetuating the schism in the furniture world between one-of-a-kind craft production and design for mass reproduction.

In light of our post-Modern furniture climate, the greatest accomplishment of the brief essays in the exhibition catalog *Sitting on the Edge: Modernist Design from the Collection of Michael and Gabrielle Boyd* (on view at the San Francisco Museum of Modern Art during the winter of 1998-99) is to offer a correction to the current lop-sided understanding of high Modernist design that, incidentally, opens the door to a reappraisal of the continuities, rather than the differences, within the furniture field. The vital aspect of Modernist design that the catalog recovers is the fundamentally sincere, almost religious utopian vision that inspired many of its practitioners. Although their idealism may sound naive to late twentieth century ears, the designers represented in this exhibition all believed to some extent that a better designed physical world would nurture both personal liberation and social equality. To some designers, the simplicity of Modernist forms could encourage in consumers an appreciation of economy that would liberate them from the excesses and decadence of the Victorian world. In addition, Modernist designers hoped their work would foster social equality by harnessing industrial materials and technologies to the making of objects for daily life. An intelligently designed piece that could be industrially reproduced would be affordable by a wide public and would therefore contribute to the demise of the social stratification encoded in our domestic wares.

To those familiar with the beliefs of William Morris and the goals of the Arts and Crafts Movement, the themes of personal and social liberation cited in the previous paragraph will strike a resonant chord. While the theories of production in the two camps are virtually opposite—Arts and Crafts reformers believed in the liberating quality of actual handicraft work; Modernist designers believed that liberation lay in the taming of the machine—their theories of consumption are quite similar: both argued that people's lives could be dramatically improved by filling the home and workplace with aesthetically appealing, functionally designed furnishings. Thus, *Sitting on the Edge* offers a way to see continuities within the field of furniture making. Rather than dividing over issues of production technique, materials, and the use of ornament, the field—from woodworking purists to mixed-material designers, from solitary craftsmen to members of a shop—can understand itself as unified around the central concern of inspiration and transformation in daily life.

Michael and Gabrielle Boyd's collection, a part of which forms *Sitting on the Edge,* covers the years 1900–1965 and is self-consciously modeled on MoMA's canon. The exhibition includes iconic pieces by the most famous Modernist architects and designers: Charlotte Perriand and Le Corbusier's chaise longue (1928), George Nelson's Marshmellow Sofa (1956), and Verner Panton's plastic stacking chair (1960, see page 14), among others. While the Modernist tenets of minimal ornament, large-scale, simple shapes, and the potential for mass reproduction can be found in each example in the collection, what (pleasantly) surprises the reader is the multiplicity of forms that such dogmas can inspire. The pieces in the catalog range from tubular steel and hard edges to the organic undulations of bent plywood to the fantastic curves and colors of mold-injected plastic. This dramatic portrayal of Modernism's diverse forms, in concert with the essays' focus on the movement's

Left: Charlotte Perriand and Le Corbusier's 1928 chaise longue, one of the show's "iconic pieces by the most famous Modernist architects and designers".
Right: 1948 chair by Rudolph Schindler, "essentially half-way between industrial and craft Modernism."
Photos: Ian Reeves/SFMOMA, courtesy Michael and Gabrielle Boyd.

utopian vision, effectively undermines the post-Modernist view of Modernism as unvarying and anti-social.

Despite this compelling reassessment of Modernist design, one wishes the collection posed a more trenchant re-evaluation of the school by pushing the boundaries of its canon. Studio furniture makers such as Wharton Esherick and George Nakashima, contemporaries of many designers shown here and certified "Modernists" in terms of their aesthetic simplicity and utopian social vision, are not included because, one suspects, of their reliance on traditional materials and hand craftsmanship. Yet the collection includes a chair by Rudolph Schindler (1948) that is essentially half-way between industrial and craft Modernism: its plywood form obviously was hand-assembled. A more critical scholarly approach would use the ambiguous allegiances of a piece like Schindler's to probe how the fields of design and craft have drawn their barriers, underscoring their similar social agendas while highlighting the overlaps and divergences in production practice.

The brief essays in *Sitting on the Edge* should be praised for their attention to the philosophies of Modernism, for reminding us that, in the 1920s, tubular steel embodied the potential opening of the individual and social mind. On the whole, however, they are far too short to pursue the theoretical implications of the sketchy history they provide. Most satisfying is Antonelli's essay, which looks for the "few crucial moments in the history of chairs when great, iconic design by renowned masters

was able to meet the demands of the mainstream market, generating at last a series of thrones for the common man." Her narrative focuses on select pieces such as the Eames' fiberglass chairs of 1948–50 and Giancarlo Piretti's Plia Chair of 1969, and includes some information on the technology that enabled the reproduction of these designs and an abbreviated social history to argue for their popularity. The opening of Betsky's essay proposes that constant tensions exist in the design process between ideal platonic forms and bodily comfort. But, rather than developing this thesis further, his narrative lapses into historical summary and gender essentialism. One expects that both his and Antonelli's essays would benefit from more room in which to develop their historical inquiry.

Despite Antonelli's work, the greatest weakness of *Sitting on the Edge* remains the lack of any meaningful discussion of the actual production of objects and of their success as commercial goods. The reader is given no information to connect production technique with the final appearance of pieces and their availability on the market. Nor does the scholarship offered here address how and why these objects were consumed—subtle information about daily, intimate living that must be gleaned from sales figures, the prevalence of knock-offs, and publicity vehicles such as advertisements and movie sets. Perhaps most significantly, it is this latter avenue of inquiry that will reveal to us how consumers have made distinctions between "crafted" and "designed" furniture, and may in fact demonstrate that the appeal

of each camp has been fundamentally similar.

The majority of *Sitting on the Edge* consists of full-page color plates and an illustrated exhibition checklist. The high quality of the images (photographed by Ian Reeves) make this a major visual resource for both scholars and contemporary furniture makers interested in Modernist design. However, it is in the first six pages of the catalog, where photographs illustrate the Boyd's collection in their own home, that one finds the most captivating images of the entire publication. Suddenly the vibrant colors, shiny steel, and plywood grain come together in a vision of domestic life that is energizing and exciting. These are images to convince us that life among such objects does not have to be a tyranny of hard edges and industrial impersonality but rather—like life among any group of thoughtfully designed and well-made objects—can be inspiring, and will perhaps guide us towards a more unorthodox, liberated way of living. ■

A Bridge Between Art and Life

■

Kathran Siegel

■

Rendezvous: Masterpieces from Centre Georges Pompidou and the Guggenheim Museums, held at the Solomon R. Guggenheim Museum, New York, November 1998 through January 1999. *Premises: Invested Spaces in Visual Arts, Architecture, & Design from France, 1958–1998,* at the Guggenheim Museum Soho, New York, October 1998 through January 1999.

David Mohney

"Star Bright": Wendell Castle continues his lifelong exploration of a personally defined vocabulary of surreal furniture forms whose imagery challenges function.

The boundary between art and life has been challenged and stretched throughout the twentieth century. In the second half of the century, the art world has been preoccupied by two opposing attitudes about art and life: there is art that is strictly about art, and there is art that crosses over into real life.

Viewed together, two recent exhibitions demonstrated the century's shift in art making, as well as in the critical discourse surrounding art. Both exhibitions drew upon the permanent collections of the Centre Georges Pompidou, in Paris, France, which is undergoing extensive renovation and expansion. One exhibition spanning the twentieth century to approximately 1970, titled *Rendezvous: Masterpieces from Centre Georges Pompidou and the Guggenheim Museums* appeared at the uptown Guggenheim Museum. Downtown at the newer Soho branch of the Guggenheim was *Premises: Invested Spaces in Visual Arts, Architecture, and Design from France, 1958-1998.* Both exhibitions ran from the fall of 1988 through January of 1999.

These exhibitions drove home the French involvement with Surrealism, particularly resonant in the "invested spaces" at the focus of *Premises.* One left *Premises* with the sense that the boundary between art and life has indeed become fluid. In fact, an important premise of this exhibition, according to its curators, was the idea that each work constituted "a physical as well as a psychic territory." This is familiar ground for art furniture makers, whose provocative objects, being far from ordinary looking, fail to blend into a room's decor. Always

there is some way in which the viewer or user is engaged.

This broad acceptance of the dialog between art and life provides the rationale for taking a second look at the 1966 exhibition titled *Fantasy Furniture* that was held at the Museum of Contemporary Crafts in New York, which in retrospect seems to have been prescient. All of the furniture exhibited was artist-made and highly experimental. It conveyed ideas about aspects of human experience far from their designation by function. Formal and metaphorical ideas related to Surrealism turned tables and chairs into strange, lifelike creatures. Although furniture traditionally includes decorative imagery, these furniture makers were using imagery in a primary way, to influ-

ence the meaning of the work itself. Two members of that original group, Wendell Castle and Tommy Simpson, have continued to produce furniture following the impetus of their early work.

Though for a time it seemed that these ideas had failed to spread, today a sizable group of furniture makers seem rooted, in a variety of ways, in Surrealism. Stylistically, the range of work among today's studio furniture makers is great, and the connection with Surrealism is true only of those who have invented personal styles involving some aspect of the fantastic, or more broadly, whose work communicates playfulness, irony, or mischief. This work falls into the subcategory of art furniture.

Surrealism challenges our ordinary perceptions of things. By turning found objects of utility into objects of pure fantasy, the Surrealists questioned the original intention around which a thing had been designed, raising issues about functionality and human endeavor. Surrealists had a special interest in fantasy that could be captured from dreams, or through a series of mind-unlocking techniques. They created fantastical imagery depicting strange realities and made it look believable, however far from the realm of ordinary experience. Over time, our culture has assimilated so much of this thinking that it is no longer disorienting.

Since the late 1960s, increasing numbers of furniture makers have taken this essentially romantic, personally expressive approach. Often a bold use of color separates their work from that of other makers who prefer to let the material

Charles Mayer

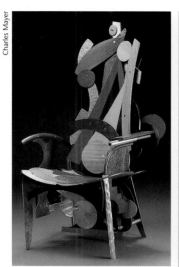

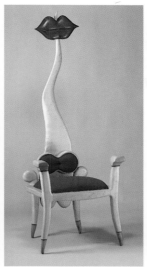

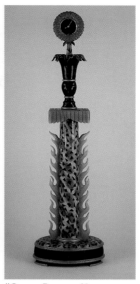

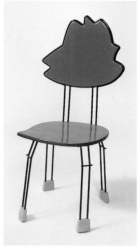

"#0041": Jay Stanger begins with a vocabulary reminiscent of constructivism, but then takes off.

"Shaman Lights": Keith Crowder's joinery borrows from other cultures, integrating secondary materials with wood.

"Tut": Dale Lewis has built a personal style by juxtaposing elements of figurative sculpture, sometimes comically rendered, around traditionally functional forms.

"Greco-Roman Happy Meal": Paul Sasso's visual language connects with Surrealism through the comic book, disguising serious concerns in playful garb.

Mark Hazel's chairs have gestural and animated postures, which lend them a humorous character.

speak. Where the primary concern of traditional woodworkers is with the material, art furniture makers are interested in material primarily as a means to express an idea. Art furniture makers also are likely to treat furniture as tableau, and their work most likely is one-of-a-kind.

This focus upon the idea and an artist's personally invented visual language is Modernist and belongs specifically to the twentieth century. Though Post-Modernism presents some significant changes in attitude, Modernism's overriding emphasis on the importance of an artist's personal vision still stands. Surrealist artists went one step further, choosing to investigate the interiors of their own psyches. They chose to deal with life in a subjective and illogical way, in sharp contrast to the rational approach to problem solving, which placed its utopian hopes in the scientific method and the capabilities of the machine. Surrealism was never particularly scientific. It came only as close as its debt to Freudian theory, also, in retrospect, not scientific. Surrealist artists believed that levels of consciousness altered the realm of the possible and could be called upon to aid in the creation of imagery.

Many Surrealist techniques are commonplace among art furniture makers and, in fact, among most contemporary artists. Wishing to escape the conventional trap of conscious thought, Surrealists used automatism to generate form. Artists made random markings and then identified unconventional shapes and relationships among their scribbles. Biomorphic shapes, distinguished by a certain gestural or playful quality, entered the Surrealist vocabulary through automatism. Surrealist artists also juxtaposed elements from different contexts to reveal strange new forms, and reconstructed fantastical combinations of imagery out of dreams.

The animated potential of biomorphic shapes found its way into the studios of Walt Disney as early as the 1920s. In 1940, the cartoon feature *Fantasia* opened in movie houses, bringing Surrealist forms to popular culture. Cartoons later entered museums on Pop Art canvases, and cartoon imagery has worked its way into the visual language of some studio furniture makers, who grew up with television and comic books.

The technique of juxtaposing elements from different contexts found support not only in Freudian dream imagery but also in the art of other cultures, where many objects contained metaphorical imagery and were functional at the same time. The original Surrealists were attracted to objects that had made their way to Europe from Africa, Oceania, and the Americas. They were less interested in appropriating images from other cultures than in finding inspiration and validation for their own inventions in these non-European forms.

The metaphorical approach to the functional object now has spread from the art world into our cultural mainstream. Instances that combine imagined form with the useful object exist not only in furniture making but also in architecture, sculpture, performance art, and installation art. These changing attitudes were less obvious in *Rendezvous*, which blended the privately funded Guggenheim collection with the Pompidou's public collection. Though the curators sought to make and explore the distinction between these two sources of acquisition, *Rendezvous* primarily was a survey of Modernism — art about art.

Design work, mostly furniture and lighting, was exhibited in two alcoves apart from the main exhibition. The decision to exhibit this work separately was consistent with the conventional attitude, which maintains a strict hierarchical division between the design arts and the fine arts. The design segment of *Rendezvous* was extremely limited, covering only a sampling of industrially produced

work from the Bauhaus until the introduction of plastics in the 1950s.

Premises explored the relationship between physical and mental constructs, exhibiting architectural models, video images, and photographic records alongside works by artists, mainly installations. The influence of Surrealist thinking was apparent in the confluence of the real with the imagined. This exhibition was open-ended and pointed toward an integrated way of being in the world. The legacy of Surrealism was acknowledged, particularly as it has inspired a continuing artistic preoccupation with the psychological formation of the person and with the role played by memory in one's apprehension of experience and of space.

Considering the two Guggenheim exhibitions as a progression demonstrates that the parameters of art, as the twentieth century ends, are changing. It is too early to know exactly when this shift occurred. We have, however, moved far enough along to recognize that a less restrictive take on what is real, or even imaginable, has begun to penetrate the mainstream. Fantasy is less implausible: the New York skyline has been replicated in Las Vegas, for tourists who want a visit without the urban realities. Seaside in Florida, Kentlands in Maryland, and numerous other fantasy communities simulate an idealized lifestyle for their inhabitants. Computer technology has further extended what we can experience, to such an extent that empirical reality is sometimes indistinguishable from virtual reality. Our world has absorbed the surreal.

Fantasy Furniture demonstrated that art furniture offered early evidence of this challenge to the Western divide between art and life, the imagined and the real. Seen from this perspective, two opposite orientations converged, in the 1960s, within what was to become the studio furniture movement. What brought these groups together was a shared interest in function, though in the service of different ends. Loosely speaking, one group of furniture makers found its roots in the Arts and Crafts Movement. The other group emerged from college fine arts programs. Those with fine arts backgrounds did not necessarily begin with any foundation or interest

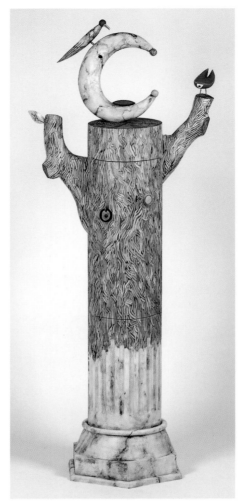

"Nymph of Laurel": Tommy Simpson's homage to Daphne, who was changed into a laurel tree. "Being a worker in wood," says Simpson, "Daphne is a frequently called upon spirit."

in crafts. Their fascination with blending furniture concerns and fine art ideas about imagery came from Surrealist painting. Every art student's bag of tricks contains Surrealist techniques, including automatism, free association, and irrational juxtapositions. Surrealist imagery helped drive interest in visual metaphor and in narrative.

Art departments of the 1960s, holding to a purist position, maintained strict divisions between such disciplines as painting and sculpture, and declined to address any ideas about function or use. Nevertheless, some young artists saw function as a provocative element and applied it to sculptural ideas. There was a subversive thrill in crossing that particular boundary between art and life. It has been the refusal of the art establishment to embrace any of these artists, to-

gether with only limited acceptance from the crafts community, that eventually threw the two different groups together. Object makers of the 1960s, notably Tommy Simpson and Wendell Castle, were not, strictly speaking, furniture makers. Individually, their work crosses all the lines between painting and sculpture and design.

Castle uses automatism as one method for identifying new shapes of interest to him. Like other formalists, Castle has devoted years of his life to building imagery through the exploration of a personally defined vocabulary of form. From today's vantage point, Castle's interest in function is as much conceptual as practical, maybe more: the idea of use generates content, whether formal, social, or some mix of the two. Though his work flirts with traditional methods and styles, Castle has managed to present his various interests as unresolved dialogs within individual pieces.

Simpson juxtaposes images from various contexts and weaves them into the fabric of his designs. In this way he builds metaphor, telling a story every bit as compelling as the cabinet, bed, or other form it describes. "Nymph of Laurel," for instance, alludes to the Greek myth of Daphne, who changed into a laurel tree to escape Apollo's amorous pursuit. Apollo, god of reason, is tricked by the intuitive Daphne, an independent-minded young woman. In this piece, two transformations are before us simultaneously. One involves the sculpture and its transformation into furniture. The other is told through Daphne's story. Using the cabinet entwines its owner in a ritualistic act of complicity. Art and life merge.

Today many studio furniture makers exhibit a hybrid sensibility that combines high craft with artistic intent. An increase in university programs that specifically address studio furniture has contributed to this hybridization. The growing popularity of whimsical furniture owes much to its surrealist roots, though today's whimsy is often cartoonized and highly finished. This tendency must be approached with caution, so that the work does not become too easy. Fantasy has a tough and incisive edge. Art furniture challenges us to rethink the things we know. ∎

ANTIQUES OF TOMORROW

Ellis Memorial Antiques Show,
held at the Boston Center for the Arts,
Boston, MA, Oct. 28–Nov. 1, 1998.

A benefit for Ellis Memorial and
Eldredge House, Inc., Boston, MA.

Miguel Gomez-Ibanez

Where else but at the 1998 Ellis Memorial Antiques Show could you catch a glimpse of a tall-case clock in the mirror of "Step Vanity" by Alphonse Mattia?
Photo: Olaperi Onipede

The Ellis Memorial Antiques Show is Boston's preeminent gathering of antiques dealers and collectors. It is a Society Page event, organized each Fall since 1959 by and for the well-to-do as a charity benefit. Some of the best known dealers in the Northeast pay for the privilege of showing their wares to Boston's elite. The dealers bring furniture appropriate to the occasion, often with New England or Boston roots, and with asking prices up to several hundred thousand dollars.

Each year, the show includes a loan exhibit drawn from some local collection. In the past, these exhibitions have been of ship's models, wine accouterments, or antique toys. This year, 1998, the show organizers included an exhibit of contemporary studio furniture.

The Ellis organizers intended to use the studio furniture exhibit to attract press interest and a new group of visitors to the annual event, in an effort to build a bridge between the worlds of collectors of American antiques and the makers and collectors of studio furniture. These have traditionally been separate groups, but to Francis L. Coolidge, chair of the Loan Exhibition Committee and herself familiar with several local studio furniture makers, there were clearly overlapping interests, and it seemed natural that closer ties could develop.

The exhibit certainly demonstrated that there are similarities between antiques and contemporary studio furniture. In terms of education and affluence, collectors of studio furniture tend to be from similar backgrounds as those who came to admire and buy the antiques. And the palate of materials, tech-

niques, and finishes—including expert hand-crafted joinery in cherry, mahogany, maple, and walnut—is common to both.

The studio furniture exhibit was curated by Rosanne Somerson, head of the Furniture Design Department at the Rhode Island School of Design. The Ellis Loan Exhibition Committee also enlisted as advisor Jonathan Fairbanks, Curator of American Decorative Arts at the Museum of Fine Arts, Boston. Somerson drew on her colleagues and contacts to assemble a list of furniture makers for the exhibit, using the theme of coastal New England furniture makers.

Seven furniture makers were selected, including Somerson and Alphonse Mattia of Westport, MA; Peter Dean of Marion, MA; Timothy Philbrick of Narragansett, RI; James Schriber of New Milford, CT; Jere Osgood of Wilton, NH; and John Dunnigan of West Kingston, RI. From each, pieces were selected that were seen to be compatible with the antiques. According to Somerson, "We wanted to include pieces that had a link to antiques without being too referential. Our hope was to draw a clear bridge without having to say much; just having them look right in the setting there would be enough."

The exhibit included works ranging in style from a walnut dining chair with

simple lines and an elegantly shaped crest rail by Osgood to the more sculptural work of Somerson and Mattia. Most, like Philbrick's upholstered settee and a maple pier table by Schriber, included references to historical furniture forms. The studio furniture was displayed in groups of two or three pieces, distributed as accents throughout the show, among the forty-eight booths filled with furniture and decorative arts objects of all types. In the show setting, contemporary pieces could be viewed alongside a William and Mary highboy, several Queen Anne blockfront desks, and a variety of 200-year-old card tables.

The decision to include an exhibit of studio furniture with antiques recalled the *New American Furniture* exhibit by Boston's Museum of Fine Arts ten years ago, raising questions again about the relationship between the two fields. While the earlier MFA show used visual connections between antique and contemporary furniture to illustrate and explore the design process, the show at Ellis used similar visual connections to imply that contemporary studio furniture will be, in the words of the Ellis organizers, the "antiques of tomorrow."

In broader terms, the pairing implied that studio furniture represents our society today in the same way that antiques represent the society of their own

times—comparable objects with comparable social and cultural importance.

It should be noted here that, by definition, every object in today's culture will qualify as an "antique" 100 years from now. But here we are defining antique as not merely old, but cherished, preserved, collected, and most importantly monetarily valued as a representation of the culture of a previous age.

How can one predict whether or not the studio furniture of today will fill that role in the future, when that determination can be made only by future generations? That judgment will be made by a society viewing the studio furniture of today through the filter of their own aesthetic and cultural preconceptions, just as we see and judge antiques with the taste and sensibilities of our own times, and just as 100 years ago, "antiques" were viewed in a very different light.

While one cannot predict the future, the question can be approached by examining some of the qualities shared by antiques and studio furniture, qualities that might make studio furniture attractive to future generations of antique collectors. On the most basic level, studio furniture is made to last, unlike many other objects in our throw-away culture. This means there is a good chance that studio furniture will survive the requisite 100 years to achieve antique status.

In addition, studio furniture is created by a known maker and in limited quantity, unlike most objects in our society, which are manufactured anonymously and in vast quantities. We can safely predict that there will be less of it to collect than there will be other types of furniture, perhaps increasing its value.

From an academic point of view, studio furniture also has qualities that might enhance its appeal to future antiquarians. Since its maker is known, often the purchaser of studio furniture can be identified as well. Over time, this establishes what antique collectors know as a "provenance," and it is seen to enhance the value of a piece. Further, the body of work created by a maker or a group of regional makers or the relationship of these makers to their clients might lend itself to scholarly analysis and study, often a contributing factor in establishing value for decorative arts objects.

But in other ways, studio furniture does not seem so well suited to the traditional standards of antiquarianism, and that was apparent at Ellis when one overheard dealers and visitors discussing the furniture on display. In particular, the traditional concept of "connoisseurship," so much a part of the world of antiques, does not seem to fit very comfortably with the world of studio furniture today.

Most antiques are commonly accepted furniture forms that reflect their time's consensus regarding taste and function. With the overall form of each type of furniture established, antiques are differentiated by the subtleties of their design and the details of their craftsmanship. This is the stuff of connoisseurship, the basis for establishing value, the criteria for "good, better, best" so definitively described by Albert Sack in his book, *Fine Points of Furniture*.

Studio furniture, on the other hand, can be unique in form, since today there is a much less rigid understanding as to style and fashion. Often, makers of studio furniture are involved in personal expression in a way that the makers of antiques were not. Differences between pieces can be as apparent in their concept as in their details. When the "idea" of a piece is as important as its execution, determining value is more a question of opinion and taste, not the rational application of comparative standards.

At Ellis, this difference was apparent in the sculptural pieces of studio furniture selected for the exhibit, such as "Flat Cabinet" by Alphonse Mattia. In this piece, Mattia began with the idea of a vertical plane penetrated by a cabinet to create the sense of an optical illusion involving two-dimensional and three-dimensional forms. The function of the cabinet is generic, or in Mattia's words, "unidentifiable." The intended function of the piece as a whole is as a gathering place, "something that would stand out from the wall like an island you would gravitate toward."

It would be difficult to compare "Flat Cabinet" to the surrounding nineteenth-century furniture based on the traditional principles of connoisseurship. It would be equally frustrating to compare it to another piece of contemporary studio furniture by analyzing only details of design and construction, since "Flat Cabinet" asks to be considered on a more conceptual level.

The ascendancy of the idea behind a piece of furniture to an equal level with the details of execution is not new to contemporary studio furniture. It can be seen in the patent furniture movement of the 1860s, when the mechanical concept behind a chair designed by George Hunzinger, for example, was more important than its outward form. Later, early Modernist designers including Marcel Breuer worked to incorporate the latest materials and industrial techniques into their furniture, while Gerrit Rietveld and others worked with abstract concepts of planes and space. For both, the conceptual premise of the furniture was as important as its final form.

The effect of an increasing emphasis on concept and originality on the traditions of connoisseurship can be seen when one examines early twentieth century furniture that is now beginning to achieve "antique" status. Early molded plywood chairs by Charles and Ray Eames, for example, are now beginning to be considered collectible "antiques," although they are not quite yet the required 100 years old. Early prototypes, made when Eames and his wife were working out with Eero Saarinen the details of bending and laminating plywood, are the most valuable from a collectors point of view, for in these pieces one can clearly see evidence of the maker and of the design process. These one-of-a-kind prototypes might be expected to find their way into museums, and that has in fact been the case. Beyond the prototype, there is general agreement that the initial production run is collectible, later production runs are less so, and re-issues are, comparatively, of no value at all, despite the fact that their outward appearance is identical and the details of craftsmanship are as good or better.

"They are not original," says Barry Friedman, owner of the Friedman Gallery in New York, of the later production runs of early twentieth century furniture. His gallery, which specializes in early twentieth century furniture and decorative arts and has helped to create the market, exhibits examples from only

the earliest production runs. He dismisses later copies, saying "the design has already been done, therefore the design value is zero." This view is shared by museum curators like MFA Boston's Jonathan Fairbanks, who characterizes a manufactured Eames chair as merely an "echo" of the original.

If the concept of connoisseurship in the twentieth century is being gradually redefined to be the first of this and the first of that, rather than the best or most sophisticated example, then why won't the antiques of the future be the first aluminum-tube and plastic-webbing patio chairs, or the first molded stackable deck chair from Kmart? The answer may be that, for some people, these and other similar objects will become the antiques of the future on grounds that those forms will embody the spirit or ethos of late twentieth century America.

In the final analysis what does or does not achieve antique status depends upon how future generations view this period in history and what, to them, represents the spirit and ethos of our age. Just as pine furniture represents to some the simplicity and honesty of agrarian early America, or Philadelphia Chippendale represents the wealth, ability, and growing self confidence of America prior to the Revolution, or a Hunzinger platform rocker represents the ingenuity of our Industrial Revolution, something will come to be seen as the embodiment of our own time.

What will that be? Given the fragmented nature of our society, it seems likely that in the future there will be a market for collectors of antique plastic lawn furniture, as well as other furniture forms. But it also seems reasonable to predict that studio furniture will be collected, at least in part, because it will provide collectors with the qualities of rarity, authorship, and documented pedigree found in the best antiques.

What remains to be seen is how studio furniture will be interpreted by future generations, and that of course is impossible for us to know. What messages will they see embedded in these objects about our technology, wealth, fashion, taste, and material culture? One possibility is that the idiosyncratic nature of studio furniture will be seen as a reflection of

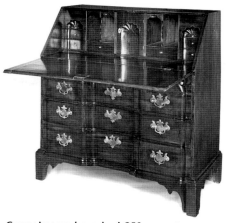

Courtesy of Bernard & S. Dean Levy Inc., New York

Connoisseurs have had 250 years to agree on the value and importance of antiques like this Queen Anne block-front desk, made in Boston around 1745. Not so the neoclassical upholstered settee made recently by Timothy Philbrick of Narragansett, RI, or the chest-on-stand, entitled "Ascent/Descent" made by Roseanne Somerson in Providence around 1995. All were shown at the Ellis Memorial Antiques Show.

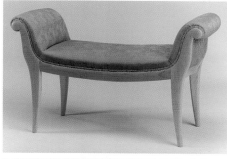

the individualistic or pluralistic nature of our culture. Or the opposite may be the case. What seems to us today as wildly disparate voices and views may one day look much more coherent. The differences between John Dunnigan and John Cederquist, for example, may be eclipsed by their similarities. We can't yet see the forest for the trees.

Whether or not the studio furniture on display at the Ellis Memorial Antiques Show will be the "antiques of the future," the exhibit seems to have had a positive impact on the traditional Ellis crowd. "There was a wonderful response from our dealers and the public," according to Coolidge. The craftsmanship and design stood up well in comparison to the antiques; the materials and details appealed to antiques lovers, and, in the context of $200,000 highboys, the studio furniture was seen as a good buy.

The show may also have had a positive impact on the furniture makers who came. They were able to see contemporary work in the context of some of the finest examples of eighteenth and nineteenth century furniture, picking up where *New American Furniture* left off ten years ago and continuing the dialog between generations.

But while the inclusion of studio furniture in a well established antiques show was encouraging, it also raised questions about the appropriateness of the pairing, if visitors to Ellis were being encouraged to buy studio furniture just as they would invest in antiques. For studio furniture to achieve the broad-based and long-term commercial success of antiques, it must develop its own principles of "connoisseurship."

A new framework will have to be described into which individual pieces of studio furniture can be set, so that they can be seen in a recognizable and understandable context. The ability to see studio furniture in its continuum will allow for reflection, comparative analysis, and ultimately the development of an appropriate form of critical evaluation that is independent of a single person's opinion or taste. Defining this context and developing new criteria for the comparative analysis of studio furniture are the challenges presented by this year's Ellis Memorial Antiques Show. ■

CONTRIBUTORS

Russell Baldon

Amy Forsyth

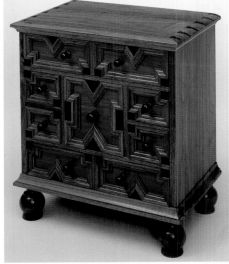

Miguel Gomez-Ibanez

AUTHORS and *EDITORIAL ADVISORS

Glenn Adamson ("California Dreaming," p. 32) is a PhD candidate in the history of art at Yale University. He has worked at the Everson Museum in Syracuse and the American Craft Museum in New York City. His dissertation, in progress, is a study of the relationships between art and craft in the late 1960s and early 1970s. He is currently on the curatorial team for the upcoming exhibition "Across the Grain: Woodturning in North America 1930 to 2000" at the Yale University Art Gallery.

Russell Baldon ("Next," p. 126) designed and built toys for several years before receiving a BFA from California College of Arts and Crafts and an MFA from San Diego State University. He has studied and worked with some of the country's leading furniture makers, and recently was artist-in-residence at the Oregon School of Art and Craft. He shares and maintains Pokensniff Studio in Alameda, CA.

Arthur Espenet Carpenter ("Memoir," p. 43) has work at several major museums, including the New York Museum of Modern Art, the San Francisco Museum of Modern Art, the Museum of Contemporary Crafts in New York, and the Smithsonian Institution's Renwick Gallery. A 1999 retrospective of his work was held at the Craft and Folk Art Museum in San Francisco.

***Edward S. Cooke, Jr.** ("Defining the Field," p. 8), the Charles F. Montgomery Professor of American Decorative Arts at Yale University, has written extensively on historical and contemporary furniture. Among his publications are *Making Furniture in Preindustrial America: The Social Economy of Newtown and Woodbury, Connecticut* and *New American Furniture: The Second Generation of Studio Furnituremakers*. He has just finished an essay on Garry Knox Bennett and is currently working on a volume of essays on the history and impact of summer craft education in America. Cooke is also a trustee of The Furniture Society.

John Dunnigan ("Understanding Furniture," p. 12) is a furniture maker who lives and works in West Kingston, RI, and is Professor in the Department of Furniture Design at the Rhode Island School of Design. For more than twenty-five years he has produced furniture for exhibitions and commissions, and his work is included in several private and public collections, including the Museum of Fine Arts, Boston, and the Renwick Gallery, National Museum of American Art, Smithsonian, Washington, DC.

***Dennis FitzGerald** is shop manager and adjunct faculty member at the School of Art and Design at Purchase College SUNY. He is also vice-president of The Furniture Society.

***Amy Forsyth** ("Booking Passage, p. 110) studied architecture at Penn State and Princeton Universities, and teaches design, drawing, and theory in the College of Architecture at the University of North Carolina at Charlotte. For the past several years she has shifted her attention to furniture, and has taken workshops with John Dodd, Michael Puryear, and Rich Preiss. She now spends every possible moment in the shop building tables, cabinets, chairs, and other useful, if peculiar, artifacts.

***Brian Gladwell** ("Putting It Together," p. 119) is a furniture maker (see p. 109 for a picture of his work) and teacher in Regina, SK. He is also treasurer of The Furniture Society.

Miguel Gomez-Ibanez ("Antiques of Tomorrow," p. 139) is an architect-turned-furniture maker who works in Wellesley, MA. A one-time journalist, he writes the "Furniture in the News" monthly column on The Furniture Society's website.

Roger Holmes

Josh Markel

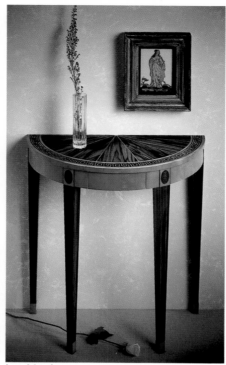
Loy Martin

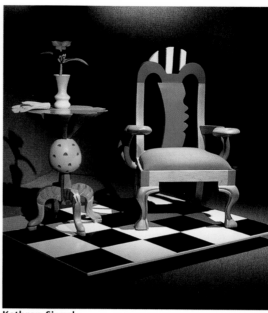
Kathran Siegel

Peter Handler ("It's Not All Wood," p. 103) has been making furniture in Philadelphia, PA, since 1982 and is a trustee of The Furniture Society.

Roger Holmes ("From a Distance," p. 58) works at home in Lincoln, NE, in a woodworking shop and publishing office disguised as a garage. He is author of the book *The Complete Woodworker's Companion* and editor of a series of gardening books.

Josh Markel "Where to Find It," p. 74) makes furniture in Philadelphia, PA, and, along with Bob Ingram, organizes the Philadelphia Furniture Show each spring.

***Loy Martin** ("Embedded Energies," p. 76) earned a Ph.D. in English literature from the University of Virginia in 1973. He taught in the English departments of the University of Michigan, Stanford University, and the University of Chicago before leaving his academic career in 1982 to design and make studio furniture full time in Palo Alto, CA. Since then, his work has been published in various books and periodicals and shown in a number of West Coast galleries.

Teaching furniture history at the Art Institute of Seattle provided an academic context for **Margaret Minnick's** ("Commissioning," p. 68) interest in Northwest studio furniture makers and their clients. A generous research grant by Seattle patrons to The Furniture Society is enabling her to continue tracing the history of the region's furniture making with the goal of presenting the results in a museum exhibition to bring fame and fortune to every maker involved.

Kathran Siegel ("A Bridge Between Life and Art," p. 136), of Bucks County, PA, makes furniture as an element within a larger narrative context also fabricated of carved and painted wood. Her studies in painting at Bennington College and the University of New Mexico, where she earned a BFA, remain a strong element in her work. Siegel also holds an M.Ed. from the University of Florida and has taught, on and off, throughout her career.

Kristina Wilson ("Icons of High Modernism," p. 134) is a doctoral candidate in the history of art, focusing on American decorative arts, at Yale University.

EDITORAL/PRODUCTION TEAM

John Kelsey, coeditor, is a journalist, furniture maker, and the publisher of Cambium Press, which specializes in books on woodworking and furniture design. A graduate of the School for American Craftsmen, Kelsey was editor of *Fine Woodworking* magazine throughout its black-and-white years, 1976–1984. He has written more than a dozen books on woodworking and other craft subjects.

Rick Mastelli, coeditor, is a craft editor, writer, photographer, and award-winning videographer. A former associate editor of *Fine Woodworking* and former editor of *American Woodturner,* he is also a former furniture maker, having suspended woodworking you can actually complete when he began building his own house ten years ago. As a partner of Image & Word, he has contributed to a number of books and videos on craft, gardening, and American cultural history. He is also a special advisor to The Furniture Society.

Deborah Fillion, art director and a partner of Image & Word, has been designing and producing books and magazines on crafts, gardening, homebuilding, and American cultural history for twenty years. She has recently begun to exhibit her drawings, paintings, and monoprints.

Index of Names (boldface indicates photo)

JOIN
THE FURNITURE SOCIETY AND YOU WILL

- Gain access to the world of studio furniture

- Enjoy a 33% discount on future books in the **FURNITURE STUDIO** series

Phone: 804/973-1488
Fax: 804/973-0336
www.avenue.org/Arts/Furniture

Place
stamp
here

The Furniture Society
Box 18
Free Union, VA 22940

Phone: 804/973-1488
Fax: 804/973-0336
www.avenue.org/Arts/Furniture

Send this form with membership fee to:

The Furniture Society
Box 18
Free Union, VA 22940